SUCCESSFUL
GLAMOR
PHOTOGRAPHY

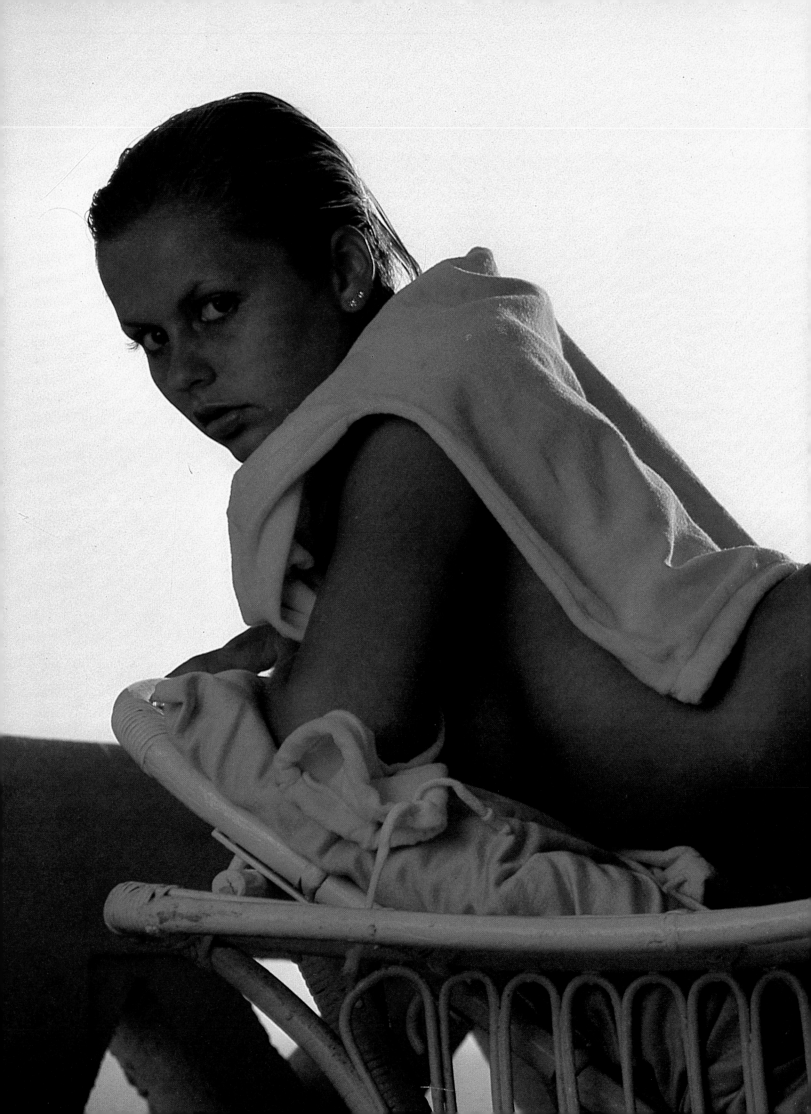

SUCCESSFUL
GLAMOR
PHOTOGRAPHY

John Kelly

Amphoto Books
American Photographic Book Publishing
An imprint of Watson-Guptill Publications
New York

Paperback Edition
First Printing 1983

Copyright © 1981 by Quarto Publishing
Limited

First published 1981 in New York by
American Photographic Book Publishing: an
imprint of Watson-Guptill Publications, a
division of Billboard Publications, Inc., 1515
Broadway, New York, N.Y. 10036

Library of Congress Catalog Card Number:
81-69891
ISBN 0-8174-5924-3 pbk.

3 4 5 7 8/88 87 86 85

This book was designed and produced by
Quarto Publishing Limited 32 Kingly Court London W1

Project Editor
John Roberts
Text
Anne Charlish, Jeremy Harwood
Art Editor
William Graham
Art Assistants
Andrew Fenton, Helen Kirby
Art Director
Robert Morley
Editorial Director
Jeremy Harwood
Illustrations
David Worth, David Staples, Bill Easter, Ed Stuart

Color reproduction by Rainbow Graphics, Hong Kong
and Rodney Howe Ltd., London
Printed in Hong Kong by Lee Fung Asco Printers Ltd

CONTENTS

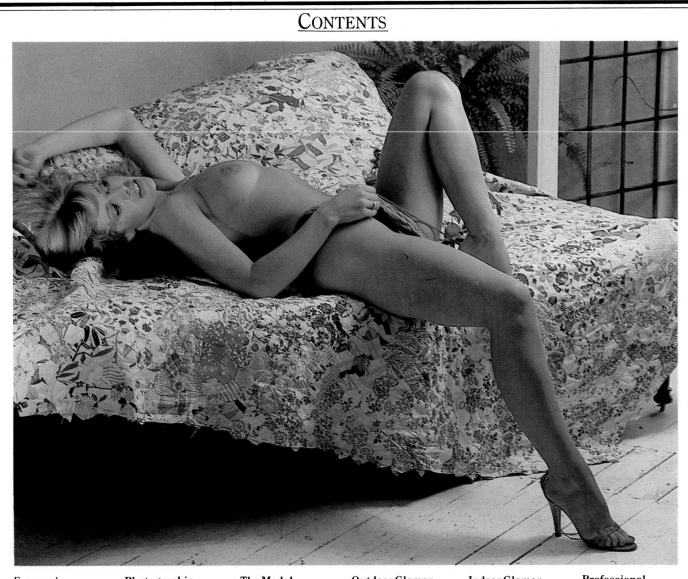

INTRODUCTION

THE CAMERA IS a very powerful instrument. It can tell the truth, but it can also distort it. More precisely, it can create beauty and interest where they had not previously existed.

Nowhere is this more true than in the world of glamor photography. With the burgeoning of the beauty business over the last twenty years or so, photographers were promoted to the top of the tree. They and they alone were able to supply irrefutable evidence that beauty exists. It may exist only for an instant – when the hair, eyes and mouth are just so – but that instant can be captured forever by a competent photographer.

I had always been interested in photography and beautiful women, so I was only an f-stop away from combining the two when I left art school. I worked for a number of newspapers and glossy magazines before finally setting up my own studio as a freelancer in 1972. By that time, I had learned two important rules. The first was that, contrary to popular belief, glamor photography is not all fun and games. True, I photograph some of the world's most beautiful women, but a lot of hard – and sometimes frustrating – work goes into the end result.

The second rule – at least as far as I am concerned – was that all a camera needs is an informed and sympathetic photographer behind the viewfinder. For this reason this book is not highly technical, as photography books go. I have assumed that most readers will know their way around a 35mm camera and understand the importance of focusing their image and choosing the right shutter speed. Modern camera technology has solved most of the problems that previously daunted beginners and I see no point in duplicating a lot of unnecessary information.

The other reason why this is not a technical manual is that I am an instinctive, not a technical, photographer. I rely almost entirely on the camera's built-in exposure meter, for instance, while seventy-five per cent of my pictures are taken with an 85mm lens. I use low-speed Kodachrome almost exclusively and rarely photograph under impossible lighting conditions.

I have concentrated on what I consider to be the most important aspects of glamor photography, the prime one of which is training yourself to think visually. I offer suggestions, but not rules. When you apply my advice, you should filter it through your own perception. Otherwise it will be useless.

What I have not been able to do is to explain exactly *why* I took a certain picture. Study my photographs and draw your own conclusions. If they work, the reasons should be self-evident. Perhaps you will find it impossible to put the *why* into words too, but that doesn't matter. Photography is a visual medium and its success does not depend on literal explanations. Rather like a beautiful woman; no one needs to know why she's beautiful – she just *is!* And really I think this is what Successful Glamor Photography is all about.

John Kelly

PHOTOGRAPHIC EQUIPMENT

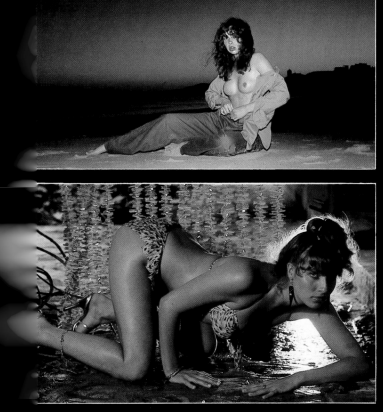

Cameras and accessories need to be versatile to cope with different lighting conditions. The two lower pictures are Polaroid test shots, taken to evaluate results in advance. Whatever the circumstances, the advice in this chapter will help.

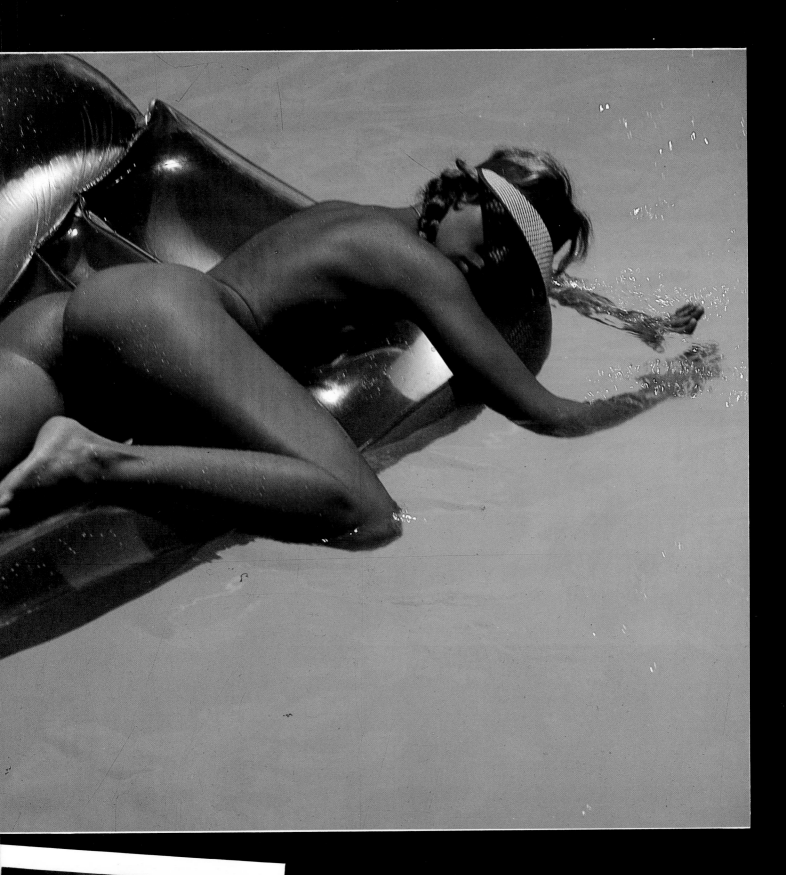

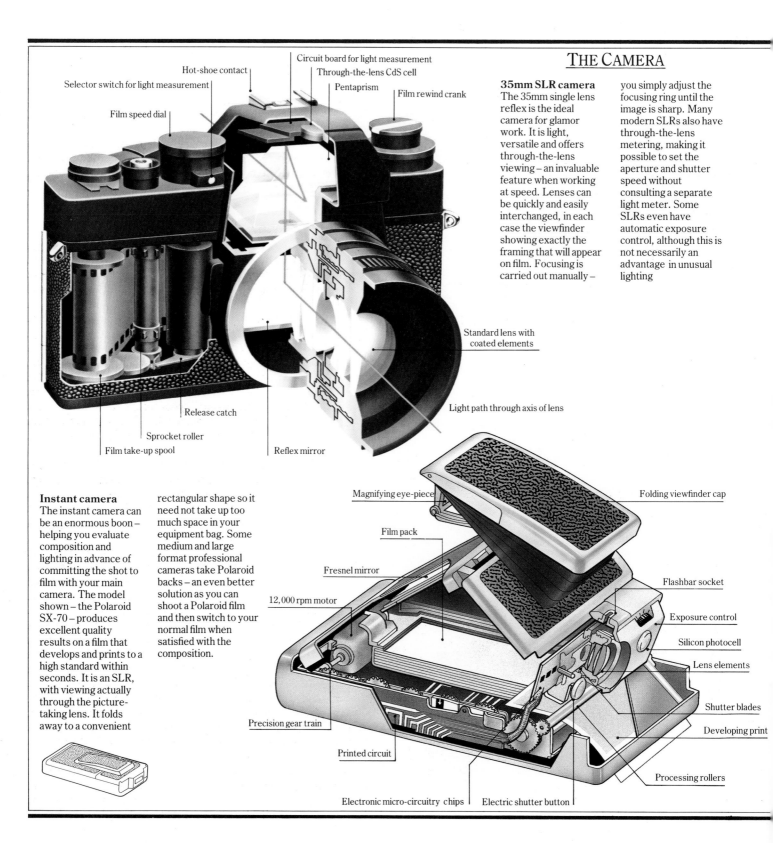

Selector switch for light measurement

Hot-shoe contact

Circuit board for light measurement

Through-the-lens CdS cell

Pentaprism

Film rewind crank

Film speed dial

THE CAMERA

35mm SLR camera
The 35mm single lens reflex is the ideal camera for glamor work. It is light, versatile and offers through-the-lens viewing – an invaluable feature when working at speed. Lenses can be quickly and easily interchanged, in each case the viewfinder showing exactly the framing that will appear on film. Focusing is carried out manually –

you simply adjust the focusing ring until the image is sharp. Many modern SLRs also have through-the-lens metering, making it possible to set the aperture and shutter speed without consulting a separate light meter. Some SLRs even have automatic exposure control, although this is not necessarily an advantage in unusual lighting

Standard lens with coated elements

Release catch

Sprocket roller

Film take-up spool

Reflex mirror

Light path through axis of lens

Instant camera
The instant camera can be an enormous boon – helping you evaluate composition and lighting in advance of committing the shot to film with your main camera. The model shown – the Polaroid SX-70 – produces excellent quality results on a film that develops and prints to a high standard within seconds. It is an SLR, with viewing actually through the picture-taking lens. It folds away to a convenient

rectangular shape so it need not take up too much space in your equipment bag. Some medium and large format professional cameras take Polaroid backs – an even better solution as you can shoot a Polaroid film and then switch to your normal film when satisfied with the composition.

Magnifying eye-piece

Folding viewfinder cap

Film pack

Fresnel mirror

Flashbar socket

12,000 rpm motor

Exposure control

Silicon photocell

Lens elements

Shutter blades

Developing print

Precision gear train

Printed circuit

Processing rollers

Electronic micro-circuitry chips

Electric shutter button

Cameras and lenses

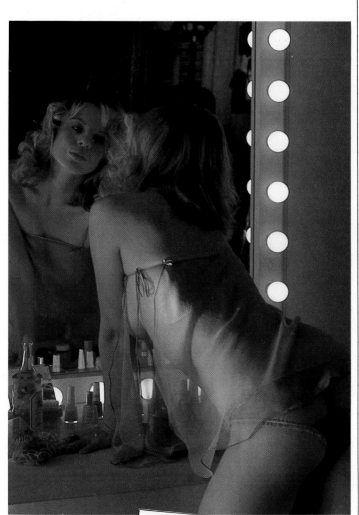

The two main cameras for glamor photography in action: the 35mm SLR (above) gives high quality results on a wide choice of film and the Polaroid (right) gives a small scale instant print to test the shot. This is especially useful when the lighting is difficult to evaluate.

I N COMPARISON TO other branches of photography, the amount of equipment needed for successful glamor photography is relatively small. The basis of any kit is a 35mm SLR camera, with the appropriate range of lenses. Each photographic assignment has its own individual requirements, which will determine which lenses should be selected for use.

In addition, there are a number of standard items that should be part of every camera kit. The Equipment Checklist given here serves as a guide to the complete range of equipment required, though, obviously, some of it is needed for studio work and some on outdoor locations.

THE CAMERA

Today's camera technology is so extremely sophisticated that there is sometimes the risk of using technique for its own sake, or buying expensive camera accessories that are little more than gimmicks. This is totally counter-productive as far as glamor photography is concerned; the aim is to achieve total spontaneity of effect. The trick is to learn how to use your camera and then forget about it, leaving yourself free to concentrate on the image you are trying to create.

The 35mm SLR (single lens reflex) camera represents the pinnacle of achievement in modern camera design. It is now the camera most widely used by professionals and amateurs alike and the obvious choice for any aspiring photographer. Not only is the camera compact and easy to handle; the fact that many of its functions are automatic makes its operation simple, quick and undemanding.

Most modern 35mm SLRs, for example, have a viewing system that allows you to see precisely what the lens is imaging – not only what it is framing, but also the depth of field. Additionally, the light sensitive cells incorporated within the camera make it possible to ensure highly accurate exposure measurements of the area to be photographed.

As far as glamor work is concerned, the SLR does have one minor disadvantage in the eyes of some photographers. The mirror arrangement does not allow you to see the subject at the moment the photograph is being taken. At fast speeds, this is hardly noticeable, but, in long or panned exposures, it can be inhibiting. Also, under low light conditions, or with lenses that have small maximum apertures, viewing and focusing can be difficult. To overcome this, most lenses have a pre-set diaphragm that allows normal viewing when the aperture is fully open, but stops down to the correct aperture at the moment of exposure.

The Polaroid is a useful additional item in glamor photography, because its use enables you to take quick instant reference prints as a final check before you embark on the actual shoot. It is not a necessity, however, though professionals almost always use one.

The camera is a particularly helpful accessory if you plan to concentrate on indoor glamor photography. It will not only enable you to see immediately if the pose you have in mind will work, but also whether the technical arrangement of the lighting needs

adjustment. Though Polaroid color is usually not comparable, the lighting will reproduce faithfully, allowing you to make any necessary changes before the final shoot.

The Polaroid has one further advantage. Because no dark room is required for development, the film itself is the only extra cost after the purchase of the camera.

LENSES

Modern technology has deeply influenced lens design; the lenses of today are much more refined than their predecessors. The range of lenses available for 35mm cameras is therefore extensive. For glamor photography, the 35mm, 85mm, 135mm and the 80mm-200mm zoom lens are generally considered the most useful by professionals. However, it is always worth experimenting with different lenses.

Most cameras are sold with a 50mm or 55mm lens. Of all focal lengths, this is the least obtrusive and gives a faithful, straightforward rendering of an image. But you may find it eventually restricting for glamor shots. It is far better to use one of the appropriate accessory lenses given below.

The 35mm lens is a moderately wide angle lens that is indispensable for indoor photography and for working in confined spaces. This lens's perspective is much closer to that of a 'normal' focal length, but it does not possess such great depth of field as wider angle lenses at full aperture.

85mm and 135mm lenses Both the 85mm lens and the 135mm lens are long focus; the former is the most useful lens for glamor photography, being particularly flattering for portraiture.

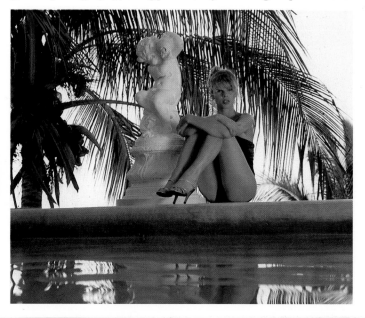

LENSES

There is no need to accumulate large numbers of expensive lenses – just establish the ones you like working with and stick to them. For glamor photography, the minimum requirements are likely to be: a moderate wide angle for 'setting' shots, and a moderate long focus or 'portrait' lens. A longer focal length, such as 135mm or 200mm will sometimes be useful. Some particular lenses you might like to consider are described here with their characteristics. These focal lengths apply to 35mm cameras. Other formats have different focal lengths for the same effects. The angles of view, given in brackets, are measured across the diagonal of the frame.

24mm lens (84°): this wide angle lens is normally an essential part of the photographer's equipment. For glamor photography, however, it will only be useful for shots of a model in an extensive and spectacular background. It may be needed in cramped working spaces indoors, but this may produce unattractive distortion.

35mm lens (62°): the moderate wide angle lens is good for glamor work, with less distortion than a true wide angle lens. It is the lens of choice when working in cramped interiors and when trying to include a large part of the setting in the shot.

50mm lens (46°): the 'standard' lens, usually supplied with new cameras, has an angle of view very similar to the human eye. It is an all-purpose lens, but produces images without any specific character and therefore less impact. The 85mm is better for use as a normal lens for glamor work. Some 50mm lenses, however, do have very wide maximum apertures – even fl.2.

Whereas a wide angle lens exaggerates perspective, increasing the apparent difference in size between near and far objects, this lens compresses it. The 135mm needs more light for its magnified image and so the lens has a relatively large aperture, plus a limited depth of field. This is ideal if you want to focus your subject against a blurred background.

A further great advantage of a long focus lens is that the photographer can work at a distance. This can be particularly useful for candid shots, or in beach photography.

80mm-200mm zoom Modern zoom lenses are often preferred to conventional fixed focal lenses, since their use obviously increases the number of ways a subject can be treated. Without changing position or lens, for instance, you can concentrate on a detail of the face or body in one shot and take a fuller view in the next. The range of such lenses is usually between two and three times the shortest focal length – 35mm-70mm, 80mm-200mm and 100mm-300mm.

However, zoom lenses do have some disadvantages. Lens flare tends to be more pronounced, since there are more lens elements, while zoom lenses focus less clearly than conventional lenses. This is a particularly important consideration in certain types of glamor work.

Wide angle and extreme long focus lenses In glamor photography, both these lenses are of limited use. As far as wide angle lenses are concerned, their only purpose is for creating a bizarre, distorted effect. In the case of extreme long focus lenses (300mm and over), the only useful effect they can create is a voyeuristic, 'peeping Tom' image.

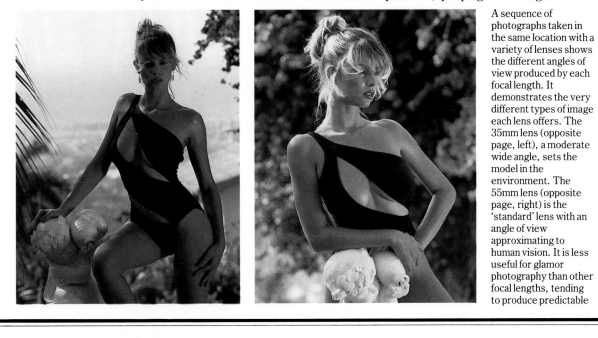

A sequence of photographs taken in the same location with a variety of lenses shows the different angles of view produced by each focal length. It demonstrates the very different types of image each lens offers. The 35mm lens (opposite page, left), a moderate wide angle, sets the model in the environment. The 55mm lens (opposite page, right) is the 'standard' lens with an angle of view approximating to human vision. It is less useful for glamor photography than other focal lengths, tending to produce predictable images, neither concentrating on the model, nor setting her in the location. The 85mm lens, (this page, left) is ideal, closing in on the model and still offering reasonable depth of field. It is more flattering to the proportions of the body and face than wider angle lenses, and offers a working distance from the subject that is generally found to be convenient. The 135mm lens (this page, right), is similar but with reduced depth of field. It is useful when you cannot approach the model closely.

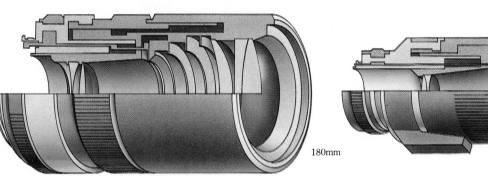

180mm

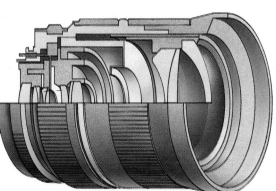

400mm

180mm lens (13°): telephoto lenses in the range 105mm to 200mm can be very useful for glamor work, and each photographer will have his favorite. The chief drawback of telephoto lenses is their smaller maximum apertures. Lens technology is overcoming this and this 180mm model, for example, opens up to f2.8.

400m lens (8°): longer telephotos are only suited for special effects shots in glamor photography. You may, for example, want a highly compressed perspective, or you may want to place the model in a spectacular and inaccessible spot that requires you to work from a great distance – perhaps from above on a balcony.

Zoom lenses: there are many different zooms available from different manufacturers and the technology of these lenses improves all the time. This 28-45mm model covers the moderate wide angle range. Other suitable zooms are in the range 80mm to 200mm. These are very useful for quick and spontaneous work as the framing of the model can be adjusted quickly without changing the camera position. Conventional telephotos have a slight advantage over zooms in that their maximum apertures are slightly larger at each focal length.

CAMERA SUPPORTS AND ACCESSORIES

In glamor photography, it is common practice to use some form of camera support – usually a tripod – to avoid the risk of camera shake. This is far less acceptable than subject movement, particularly when shooting at slow speeds. At fast speeds, the camera can be hand held, but in the studio, or when precise composition is important, a support should always be used.

The ideal tripod should make it possible for you to take sharp pictures with a slow shutter speed under very windy conditions, with its legs fully extended. If it does not perform to these requirements, you will have wasted your money. Points to check are the tripod's ability to hold a steady weight and also its resistance to torque. Check the latter by trying to twist the head; if this moves significantly, the design is poor. It should also be possible to spread the legs to a wider angle for a lower camera position, though an alternative is to reverse the center column so that the camera hangs from the tripod. Some center columns have a rachet and crank for raising and lowering the camera, but, on cheap tripods, this device can simply make them less steady.

Motor drives, winders and shutter releases As its name suggests, a motor drive uses an electric motor, powered by batteries, to trigger the shutter and wind on the film. This is invaluable for fast action shooting, but it is also extremely useful throughout the glamor photography field. Your aim in glamor photography is to concentrate as much of your attention as possible on the subject and anything that helps you to do this is a valuable aid. On most models, the firing rate is adjustable up to five frames per second, though the unit can also be set to fire single frames. A cheaper alternative is an automatic winder.

Cable releases are another way of simplifying firing when a long exposure time is required. Their use lessens the risk of camera shake, which can occur even when the camera is mounted on a tripod. The device is simply a flexible, sheathed cable that screws around or into the shutter release button. The longer and more flexible the cable, the less chance there is of vibration.

Lens attachments Two useful lens attachments are a lens hood and filter holders. The former is essential when working in intense sunlight, or when using lamps for backlighting, since, in both cases, it is very difficult to avoid creating flare. The use of a lens hood removes this risk, since it cuts off extraneous light from outside the picture frame. It will also protect the front of the lens from scratches and abrasions.

Whether you need to buy a lens hood or not depends on the model of lens you purchase. Some lenses have built-in hoods that retract when not needed; most, however, take separate hoods that screw or clip onto the front of the lens.

Filter holders reduce the wear and tear on filters. This is especially the case when gelatin filters are used. These are cheaper, but more fragile, than glass filters.

Viewfinders Many SLRs have the facility for changing viewing heads and a range of these to suit particular circumstances is part and parcel of any professional's equipment. A magnifying penta-prism head, for instance, allows rapid viewing of an enlarged screen without having to press your eye close up to the camera. A waist-level finder can be used for low-level viewing, while a high-magnification focusing viewer is useful for close-ups.

Camera protection Proper protection and storage of delicate photographic equipment is obviously vital. You should consider carefully the circumstances under which you will be taking photographs and act accordingly. A damp and salty atmosphere, for instance, will corrode the camera mechanism, while abrasive dust and dirt can damage lenses. Excessive heat can ruin both equipment and film.

The chief item of protective equipment is some form of camera case. There are several varieties available – the best, but most

Many modern motor drives can be set to shoot continuously at speeds of up to five frames per second. Alternatively, they can be used for single shots as a power winder (left). For sequences – in this case, the model taking off her bikini top – both modes can be very useful, allowing you to take a number of shots in a very short time without taking your eye from the viewfinder.
85-210mm zoom lens, Kodachrome 64, 1/125sec at f5.6.

ACCESSORIES

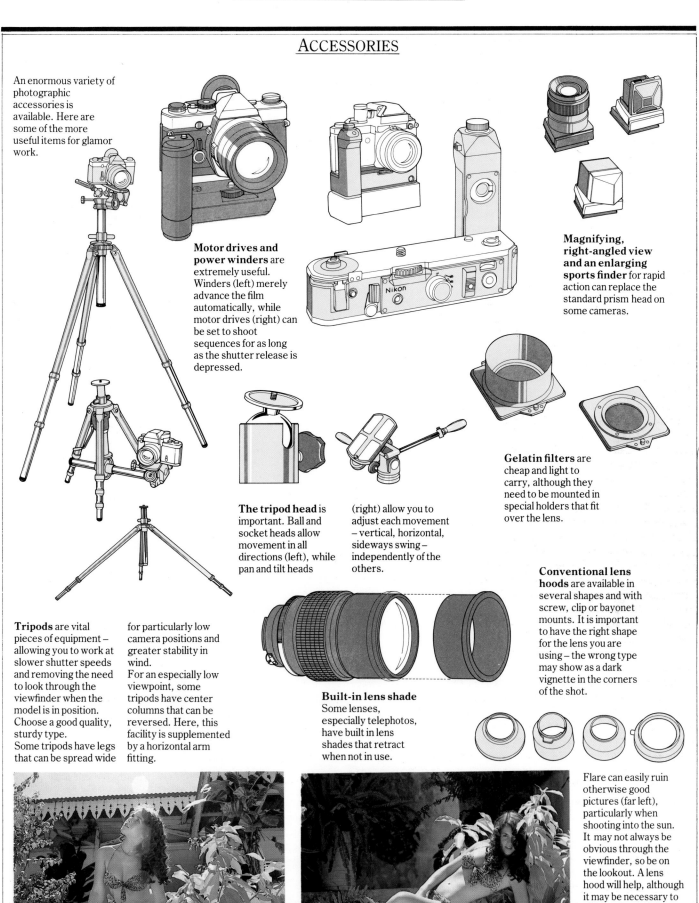

An enormous variety of photographic accessories is available. Here are some of the more useful items for glamor work.

Motor drives and power winders are extremely useful. Winders (left) merely advance the film automatically, while motor drives (right) can be set to shoot sequences for as long as the shutter release is depressed.

Magnifying, right-angled view and an enlarging sports finder for rapid action can replace the standard prism head on some cameras.

The tripod head is important. Ball and socket heads allow movement in all directions (left), while pan and tilt heads (right) allow you to adjust each movement – vertical, horizontal, sideways swing – independently of the others.

Gelatin filters are cheap and light to carry, although they need to be mounted in special holders that fit over the lens.

Tripods are vital pieces of equipment – allowing you to work at slower shutter speeds and removing the need to look through the viewfinder when the model is in position. Choose a good quality, sturdy type. Some tripods have legs that can be spread wide for particularly low camera positions and greater stability in wind. For an especially low viewpoint, some tripods have center columns that can be reversed. Here, this facility is supplemented by a horizontal arm fitting.

Built-in lens shade Some lenses, especially telephotos, have built in lens shades that retract when not in use.

Conventional lens hoods are available in several shapes and with screw, clip or bayonet mounts. It is important to have the right shape for the lens you are using – the wrong type may show as a dark vignette in the corners of the shot.

Flare can easily ruin otherwise good pictures (far left), particularly when shooting into the sun. It may not always be obvious through the viewfinder, so be on the lookout. A lens hood will help, although it may be necessary to change the camera position (left) as well. 35mm lens, Kodachrome 25, 1/60sec at f5.6.

CARE AND MAINTENANCE

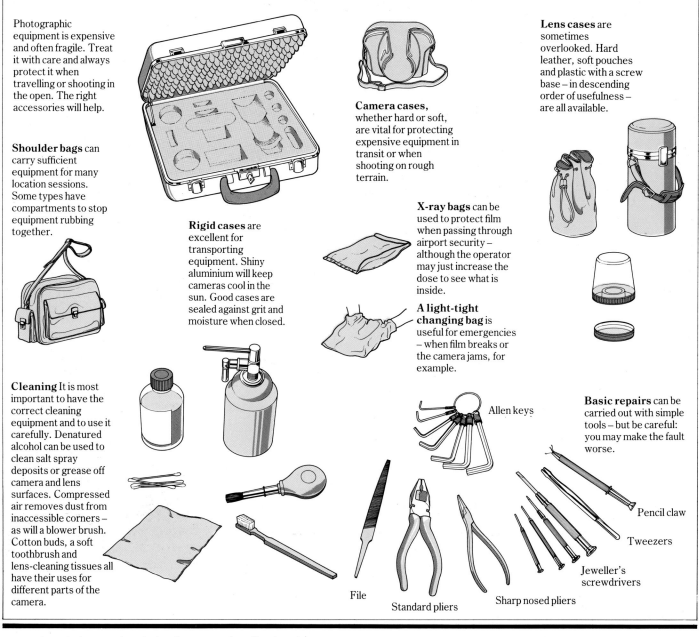

Photographic equipment is expensive and often fragile. Treat it with care and always protect it when travelling or shooting in the open. The right accessories will help.

Shoulder bags can carry sufficient equipment for many location sessions. Some types have compartments to stop equipment rubbing together.

Rigid cases are excellent for transporting equipment. Shiny aluminium will keep cameras cool in the sun. Good cases are sealed against grit and moisture when closed.

Camera cases, whether hard or soft, are vital for protecting expensive equipment in transit or when shooting on rough terrain.

Lens cases are sometimes overlooked. Hard leather, soft pouches and plastic with a screw base – in descending order of usefulness – are all available.

X-ray bags can be used to protect film when passing through airport security – although the operator may just increase the dose to see what is inside.

A light-tight changing bag is useful for emergencies – when film breaks or the camera jams, for example.

Cleaning It is most important to have the correct cleaning equipment and to use it carefully. Denatured alcohol can be used to clean salt spray deposits or grease off camera and lens surfaces. Compressed air removes dust from inaccessible corners – as will a blower brush. Cotton buds, a soft toothbrush and lens-cleaning tissues all have their uses for different parts of the camera.

Basic repairs can be carried out with simple tools – but be careful: you may make the fault worse.

Allen keys

Pencil claw

Tweezers

Jeweller's screwdrivers

File

Standard pliers

Sharp nosed pliers

expensive, being made of aluminum, gasket-lined and water, dust and grit proof. The reflective metal finish also helps keep the equipment cool, since it reflects heat. Such a case has room for other fragile items, such as lenses, as well as the camera.

Shoulder bags are acceptable alternatives. However, they will not generally offer as much protection against dust or damp as an aluminium case, so keep camera and lenses in plastic bags if you are likely to be working in such conditions. It is also advisable to protect lenses with individual lens cases, if there is any risk of items of equipment scraping together. These come in hard leather, soft padded leather, or clear plastic with a screw base. Always keep a packet of silica gel in your case to absorb damp.

You will also need a changing bag and an x-ray proof bag. The former is useful if the film jams in the camera and there is no darkroom within reach. The latter is lead-lined to protect film against x-ray machines at airports. It also provides an extra measure of safety if unprocessed film has to be mailed.

Cleaning equipment A cleaning kit for lenses and the moving parts of the camera is just as essential as an adequate form of protection. It makes no sense to buy an expensive lens and then not to look after it properly. This is especially true when photographing on location – particularly on a beach – when you should pay particular attention to the cleanliness of your lens.

Blow dust off with a blower brush and use a lens cloth or special cleaning tissue for cleaning surfaces. Dust and grit can also be removed with denatured alcohol, applied with cotton wool swabs. **Maintenance and repair equipment** Complicated camera repairs are a job for an expert, but there can be times when you have no option but to make temporary repairs yourself. Simple on-the-spot repairs are usually possible with the aid of a few basic tools, such as tweezers, a set of jeweler's screwdrivers, sharp-nosed pliers, and a pencil claw.

FILTERS

Color correction filters have their uses in glamor photography, but it should be stressed at the start that these are not as extensive as in other photographic fields. The quality demanded by the subject is such that it does not pay to compromise with the wrong film stock or less than perfect lighting conditions. Of course, this does not mean that filters should never be used;

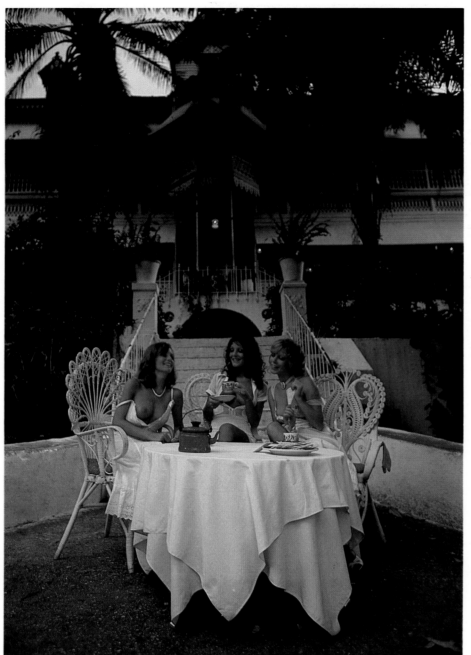

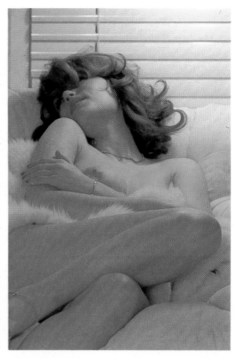

For the last shot of an assignment (left), taken as the light was fading, a graduated filter was used to darken the top half of the frame. Without it, the setting would have distracted from the emphasis on the three models.
28mm lens, Kodachrome 64, 1/30sec at f5.6.

Tungsten lighting (above), from continuous photographic lights (not flash) or standard light bulbs, gives an orange cast on daylight film. The effect can be attractive, giving a warm color to the skin, but for more accurate results, bluish filters are needed.
85mm lens, Kodachrome 25, 1/15sec at f5.6.

there may be situations – or effects may be required – that makes their use desirable. It may be, for instance, that the effect you want demands the use of tungsten film in daylight. This is strictly incorrect, since the result will be dominated by a strong blue cast. You can eliminate this, while still preserving the other effects, by placing an orange filter over the lens. Similarly, photographing with daylight film in tungsten lighting creates an orange cast on the photograph, although the effect is more acceptable. A blue filter can be used to correct this.

A further use for filters is if you are shooting in very drab, cold conditions. Here, a pale color filter will often serve to warm up the color in the photograph. Note, however, that, if you do use a filter for this purpose, you should make sure that it will not give your model's skin an unnatural tone.

Specialized filters Other filters are more highly specialized. When two color graduated filters are used together, for instance, they will produce a different hue above and below the horizon in a landscape shot. This effect is occasionally, though only rarely, used in glamor photography. Another specialized filter is the star filter. This uses cross-screens to produce a 'star' effect on point

Color correction filters require additional exposure (right) When using the filters recommended on page 22 to balance the color of the film to that of the light source, give extra exposure as indicated. Note that additional exposure is not needed with through-the-lens meters.

Type of Light	Type of Film	
	Daylight film	Tungsten balanced film
Shade under blue sky	85C	85B
Overcast sky	81A	85B
Summer sunlight or Electronic flash		85B
Photoflood lamp	80B	81A
Photographic lamp	80A	
Ordinary light bulbs	80A	82B

sources of light. The etched pattern on the filter determines the number of points to the star. It can be used, for instance, to highlight a piece of jewelry or a sequinned dress.

A polarizing filter is similarly useful in special circumstances. When light bounces off various materials – notably glass and water – the reflected light produces intrusive clear reflections, as in a store window, for instance. The filter can block this light without changing the color quality of the photograph, though it may deaden the texture slightly.

A soft focus filter can also be used to good effect in certain types of shot. As the name implies, it is designed especially to create a soft image. It will obscure detail slightly – most lenses are intended to produce the sharpest possible detail – and cover the subject in an ethereal haze, which can be very attractive for glamor shots. If you plan to produce many pictures of this kind, it could be worth investing in a soft focus lens, but this is naturally more expensive than the filter.

Star filters are particularly good with vehicles and other machinery (right). Etched with crossed lines (below), they convert points of light into brilliant cross shaped glints. Use the preview button to stop down the lens to judge effect before shooting. 85mm lens, Kodachrome 25, 1/160sec at f5.6.

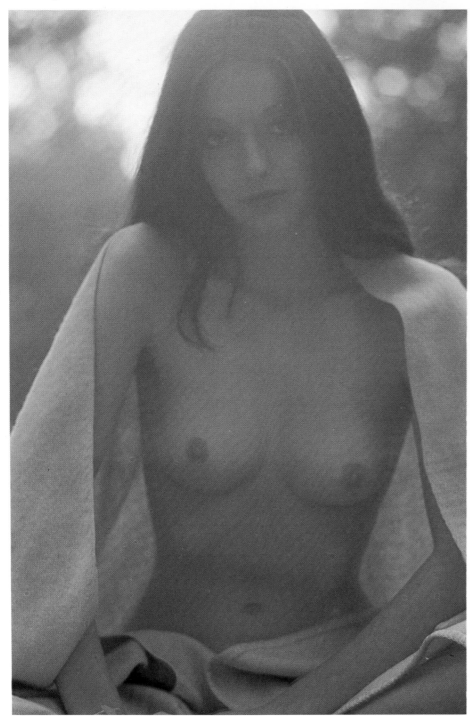

Short focus is widely used in glamor photography, flattering the model and creating a romantic mood (left). Various means can achieve this effect: Vaseline can be smeared on the lens or a clear filter (be careful, it is almost impossible to clean off without damaging the surface), gauze can be placed in front of the camera, and special attachments can be used. The simplest is an etched filter. 85mm lens, Kodachrome 25, 1/15sec at f5.6.

Soft focus attachments (above) can be used to create an accurately controlled soft focus vignette around the image.

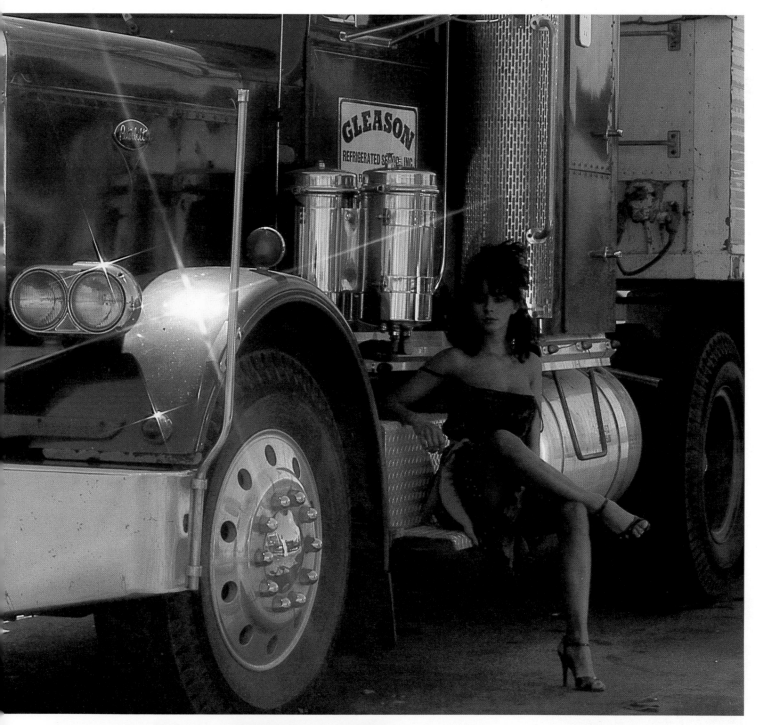

Polarizing filters can block unwanted reflections. This shot taken through the window of a boat, would have been spoilt without the filter (far left). With it, the window became almost invisible (left). Polarizing filters can also be used to eliminate reflections from surrounding surfaces such as water. Simply revolve the filter until the image darkens (right). 85mm lens, Kodachrome 64, 1/30sec at f5.6.

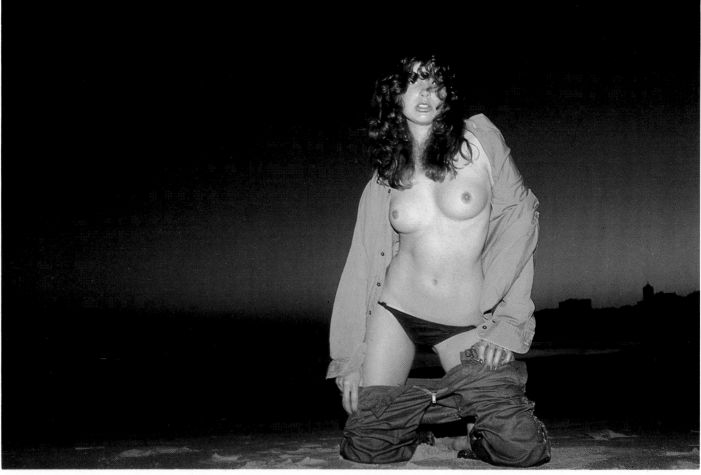

Portable flash units can occasionally be used for special effects in glamor photography (above). Their light is usually too hard to be attractive, with ugly shadows or 'red eye' caused by the light reflecting back to the camera from the model's retinas. Here, however, the effect is dramatic. The fading twilight just preserves the silhouetted background with the flash spotlighting the model in sharp relief. 35mm lens, Ektachrome 64, 1/60sec at f8.

Use the manufacturer's guide number for the speed of film you are using to calculate the aperture when using portable flash. Divide it by the distance to the subject (in feet or meters depending on the guide number system used). For example, if the guide number with ASA 64 film is 110 and the subject is 10 feet away, stop down to f11.

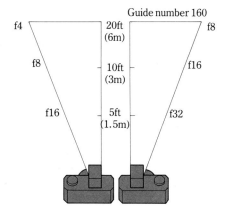

Guide number 160

f4 20ft (6m) f8

f8 10ft (3m) f16

f16 5ft (1.5m) f32

PORTABLE FLASH

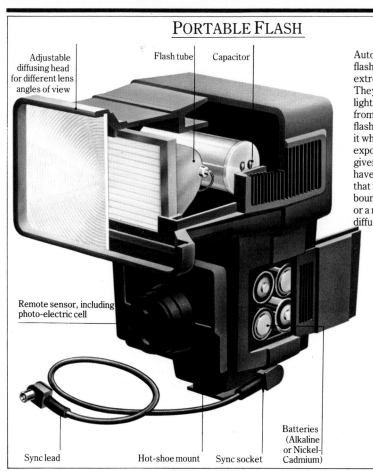

Adjustable diffusing head for different lens angles of view

Flash tube

Capacitor

Remote sensor, including photo-electric cell

Sync lead

Hot-shoe mount

Sync socket

Batteries (Alkaline or Nickel-Cadmium)

Automatic portable flash units (left) can be extremely versatile. They can measure the light bouncing back from the subject as the flash is fired and quench it when sufficient exposure has been given. The best types have tilting heads so that the flash can be bounced off the ceiling or a reflector for a more diffused light.

PORTABLE FLASH

Quite often in glamor work, it is essential to provide a source of light that you can directly control. This will give you greater control over the appearance of your model. In the studio – and sometimes on location – special lights are used (see p. 128) but the simplest way of providing your own light source is to use an electronic flashgun.

There are two main types of electronic flash on the market. The first is battery-powered – the battery can be recharged – while the second works directly on house current. Battery models give up to 200 flashes per charge. After each firing, all flashguns take a few seconds to recharge; direct-powered models take twice as long to achieve this.

On most SLRs, the working of the flash is automatically sychronized with that of the camera. The flash is attached to the camera's 'X' socket. An internal circuit then triggers the flash when the shutter is fully opened. In some models, a sensor measures the amount of flash reflected from the subject and quenches the tube when the correct exposure has been achieved.

LIGHT METERS

Most SLRs incorporate their own light metering systems, but, since these work on reflected light, the results are not always totally reliable. A reading may sometimes record too much sky or too much foreground, for example. The former, being a strong light source, tends to cause under-exposure; when in shadow, the latter can cause over-exposure.

For this reason, professionals use hand-held meters as an essential back-up to the automatic system. It is always best to use them if you are photographing under difficult light conditions, or when the distribution of light and dark tones differs radically from the average. With subjects of greater than normal brightness, for instance, take two reflected light readings – one of the brightest level and one of the darkest. The compromise is the mean.

However, only use these measurements as a guide to producing the image you want. There is no value, for instance, in preserving the maximum amount of detail in a backlit scene, when a silhouette would create a better and stronger photograph.

There are several types of meter on the market. Selenium cell meters generate their own energy from the light they measure; CdS (cadmium sulphide) meters, on the other hand, are battery-powered. They are far more sensitive than their selenium cell equivalents.

A spot meter is a specialized, but useful, purchase. It differs from a conventional hand-held meter in that it takes a pin-point reading of whichever part of the subject you desire; the latter only produces an average reading of the entire subject. This factor makes the spot meter the most accurate.

Even with these technological aids, there may still be times when you are uncertain as to what will be the final photographic result. The trick here is to bracket your shots – that is, to make a series of exposures, varying each one by a stop or half a stop over and under the reading given by the light meter. Though this may appear wasteful of film at first sight, it is a device used by all professionals in such circumstances. You should also be prepared for any change in lighting conditions – particularly on location – by having available a wide selection of film stock.

COLOR FILM

The vast majority of glamor photographs are shot in color. Though individual opinions vary, most glamor specialists prefer to shoot in Kodachrome, whenever possible. Remember, however, that Kodachrome and most daylight films are not particularly suited to poor lighting conditions; they are comparatively slow films, being rated between 25ASA and 100ASA. In

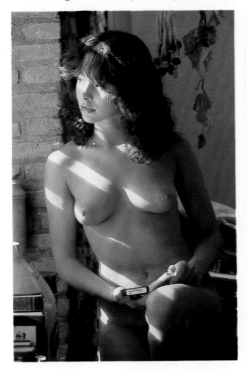

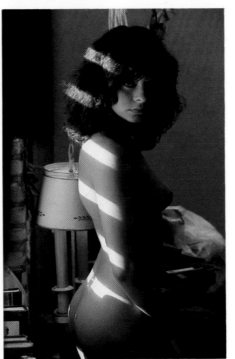

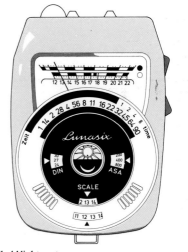

In some circumstances, exposure is difficult to judge – even with a through-the-lens meter (above). Here, the low level of light over the whole frame indicated an exposure of f4. This,

however, caused unacceptable overexposure in the small sunlit patches and one stop less produced a better result (above right).
85mm lens, Kodachrome 25, 1/30sec at f4 and f5.6.

Handheld light meters such as this Gossen Lunasix (above right) can be a real boon with glamor photography. An overall reading can be influenced by a dark or light background when it is the model that should be correctly exposed. In these circumstances use the meter to measure the light falling on the model (an incident light reading) or move closer to the model and take a reflected light reading from her skin.

Alternatively, you can use a spotmeter (above) to take a precise reading from any part of the model or setting.

such circumstances, therefore, it may be necessary to use a faster film, such as Ektachrome.

Whichever brand of film you use, it is important to remember not only that no two brands are alike; there can also be a marked difference between the results produced by two batches of the same brand. For this reason, professionals make sure that they use films from the same batch on a shoot to ensure consistency.

Color film falls into two categories – reversal and negative. Professionals tend to use the former. Films are also designed to be used with different light sources and are graded accordingly. Each type of film has what is termed its color temperature, measured on the Kelvin scale. The whiter the light, the higher the color temperature.

Daylight film, for instance, is calculated to have a color temperature of 5500K. Type A film is balanced at 3400K for use with floods and other forms of studio lighting. Type B film is balanced for 3200K tungsten lighting. To put these figures in perspective, it is helpful to note that domestic 100-200 watt lamps have a color temperature of 2900K, while 40-60 watt lamps are of 2800K.

From the above, it is clear that color film is balanced to produce its best results with the correct level and type of light. If the light is inadequate, you will have to use extra lighting equipment to compensate for this. The equipment required depends on the situation. If you are using a film that is not suited to the type of light, you can compensate for this by color correcting with the appropriate filter.

Correct judgement is vital, because reversal film has limited exposure latitude. This means that little (and sometimes no) compensation for exposure or color balance can be made in processing. The ideal is to work with short exposures, since long exposures will lead to what is called reciprocity failure. The effect of this varies from emulsion to emulsion; you should follow carefully the manufacturer's instructions to overcome it.

An over-exposed transparency looks bleached out; under-exposure, on the other hand, tends to strengthen the colors. During long exposures, too, the film will experience a shift in color, so an exposure of several seconds demands the use of the appropriate color compensation filter.

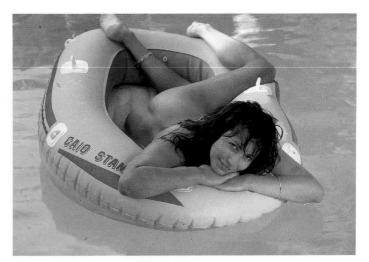

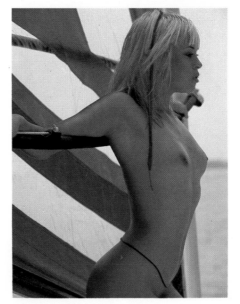

Kodachrome 25 (above) is an excellent transparency film for glamor photography, with superb color quality. It also has very small grain, making it good for enlargement. 85mm lens, Kodachrome 25, 1/30sec at f5.6. Ektachrome 64 gives the photographer an extra stop. It also does not have to be processed by Kodak. Professional laboratories often give a faster turnaround and are prepared to alter the film's development time if you wish. The color has excellent quality. 85mm lens, Ektachrome 64, 1/60sec at f5.6.

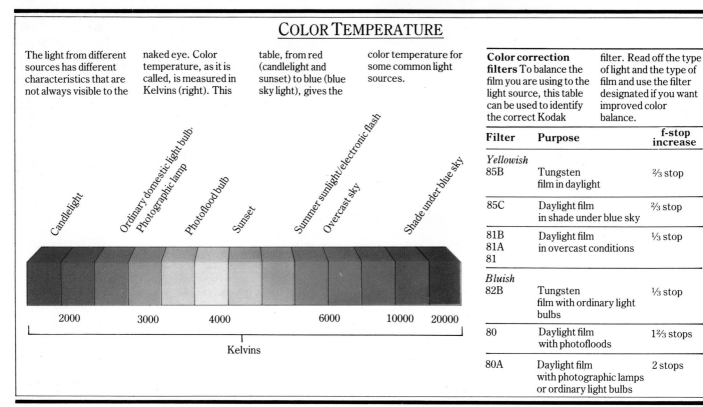

COLOR TEMPERATURE

The light from different sources has different characteristics that are not always visible to the naked eye. Color temperature, as it is called, is measured in Kelvins (right). This table, from red (candlelight and sunset) to blue (blue sky light), gives the color temperature for some common light sources.

Color correction filters To balance the film you are using to the light source, this table can be used to identify the correct Kodak filter. Read off the type of light and the type of film and use the filter designated if you want improved color balance.

Candlelight · Ordinary domestic light bulb · Photographic lamp · Photoflood bulb · Sunset · Summer sunlight/electronic flash · Overcast sky · Shade under blue sky

2000 3000 4000 6000 10000 20000

Kelvins

Filter	Purpose	f-stop increase
Yellowish 85B	Tungsten film in daylight	⅔ stop
85C	Daylight film in shade under blue sky	⅔ stop
81B 81A 81	Daylight film in overcast conditions	⅓ stop
Bluish 82B	Tungsten film with ordinary light bulbs	⅓ stop
80	Daylight film with photofloods	1⅔ stops
80A	Daylight film with photographic lamps or ordinary light bulbs	2 stops

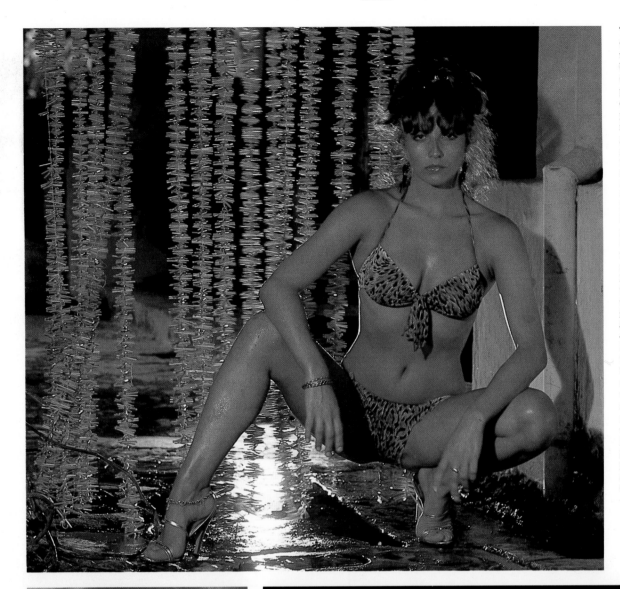

Tungsten lighting (here, two spotlamps) used with daylight balanced Kodachrome (left) gives a pronounced orange cast. For many types of photography the result is a ruined shot, but for glamor work the warm glow can be flattering to the model's skin color. 85mm lens, Kodachrome 64, 1/60sec at f5.6.
One advantage of Ektachrome (below left) is that it can be push-processed for special effects. By underexposing by four stops and asking the laboratory to push by the equivalent amount, this softened, grainy image was produced. 85mm lens, Ektachrome 400, 1/60sec at f22.
Kodachrome 64 gives the photographer more than one extra stop over Kodachrome 25 with only a slight reduction in quality (below). This can be very useful in difficult lighting conditions – here, shooting by car headlights. 85mm lens, Kodachrome 64, 1/15sec at f4.

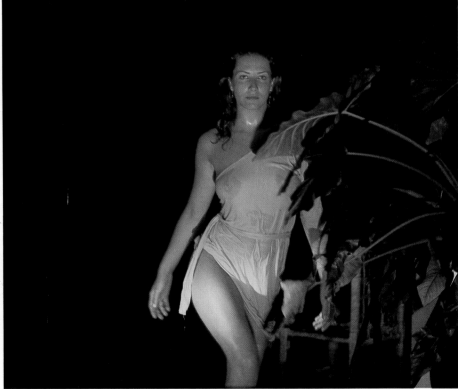

THE MODEL

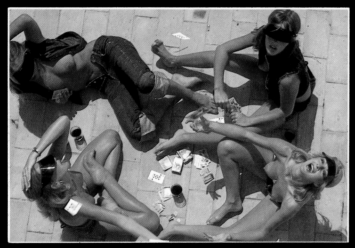

Models need special talent. They are the most important element in glamor photography and their ability to look good in front of the camera is paramount. There are many different types of models with differing strengths and weaknesses.

Choosing your model

TESTING A MODEL

The purpose of test shots is to see how well you can work with a particular model – or at least discover how you can break the ice. Test shots can produce surprisingly good results, however, as both model and photographer may be relaxed in knowing that the pictures are not intended for use. But they can also be tense and unnatural if the model is inexperienced and nervous. Your job is to help her relax.

Study test shots carefully. Take note of the most successful poses and expressions and look out for any visible defects. Remember the model's best and worst features and use this knowledge when subsequently working together.

These test shots were taken in a studio with a white background and several large reflectors. It was the model's very first session – she is shown arriving (above) and in the most successful shots (top and right). She was good for a beginner.

WITHOUT QUESTION, THE model is the most important ingredient in glamor photographs. Technique, though essential, can carry you just so far as much depends on the model.

Being a first-rate glamor photographer is not simply a matter of recognizing the conventional aspects of beauty. It comes from developing an appreciation of all types of women and knowing how to assess their strong and weak points as photographic subjects. This is not easy. At the outset, any practice at all you can get in photographing women, in any situation, will be invaluable. The more you understand about yourself as a photographer and women as people, as well as models, the better chance you have of taking good photographs.

YOUR FIRST MODELS

In the first instance, the easiest way into the glamor world is to ask girl friends, or women you know reasonably well, to model for you. Unless you are in a position to hire professionals (see p. 172 -173), it will not be easy to obtain the services of the ideal subject. A professional model already knows how to pose to the best advantage, understands about make-up, clothes and accessories and is able to take direction better than an amateur. Glamor modelling at its best requires flair and imagination, not to say an above average body and good looks.

This is not to say that an amateur cannot produce the results you want, but you will certainly have to be patient and not over-pressing to secure initial agreement. When under pressure, the easiest response is a negative one. If a woman is approached tactfully, she will feel in complete control of the situation. If she is interested – she will almost certainly be intrigued – she will contact you, once she has had the chance to think matters over in her own time.

Some women, of course, enjoy having their photographs taken and welcome the opportunity of modelling for a competent photographer. A drama or dance school, for instance, may well provide suitable candidates. Ask the principal if you can pin a card on a notice board, offering, say, photographic prints in exchange for a model's services. Drama and dance students are, for the most part, natural extroverts. They understand the business of projecting their personalities in front of a camera – indeed, they may well be eager to – and you will be spared the preliminary task of building up their confidence.

TEST SHOTS

A series of test shots should eventually become an essential part of every photographic session. Their value is not simply to help you assess the model's potential; they also are a way of establishing a relaxed working relationship and of trying out photographic ideas.

In any case, you should become more and more selective in your choice of models as you progress. Taking photographs can be expensive – particularly if your pastime becomes a profession – and it is therefore important that you should have as much control as possible over all the variables.

TYPES OF MODEL

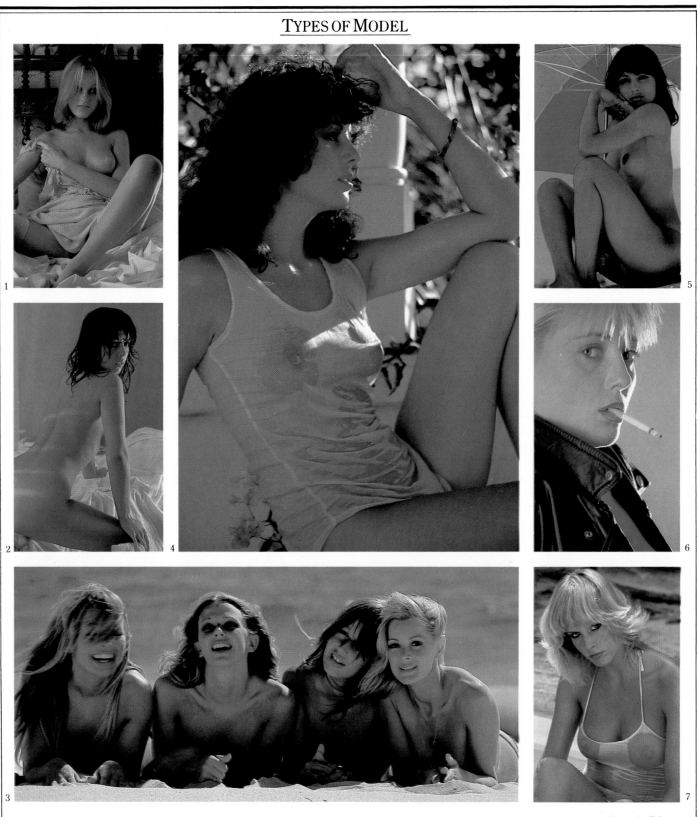

This page show a selection of outstanding models. Of course, there are as many different types of model as there are photogenic women. It is up to you as photographer to identify the strong features and weak points of each model and use poses, props and settings to make the most of their individual potential. It is also important to decide the aspects of personality you want to project and organize the shots accordingly.

1 The 'girl next door' – this model has an air of innocence. She is young, unsophisticated and a little shy.

2 Although English, this model projects a smouldering Latin sensuality that would not be out of place in Rio de Janeiro.

3 The blond outdoor look is found on all the best beaches of the world. These four women – slim, tanned and happy – are beautiful examples.

4 A woman of today, with seemingly casual and untended curls, here looks romantic, wistful and a little vulnerable.

5 Some of the loveliest women in the world come from Asia and this model is no exception. Dark skin looks particularly good in sunny locations. Here, the sun was augmented with a spotlight shone through the umbrella and reflected off the white floor.

6 This model has a modern punk look, and for the purposes of the shot looked tough and aggressive.

7 A more traditional glamor image is the blond Scandinavian look – just plain beautiful!

MODEL/PHOTOGRAPHER RELATIONSHIP

Although there is no way of anticipating exactly how a model will react during a session, it is fair to assume that she is there because she wants to be there. Never press anyone who is unwilling into modelling for you; their reluctance will show on every print.

Talk to your model, establishing as many meeting points as possible, such as mutual acquaintances or similar interests. While you are talking, take discreet note of how she sits, stands, smiles, laughs, talks and how she uses her hands. Learn to recognize any nervous mannerisms and use this knowledge as a cue to reassure her if any come into play during actual photography. Even the most experienced models can be nervous when working with someone for the first time and it is important that you are able to make them relax. The better photographer you are, the easier this is; if your model believes that you are going to take some great shots of her and that you will make her look glamorous, she will offer 100 per cent co-operation.

A model should understand from the outset exactly what it is you want from the session. Explain the results you hope to achieve beforehand and ask for her opinion as to how you can obtain them. Involvement is essential; if you fail to achieve this, you may well end up wasting your time. This is especially important if your model lacks confidence in her appearance – this is a frequent occurrence when a model is asked to pose nude or semi-nude for the first time. To deal with this, make positive comments before and during the session and be sensitive about any particular insecurities your model may show.

Occasionally you will find that models want to be accompanied by girl friends, boy friends and even their mothers. Try to discourage this, without actually refusing the request; a refusal may be misinterpreted. Inevitably, a model's tension increases if she feels she has to win additional approval. If a chaperone is necessary for any reason, make sure she or he is not within eyeshot of your model and is asked to keep very quiet.

POSING

The more you understand your subject, the greater the chances of capturing the elusive moments that make a memorable photograph. To achieve this, you must do more than establish a rapport with your models; you must develop an instinct as to how you wish to portray them. This takes time, but, as you gain in experience, you will learn to identify the qualities in a woman that make her particularly appealing.

If your model feels sufficiently comfortable in front of the camera to strike her own poses without direction, you have won half the battle. This does not mean, however, that all you have to do is to point the camera and shoot. Your job is to create the photograph – to be constantly aware of the entire image as it appears when you press the shutter. If you are not aware of this, the results will be disappointing.

As a start, study as many glamor photographs as possible and note any poses that you consider particularly attractive. If you see a glamor photograph you dislike, try to work out what you consider wrong with it.

Generally speaking, it is best to concentrate on your model's best attributes and not to draw attention to any one particular feature, unless it can withstand close scrutiny. Make a mental note of where the hands are, how the legs are positioned and if the breasts are shown to the best advantage. Pay close attention to knees, elbows, collarbones and armpits. If over-prominent, they can spoil an otherwise good photograph.

Certain problems only become apparent when seen through the viewfinder. By adjusting camera angles and the model's position, it is usually possible to overcome them. Short legs, for instance, can be lengthened by a low viewpoint. If your model lies

Before you begin to work, study your model and decide on the strengths and weaknesses you intend to show off or disguise. You want to portray the ideal, but you are very unlikely to find a model who is perfect in every respect. Some of the features to look out for are listed below. Good skin and hair are particularly important. In general, models should be slender – the camera always exaggerates the proportions and slim thighs and waist look best. Above all, it is the model's ability to look natural that counts

From the front, the overall proportions of the body are particularly evident. Short legs or a long waist, for example, will show. You can adjust the viewpoint to compensate – the legs will look longer from a low viewpoint.

From the side, posture is revealed, and also the shape of the breasts and the buttocks. Look for an upright stance and firm high breasts.

From behind, the model's back and the shape of her legs can be seen. Both are important. The back should be narrow and straight, with square shoulders, and the legs should be long and curve gracefully at the hips and calves.

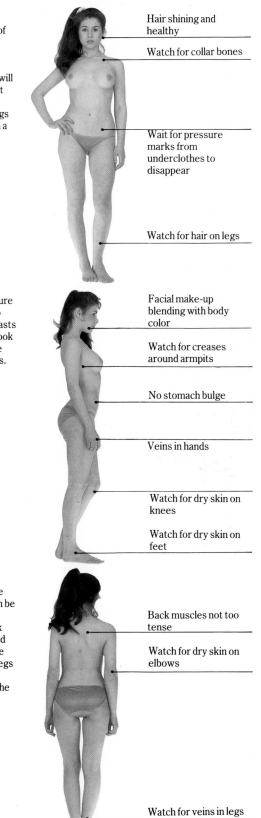

Hair shining and healthy

Watch for collar bones

Wait for pressure marks from underclothes to disappear

Watch for hair on legs

Facial make-up blending with body color

Watch for creases around armpits

No stomach bulge

Veins in hands

Watch for dry skin on knees

Watch for dry skin on feet

Back muscles not too tense

Watch for dry skin on elbows

Watch for veins in legs

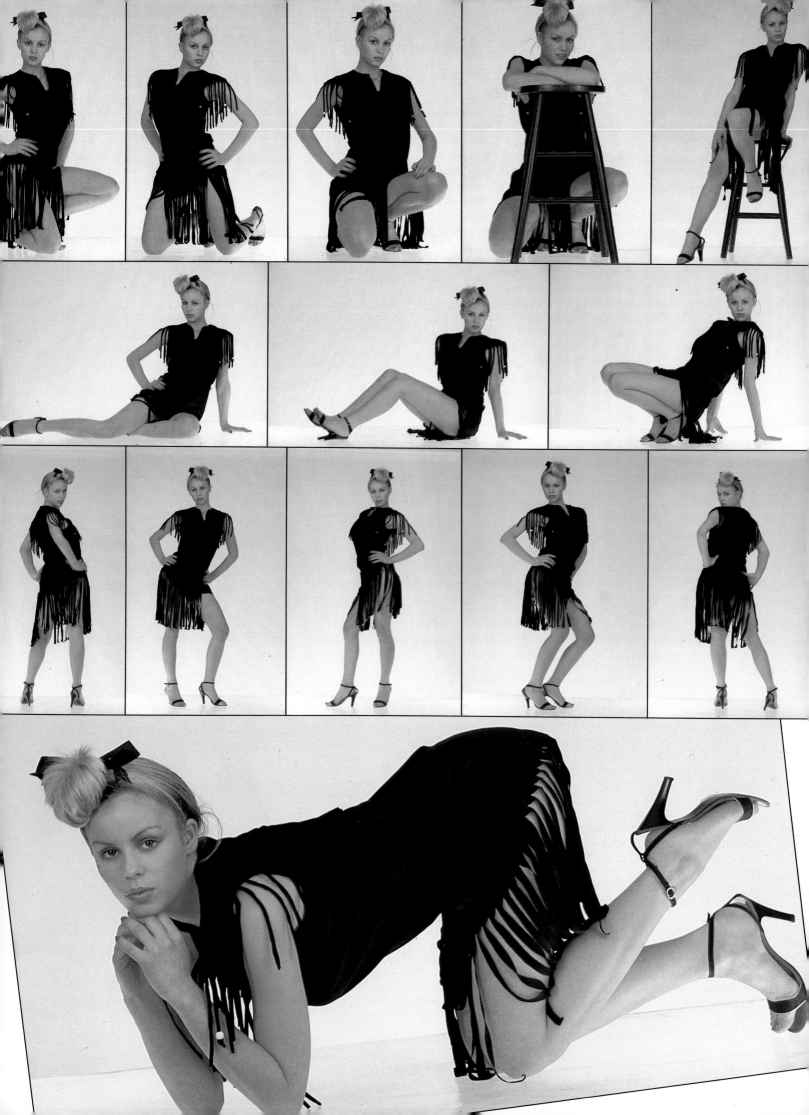

An experience model (left) shows just some of the great variety of poses that are available. This was without any prompting from the photographer – a more inexperienced model would certainly need guidance. The lighting and plain studio set dictated the shot to some extent; props and a more elaborate setting would have offered many additional possibilities.

85-210mm zoom lens, Ektachrome 64, 1/60sec at f8 with underfloor lighting, sidelights and white reflectors.

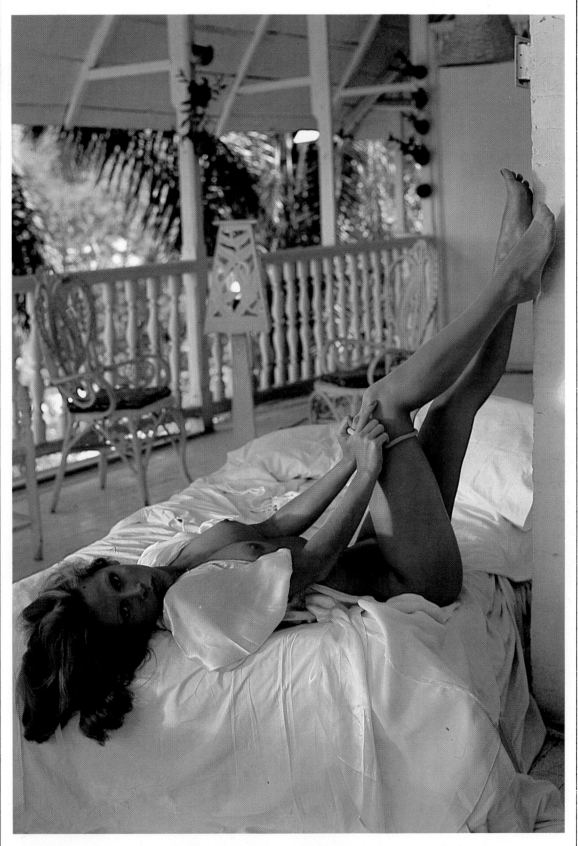

Raising the legs (above) has a slimming effect on the thighs. Here the pose is made particularly natural with the model putting on a stocking. Daylight provided the illumination, with some reflection offered by a mirror near the model's head.

35mm lens, Kodachrome 25, 1/30sec at f5.6.

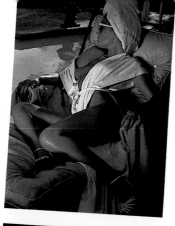

or sits down and raises her legs, the calf muscles will relax downwards, creating a beautifully smooth line. If she sits on her legs or tucks them under her, it will disguise the fact that they are either too thin or too plump. By tucking one leg under another and leaning back, the whole body is stretched to produce a slim-line look. Heavy hips can be corrected by asking the model to lean towards the camera – this, at the same time, reveals the cleavage.

If your model is positioned at a three-quarter angle or you take a side view, this will narrow the waist and accentuate the breasts. By crouching on all fours – a popular beach pose – the bottom is emphasized by the curvature of the back. Lying face up is not particularly flattering, since it tends to flatten the breasts.

Even small changes to the pose can affect the way the body looks. The motor-drive sequence (right) shows how slight movements can change the shape of the breasts and affect the apparent length and slenderness of the legs. 85mm lens, Kodachrome 25, 1/30sec at f5.6.

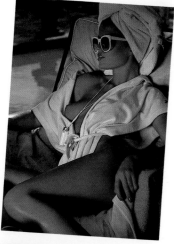

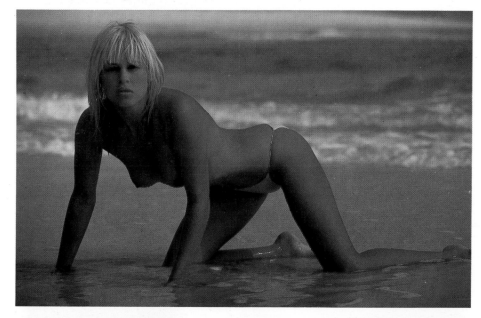

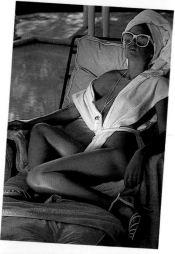

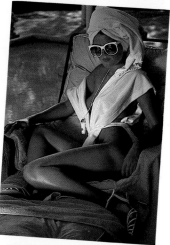

This popular beach pose (top) flatters most models – depending on the angle of the shot. 85mm–210mm zoom lens, Ektachrome 64, 1/30sec f8.

Raising the arm adds uplift and extra shape to the breasts (above left), particularly obvious in silhouette. A polarizing filter darkened the sky for this shot. 55mm lens, Kodachrome 25, 1/30sec at f5.6.

Leaning back always creates a slimming effect (above) and can be particularly flattering to the breasts. 200mm lens, Kodachrome 25, 1/12sec at f5.6.

FACIAL EXPRESSIONS

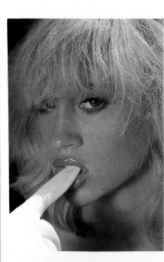
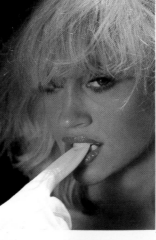
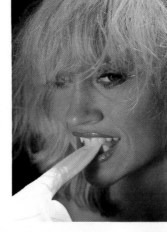

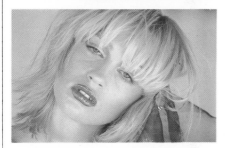
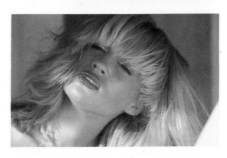

A person's face is always the first point on which attention focuses; what we register in the first few seconds often determines whether or not we take a second look. Though an attractive face is virtually a prerequisite for glamor photography, beauty alone is not always enough. A face must express something. It could be a mood, a feeling or a thought – but it must be positive.

If your model is shy, or not used to projecting herself in front of the camera, she will need direction. Help her to relax by talking to her and suggesting a range of expressions she could adopt. This will not only give her something to concentrate on; it will also stimulate her own ideas, so that she can bring something positive of her own to the photography.

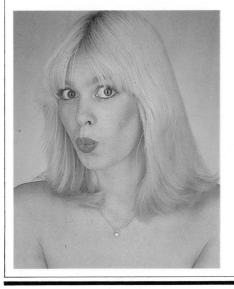
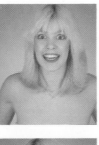
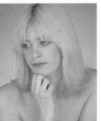
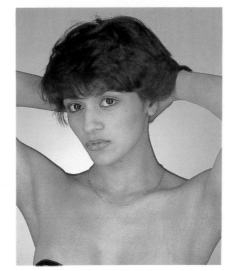
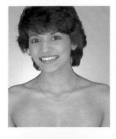

Shape, pattern and texture

SHAPE, PATTERN, TEXTURE and colour are each vital elements of composition. One of the best ways of emphasizing the inherent quality of any object is to place it next to its opposite. Rough against smooth, hard against soft, black against white are the general principles. The symmetry and coarseness of a plain brick wall, for example, will emphasize the flowing lines of your model and accentuate the softness of her skin and hair.

Background is an important factor in glamor photography: it must not dominate the model. It is often the background that creates a contrast that works best. There is no need to contrive elaborate situations. Bold, graphic lines will naturally enhance the roundness of the female form. For contrast, imagine your model reclining in a fur coat slightly parted, against an industrial backdrop, perhaps high above a freeway complex, with smokestacks belching into a grey sky.

Different shades of the same colour can be exaggerated by adding a splash of colour where it is unexpected. Remember that red will seem to come out of the picture, while blue appears to recede. A suntan can be accentuated by placing your model against a white background.

If you analyze the shapes, patterns, textures and colours before you get into action, you will achieve a photograph that is more than just a picture of a woman. An eye for detail takes a photograph out of the ordinary.

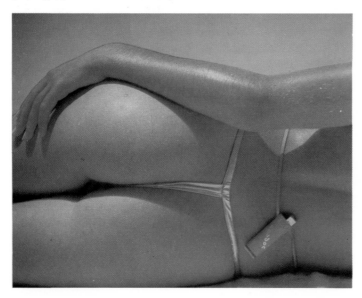

The shape and texture of the body (above) can be effectively isolated by close-up shots. Here, the rounded forms are set off by a clear background. 85-200mm zoom lens, Kodachrome 25, 1/60 sec at f5.6

Rough textures (right) contrast dramatically with the smooth skin of the model. In this case, the low angle of the sunlight actually increases the differences by picking out the surface details of the whitewashed

wall. The simplicity of the composition focuses attention on the excitement of the diagonal pose and hard shadows. 85mm lens, Kodachrome 25, 1/60 sec at f5.6

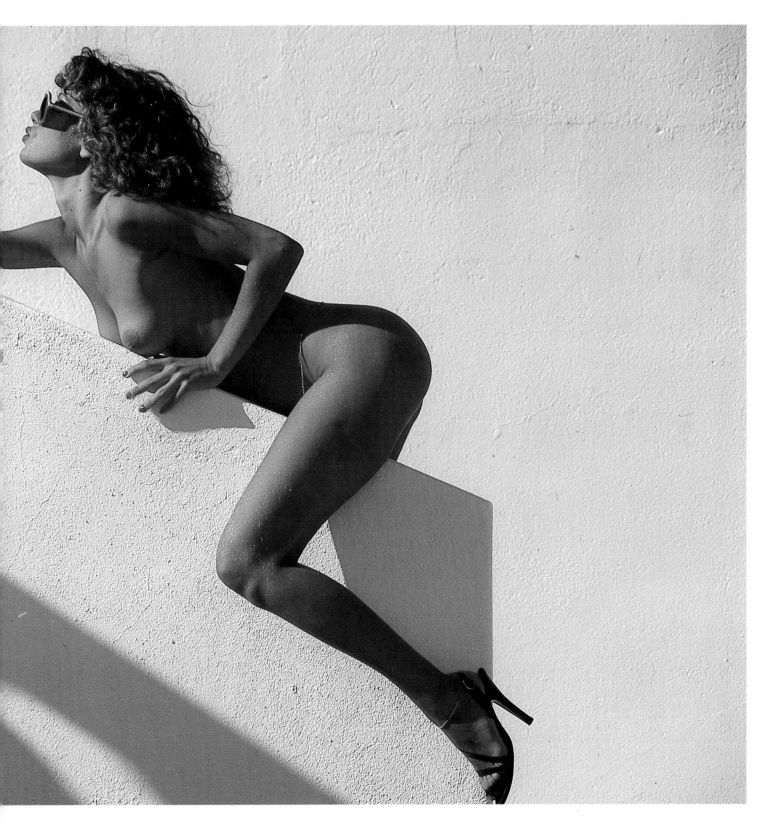

The blue of the sky can be one of the most effective backgrounds of all, making the body look suntanned and lean (below). White-framed sunglasses and jumpsuit echo this simple contrast. The blue of the sky was intensified by the use of a polarizing filter.
85mm lens, Kodachrome 25, 1/30sec at f5.6

Look out for the possible contrasts offered by location and props (below). The rough wall contrasts with the model's body, its cool white with the warm flesh tones, the whole effect accentuated by the addition of the bright red geranium.
85mm lens, Kodachrome 25, 1/30sec at f5.6

A hotel corridor in Haiti with lowered shutters offered this interesting lighting for only a few minutes in the early morning (right). Take advantage of such opportunities to achieve unusual patterns when you find them. It may be wise to bracket exposures.
35mm lens, Kodachrome 25, 1/15sec at f5.6

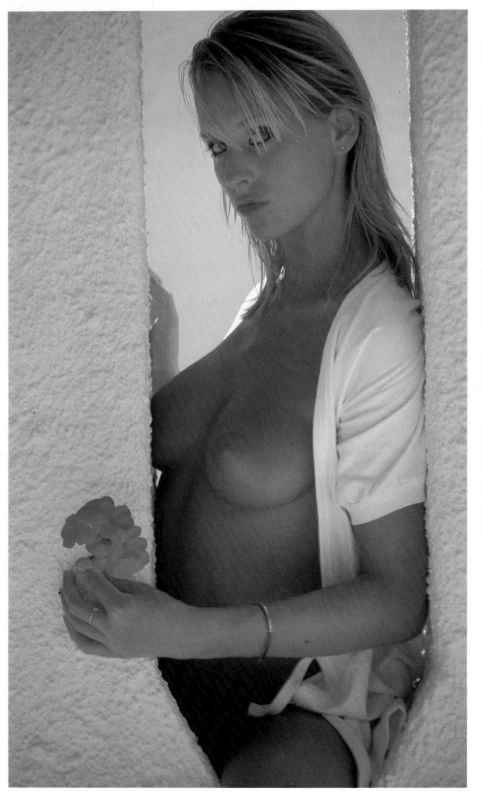

Visual puns can be successful (above). Here, the curved shapes cut out of the balcony fence echo and frame the full breasts. A limited color scheme keeps the shot simple.
85mm lens, Kodachrome 25, 1/30sec at f4.

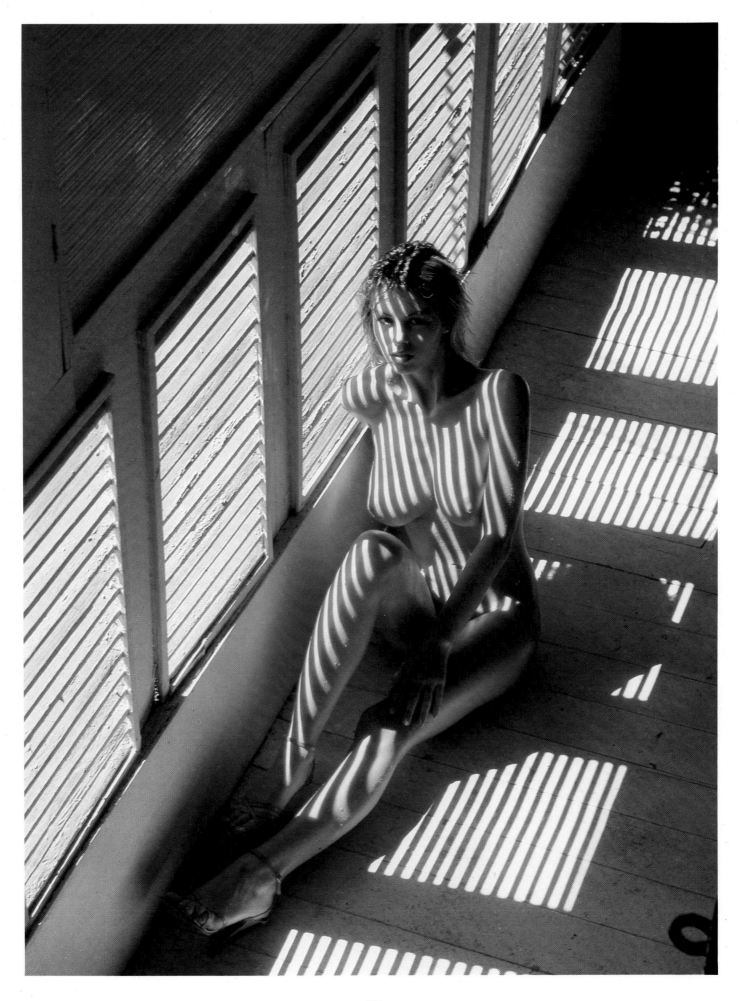

Look out for imaginative possibilities in the setting (right). A slatted window in the morning offers first the sense of situation – the camera is outside looking in through the window. Second, the clean geometric lines of the window slats contrast strongly with the model's body and cast delightful double-edged shadows over its contours. 85-210mm zoom lens, Kodachrome 25, 1/60sec at f5.6.

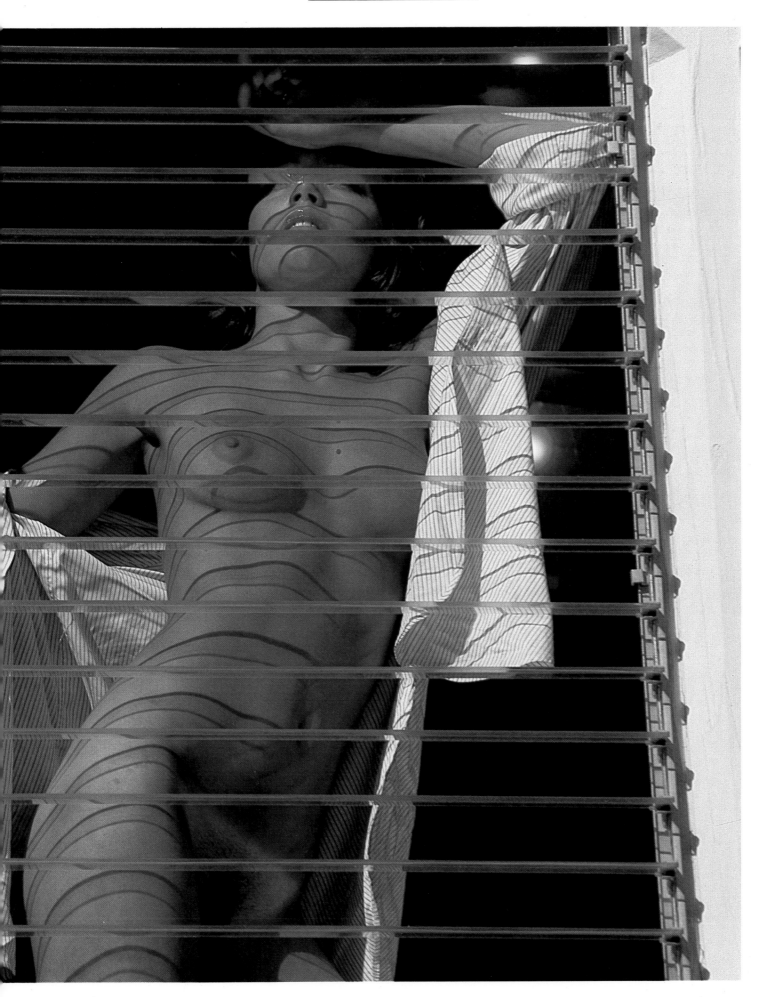

Models, 'macho' and machines

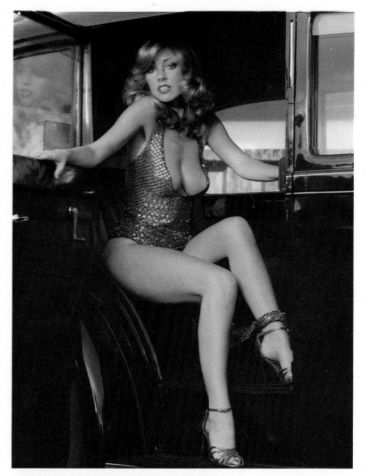

APART FROM EROTIC photography in general, curvaceous and beautiful women posed on cars and motorcycles are one of the mainstays of glamor photography.

As this sort of shot is so popular for magazines, advertisements and calendars, the market is wide. The challenge to produce an out-of-the-ordinary picture is nevertheless there, since this is a competitive field.

You should decide first of all the role the model is to play in the picutre, so that the composition works: is she the focal point with the machine, possessing less apparent visual impact, in the background or to one side; or is she there simply to lend added interest, contrast of textures and, to the male-orientated market, a feeling of more than one possession or status symbol?

Photography with machines demands a great deal of experimentation with the camera angle and the best pose for the model. Decide first of all precisely which feature of the machine characterizes it, or, alternatively, in which way it makes a good prop for your model.

When deciding what your model should wear, whether clothes or accessories, take into account the age, make and colour of the machine. Status is one of the key factors in shots such as these. You can choose either to capitalize on any obvious associations or invent an unconventional one. You might decide, for example, to reverse traditional concepts by shooting a low priced car on a lawn with castle or mansion in the background and the model relishing champagne, salmon and peaches from a hamper.

If the model is to pose against or on the automobile or motorcycle, relax her by taking a lot of test shots and discussing poses with her. Encourage her to take the initiative and to suggest the ways she would like to be photographed: this is the way to a lively and creative session which should result in an interesting and saleable end product.

Fantasy is a central element in glamor photography (right) – a naked blonde hitch-hiking in the Mojave Desert is the kind of image that could enliven any dream.. 200mm lens, Kodachrome 25, 1/30sec at f5.6.

The name of the truck, Miss Mary K, set the idea for this shot (far right), suggesting that the model should look just a little old-fashioned. Dress and hair style were chosen to fit this image.

200mm lens, Kodachrome 25, 1/60sec at f5.6.

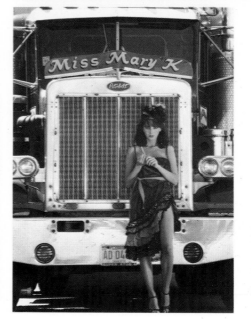

A vintage Rolls-Royce (above) made a superb setting with the dark, luxurious interior contrasting well with the model. The sexy dress and shoes were chosen to match the image of opulence. 85mm lens, Kodachrome 25, 1/30sec at f4.

This battered old truck (right) had a real personality. The hard metallic look – of both truck and model – was enhanced with a polarizing filter, which also controlled the reflection from the windows and chrome. 200mm lens with polarizing filter, Kodachrome 25, 1/60sec at f5.6.

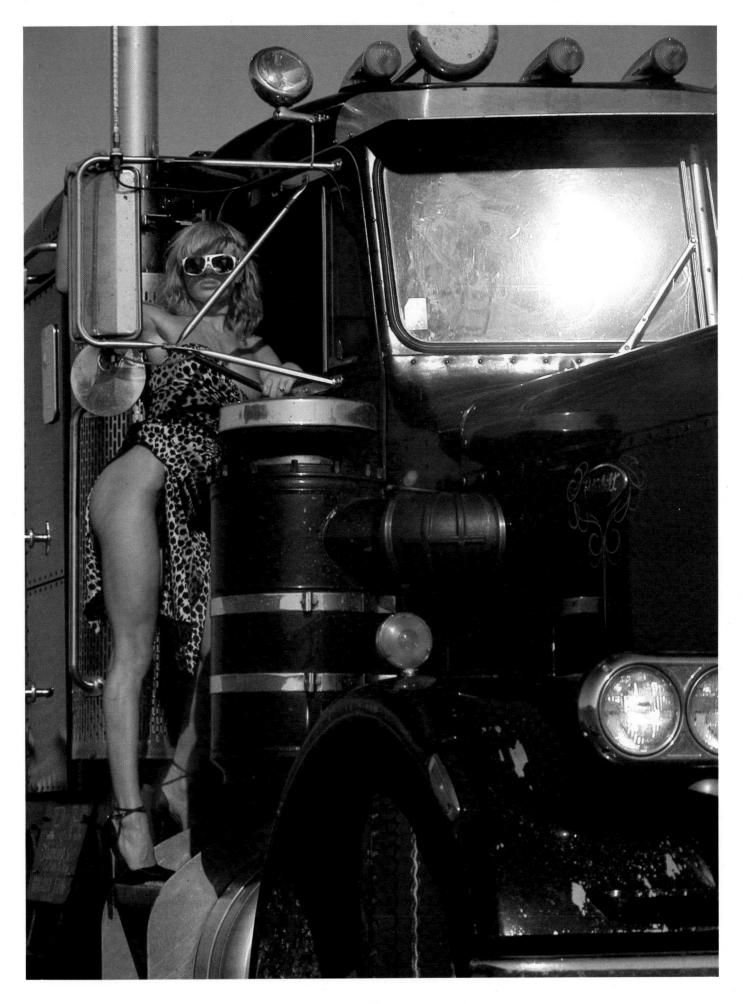

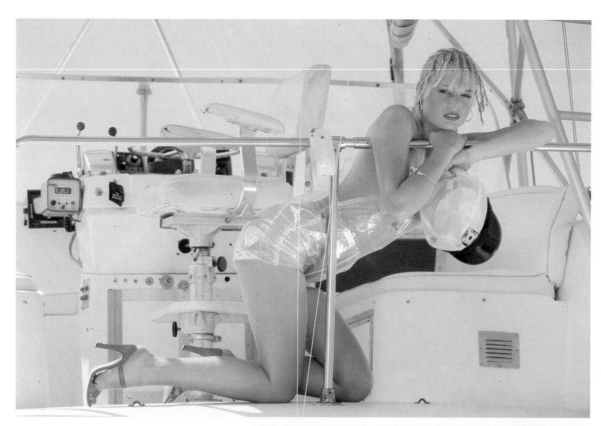

CUSTOM CAR ASSIGNMENT

For a shot with an amazing red custom car the props were carefully chosen – red helmet and bikini, with red and black sunglasses, red gloves and black shoes. This frame (right) is one of the best from a session which produced several other good shots (far right). When the circumstances are right like this, there is no point trying to save on film!
85mm lens, Kodachrome 25, 1/30sec at f5.6.

The only color in this shot (above) comes from the model's red shoes and matching lipstick. The see-through jumpsuit was chosen to match the stark whiteness of the boat. Machinery oftens makes a fussy background – try to keep everything else as simple as possible. The model was in the shade for this shot, with plenty of light reflected from the white surfaces and a gold reflector placed in front of the model.
85-210mm lens, Kodachrome 25, 1/60sec at f5.6.

With the sun low in the sky, the metallic paint of the speedboat (right) looked almost gold – a good match for the model's gold bikini pants. The low lighting of late afternoon also gleamed effectively from the chrome and the dark surface of the sea.
85-210mm zoom lens, Kodachrome 64, 1/30sec at f5.6.

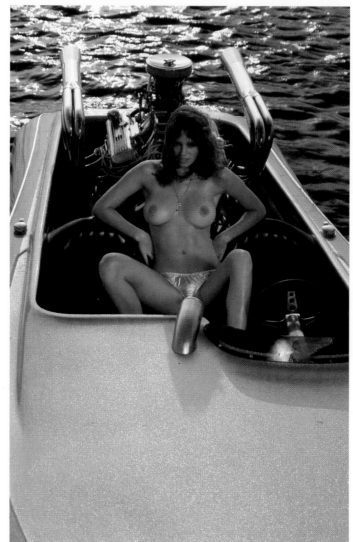

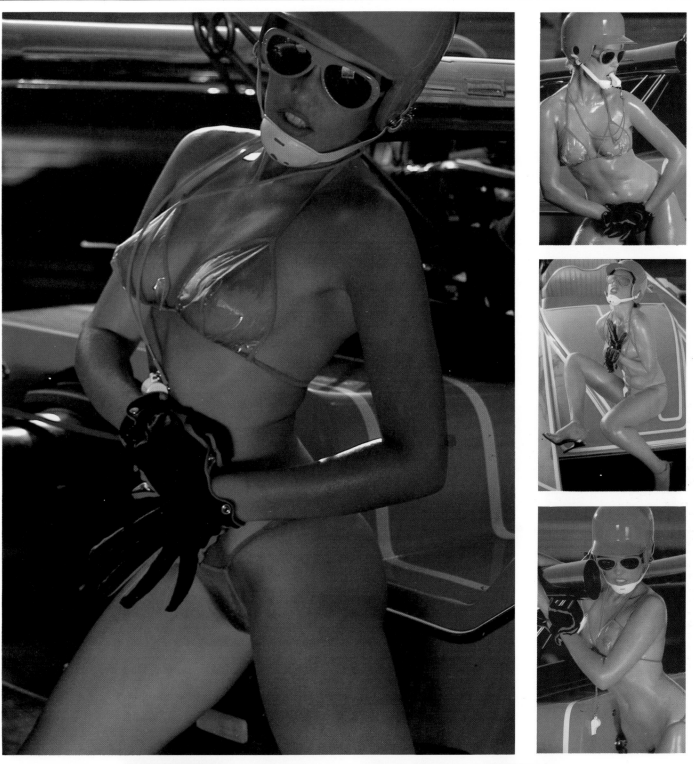

The location (right) was a large lot with parked trailers and cars. It was decided that these produced a confused background and the best shots closed in on the model and car.

Assistants held reflectors to fill out the fading evening light (left). The low sun has a high color temperature, which gives a warm glow to the scene and flatters the model's tan – making this a good time of day for glamor photography.

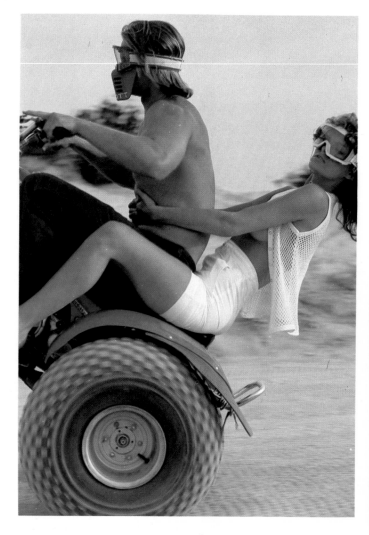

Machines, here a custom bike (above), can be combined with location and the costume of the model or models to create a dramatic 'situation'. In this example, the addition of the male rider gave an extra dimension. The session took place in a Californian desert location (right), with the bike accelerating past the camera position.

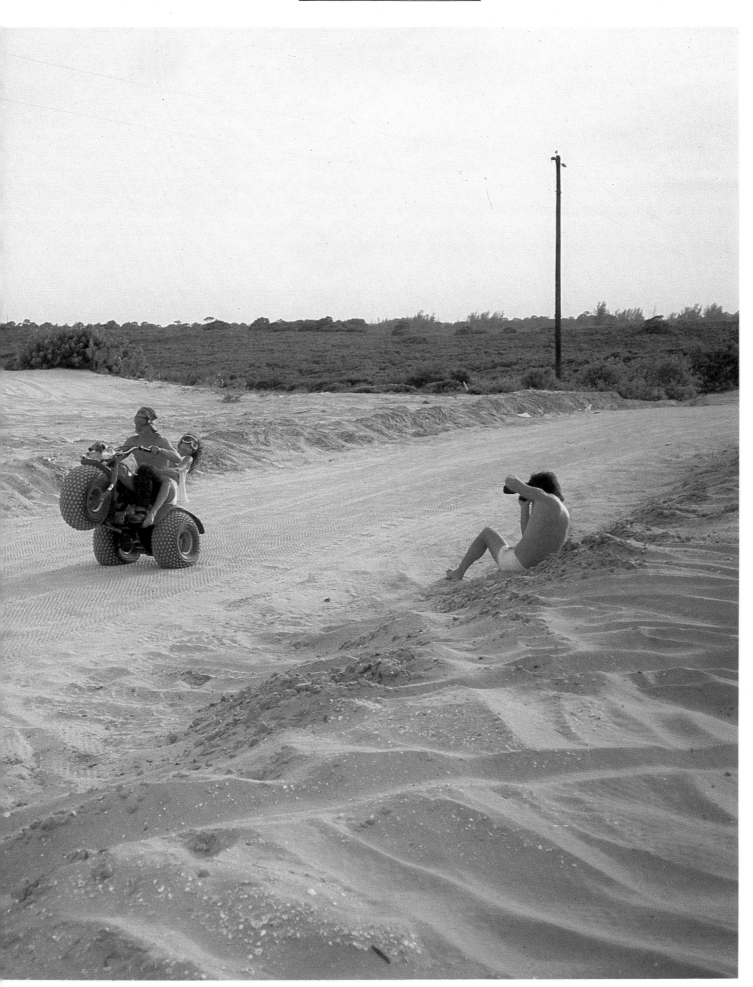

The art of make-up

MAKE-UP IS A VITAL tool of the glamor trade. It is therefore important that you have a clear idea of how you want your model to look and also the expertise to advise her. You need not go as far as becoming a make-up expert, but you should certainly develop a basic knowledge of cosmetics.

To begin with, study women's faces and the way make-up is applied and used. Keep a file of photographs and cuttings of styles you like for copying or improving on.

The proper use of make-up will help you overcome one of the basic problems of glamor photography, particularly if you are shooting amateur models. The problem is that few women consider themselves pretty enough for this purpose and almost all are convinced that they are not photogenic. The only way a model will relax in front of the camera is if she feels beautiful.

This is where make-up can play a large part in boosting a girl's confidence. Professional models are already aware of this and are adept at using make-up to disguise and enhance aspects of their faces. They practice with different colors and shades, know how they look and how they should look. Amateurs, on the other hand, often put on too much make-up and choose unsuitable colors in an attempt to imitate the professionals.

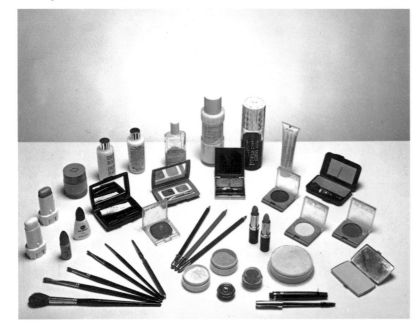

The basic selection of cosmetics and make-up equipment shown here (above) is a useful starting point. It includes: cleanser, toner, eye make-up remover, foundation, face powder, eyedrops, mascara, blusher, eyeshadows and eyeliners, lipsticks, lip gloss and lipliner. For accurate application, a selection of different sized brushes will be essential. You can expect your models to have their own basic make-up, but keep your own stock as well for emergencies.

The make-up for this shot (right) was chosen to match the overall pink mood of the shot. The shawl, flower and ribbon in the hair, and roses in the background are all matched by the rich lipstick and blusher. 85mm lens, Kodachrome 25, 1/60sec at f5.6. For more spectacular effects, additional types of make-up such as glitter (far right) can be used. To balance the effect, red glossy lipstick was also used. The hard lighting of this night shot emphasized the shiny finish. 85mm lens, Kodachrome 64, 1/15sec at f5.6.

BASIC RULES

The basic rules of skin care and make-up technique are few and simple. Cleansing cream, for instance, is an essential part of any model's make-up kit. Before applying new make-up, all traces of the old must be removed and this may be necessary several times in a single session.

Skin tonic or freshener should be applied generously after cleansing. It removes excess grease and makes the skin come alive by stimulating the blood flow. It is also extremely effective for brightening up tired skin during a session. Moisturizer pre-

pares the skin for make-up. It is best to allow this to soak into the skin for at least five minutes before applying foundation; otherwise the make-up may clog.

The color of the foundation should accord with the model's skin tone. Blondes and redheads are generally suited to pale shades, though pink should be avoided; brunettes are favored by a beige tone; women with darker skins will find a slightly brown tint suitable. Most skins require only a thin film of the lighter type of foundation, though, if the skin is poor, it can be evened out with a thickish one. Whatever the choice, the final effect must look completely natural. Smooth the foundation on the face with a

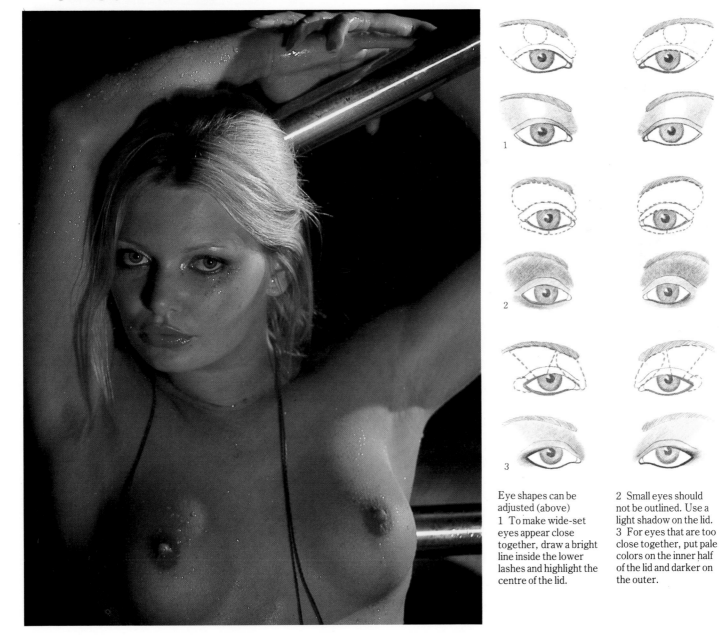

Eye shapes can be adjusted (above)
1 To make wide-set eyes appear close together, draw a bright line inside the lower lashes and highlight the centre of the lid.

2 Small eyes should not be outlined. Use a light shadow on the lid.
3 For eyes that are too close together, put pale colors on the inner half of the lid and darker on the outer.

moistened sponge, gradually thinning out down the neck so as to avoid any 'tide' marks.

Blushers and shapers add depth, color and shape to the face. They can enhance a model's good points and shift the emphasis away from the weaker ones. Used effectively, shapers can slim down a round face, raise the cheekbones and 'shorten' a nose. Blusher is applied with a soft sable brush in sweeping strokes from the middle of the cheekbone to the ear. When the line has been defined, add a narrow, slightly darker, streak of color underneath it and a lighter streak on top of it. Carry the blusher up on to the temples, fading into the middle forehead. If the nose is too broad, brush lightly down the side of the nose; if it is too long, add a touch of blusher at the tip. Put some blusher on the end of the chin and continue it lightly down the center of the neck.

THE EYES

Eyes are one of the main features of any woman's face. Mascara is generally considered to be their most important make-up. Apply it to the upper and lower lashes, using two light coatings, rather than a single heavy one. Use a lash comb to separate the lashes before they dry.

Eyebrows also play an enormously important part in adding expression and personality to the face. If the eyebrows look right, less eye make-up is needed, so ensure that they are well plucked and shaped. Ideally, the high point should line up with the center of the eye vertically and end in line with the center of the eye horizontally. If it fails to do so, correct by pencilling in tiny hair marks with an eyebrow pencil.

THE LIPS

Lip color should always be applied last, the color being selected to match the clothes the model is wearing and not the color of the eyes. Blondes are flattered by plum shades and deep pinks, while bright reds can look extremely theatrical and exciting. Redheads are suited to rich brown shades, while brunettes can wear dark oranges and deep burgundies. Any vivid color will suit a dark haired model, though the actual shade will depend on the color of her skin. The darker the skin tone, the stronger the color that can be taken.

Always outline the lip first with a lip pencil and then fill in with lipstick applied with a brush. For very full lips, it is often sufficient just to use a lip pencil and lip gloss.

CAMOUFLAGE AND PRECAUTIONS

There may be times when you will have to resort to camouflage. Here, cover sticks are especially useful for covering up blemishes and concealing dark circles under the eyes. Powder, on the other hand, should be used only to take the shine off the face and never to alter the color. Only use loose powder that is translucent.

Although most models will have their own make-up kit, you should have one of your own as well. Build this up gradually, because it can be an expensive investment. Above all, buy only allergy tested products. There is nothing worse than a model developing rashes and swollen eyes seconds after applying cosmetics that do not agree with her.

MAKE-UP EQUIPMENT

A make-up set can run to a considerable number of items. If you intend to do a lot of beauty or glamor photography, however, a full kit will be a wise investment. The materials shown here are comprehensive, although you will need many more colors to suit every occasion.

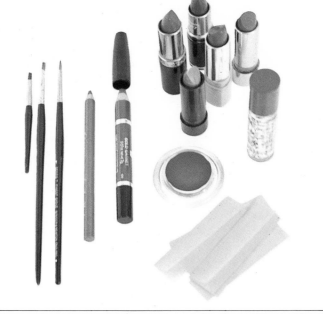

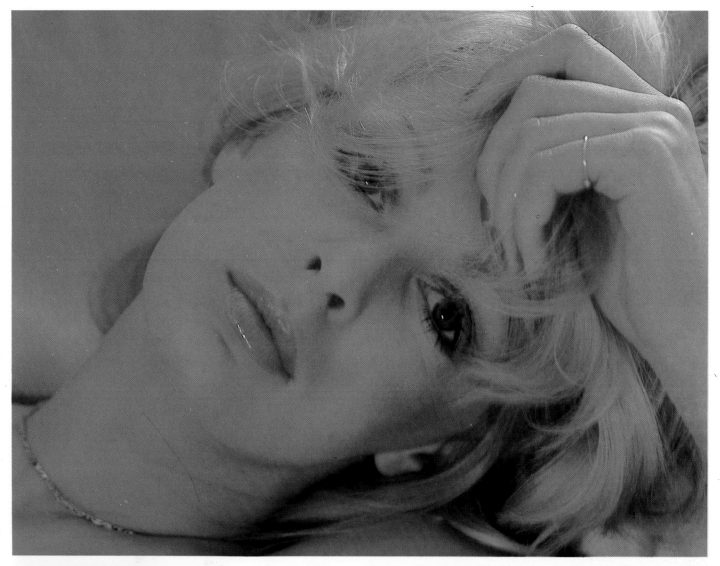

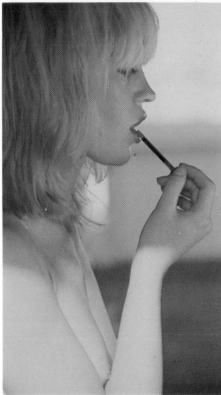

For a sensual, intimate shot (above), the lips and eyes are the centers of interest. A lot of lip gloss was used to pick up the highlight on the lower lip, matching the sparkle in the eyes.
85mm lens, Kodachrome 25, 1/30sec at f5.6.
You can even shoot the model applying her make-up (left). This early morning shot is entirely natural – it was taken while the model was preparing for the session.
85mm lens, Kodachrome 25, 1/30sec at f5.6.

THE LIPS AND EYEBROWS

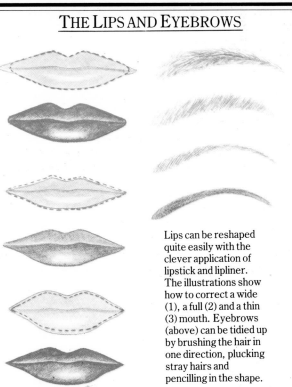

1

2

3

Lips can be reshaped quite easily with the clever application of lipstick and lipliner. The illustrations show how to correct a wide (1), a full (2) and a thin (3) mouth. Eyebrows (above) can be tidied up by brushing the hair in one direction, plucking stray hairs and pencilling in the shape.

Coloring the body

IN GLAMOR PHOTOGRAPHY, make-up does not necessarily stop at the neck. Frequently, body make-up is used – this can mean anything from body oil to exotic designs painted on the body with removeable make-up. The former is absolutely indispensable when photographing a nude or semi-nude model. For photographic purposes, baby oil is best.

Body make-up has two other main purposes – camouflage and display. As most of us are only too aware, the camera mercilessly highlights any defects we may possess. Unless you want to draw attention to a birth-mark, scar or blemish, your model should camouflage it carefully before a photographic session. Any ordin-ary make-up that matches the skin will be suitable.

Be particularly wary, though, of fake sun tan creams. Although they are ideal for covering up sun burn marks, most of them become streaky if applied over the entire body. The texture of the skin is generally far more important that the color, although a rich sun tan is unbeatable for beach shots.

It is very easy for body designs to go wrong, so do not attempt anything over-complex unless your model knows exactly what she is doing, or you are working with a professional make-up artist. Properly executed designs can be quite stunning, but amateurish ones will look dreadful.

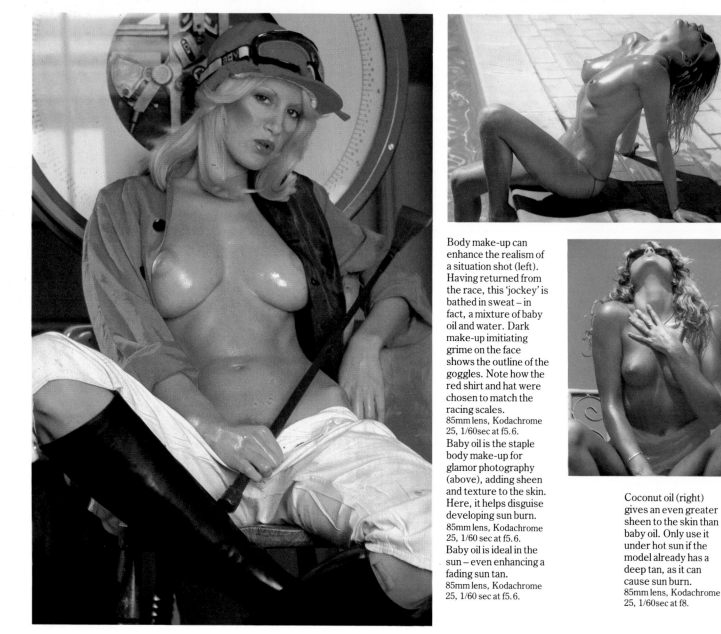

Body make-up can enhance the realism of a situation shot (left). Having returned from the race, this 'jockey' is bathed in sweat – in fact, a mixture of baby oil and water. Dark make-up imitiating grime on the face shows the outline of the goggles. Note how the red shirt and hat were chosen to match the racing scales.
85mm lens, Kodachrome 25, 1/60 sec at f5.6.

Baby oil is the staple body make-up for glamor photography (above), adding sheen and texture to the skin. Here, it helps disguise developing sun burn.
85mm lens, Kodachrome 25, 1/60 sec at f5.6.

Baby oil is ideal in the sun – even enhancing a fading sun tan.
85mm lens, Kodachrome 25, 1/60 sec at f5.6.

Coconut oil (right) gives an even greater sheen to the skin than baby oil. Only use it under hot sun if the model already has a deep tan, as it can cause sun burn.
85mm lens, Kodachrome 25, 1/60sec at f8.

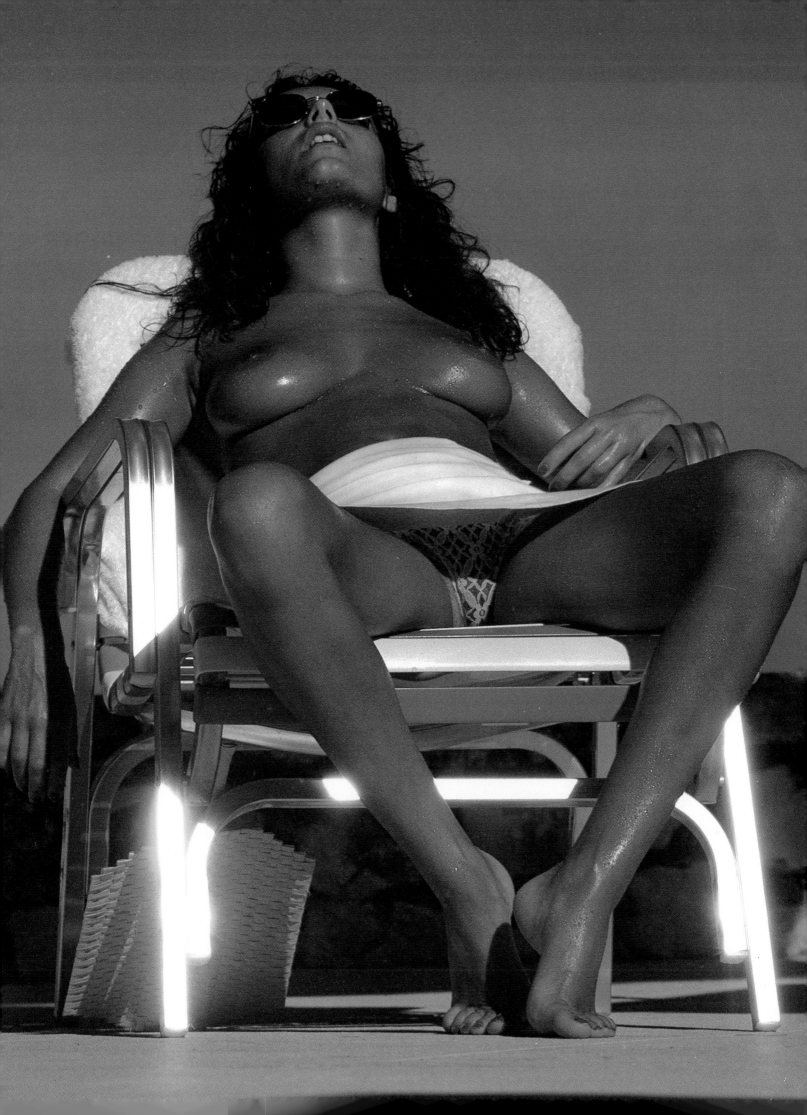

SPECIAL BODY DESIGNS

Body make-up can be used to produce exciting designs, creating really startling impact if well executed. Be careful, however, not to be over-confident, for such designs will look very disappointing in a photograph if they are less than perfect. Just as the camera will exaggerate skin blemishes, it will also show up any slight mistakes in a body make-up design.

The first precaution is to make sure you are fully prepared, with the right equipment and a clearly worked out intention. It may be wise to find a good reference for your design rather than relying entirely on imagination: you could try adapting from a magazine photograph or material catalogue, for example. The best designs will be simple – a bold conception with a limited range of colours and without unnecessary elaboration. Look for humorous ideas – adding a make-up suspender belt, for example – or designs with an implication of mystery and exotic allure. Chose props and the setting to match your make-up idea.

The snake (right) is a good example of the success of uncomplicated ideas when using special-effect body make-up. It was drawn with a brush using dark kohl. A little glitter was added, with sequins for the snake's eyes. The sunglasses were chosen to echo the design, which was well suited to the jungle vegetation of the setting.

55mm lens, Ektachrome 64, 1/60sec at f4.

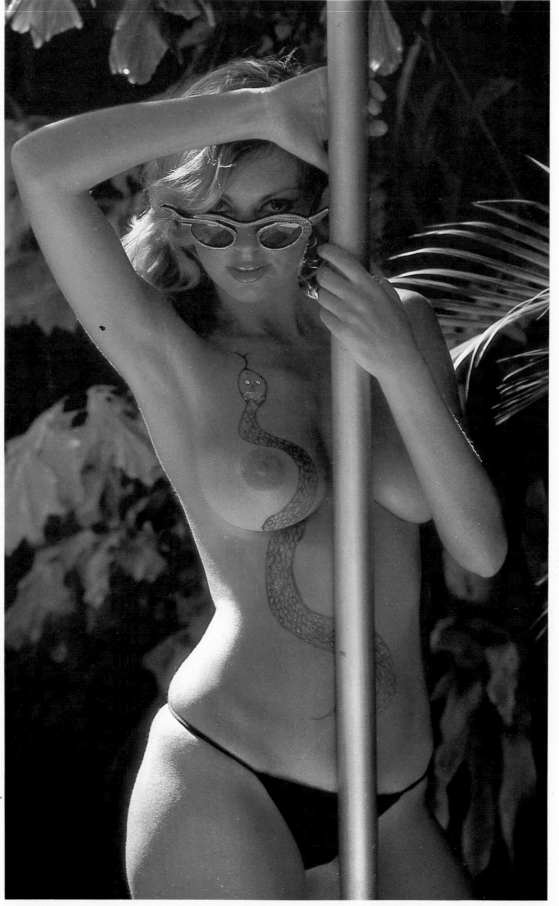

Sun burn is unlikely to be attractive in photographs (right). The obvious discomfort of the model can communicate itself to the viewer of the photograph! First of all, take precautions against it. Do not, for example, have a fair skinned model working in hot sun immediately but allow her to develop a tan at her own pace. When sun burn does occur, tan make-up can be used, although it is rarely totally satisfactory.
85mm lens, Kodachrome 25, 1/30 sec at f5.6.

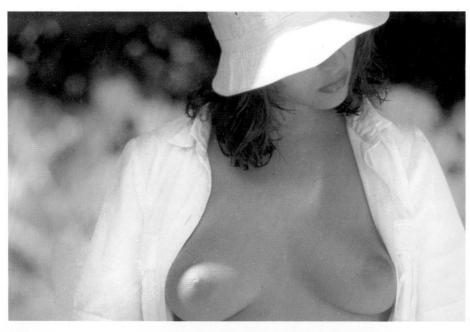

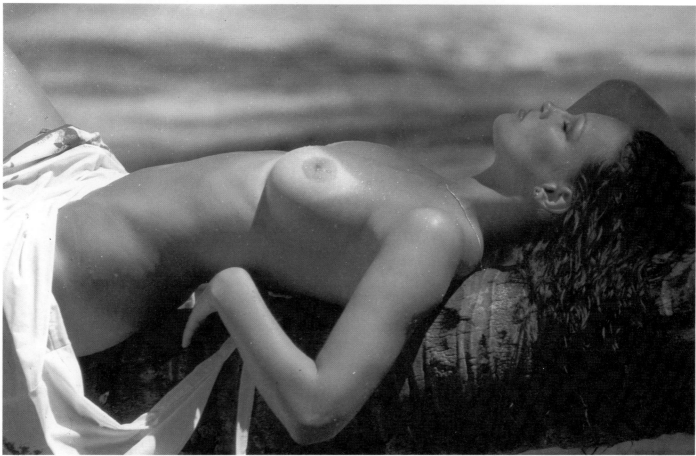

The white outline of swimsuits in sun tan are usually best avoided, but occasionally (above) they can look really attractive. Here, the untanned breast accentuates the model's tan – and is itself emphasized in turn.
85mm lens, Kodachrome 64, 1/125sec at f11.

Props and accessories

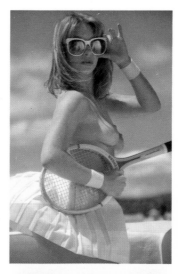

P ROPS AND ACCESSORIES can create a mood, enhance a feeling and make the difference between a sensational and mediocre photograph.. There are no guidelines for what and what not to use – just the dictates of good taste and sex appeal. This is nearly always subjective. You should discuss with your model beforehand the kind of shots you are going to take so that she can bring her own accessories. In addition, the glamor photographer should possess a wide range of props and a well-stocked wardrobe. Not only will this allow greater freedom to accommodate a change in mood during a session, but it may also inspire your model to think of new ideas about how she would like to look.

Think of props and accessories for photography as you would for the theater. Glamor photography is about dressing up and acting a part. If your model sees something that captures her imagination, it will be easier for her to act in front of the camera. Develop a magpie instinct and keep anything that could be useful as a photographic prop.

In more ways than one, a good rule to follow in glamor photography is 'less is more'. Nothing in your photograph should be superfluous. Props and clothes must work for you and your model. They must be there for a purpose. In real life, for instance, it is extremely unlikely that a woman would go swimming wearing a blouse. In the world of glamor, however, one of the classic shots is of a model emerging from the sea with a wet, translucent garment clinging to every curve. Sunglasses may hide the eyes, but they make a devastating point about nudity when they are the only thing your model is wearing. This is true of any accessory – scarves, shoes, stockings, for instance – on an otherwise nude model. Soft and luxurious fabrics, especially silks and furs, have instant sex appeal. So, too, does leather, with its overtly masculine associations.

The more you put into a photographic session, the more you will get out of it. A model will know if you have gone to a good deal of trouble and will repay your efforts. Dress her up in an elaborate costume, provide her with an unusual or exotic prop, snd she will invariably play her part. She will also enjoy it.

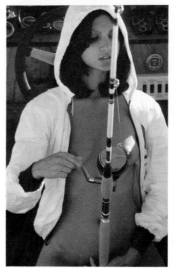

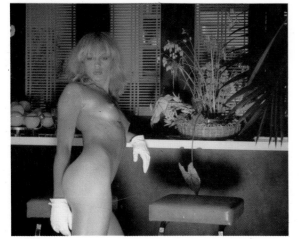

Keep props simple. White gloves alone (left) suggest the model's aggressive sensuality.
85mm lens, Kodachrome 64, 1/15sec at f5.6, single lamp with two gold reflectors.
While a tennis skirt and racket (top) set the scene, it is the model's glance that involves the viewer.
85mm lens, Kodachrome 25, 1/60sec at f5.6

Letting her try her hand at fishing (above) helped relax the model on this boat trip. session.
85mm lens, Kodachrome 25, 1/60sec at f5.6
Choose props carefully so that they suit the model and combine effectively in the shot, perhaps concentrating on a color. Red sunglasses and jacket (right) complement the model's bronzed skin.
85mm lens, Kodachrome 25, 1/60sec at f5.6

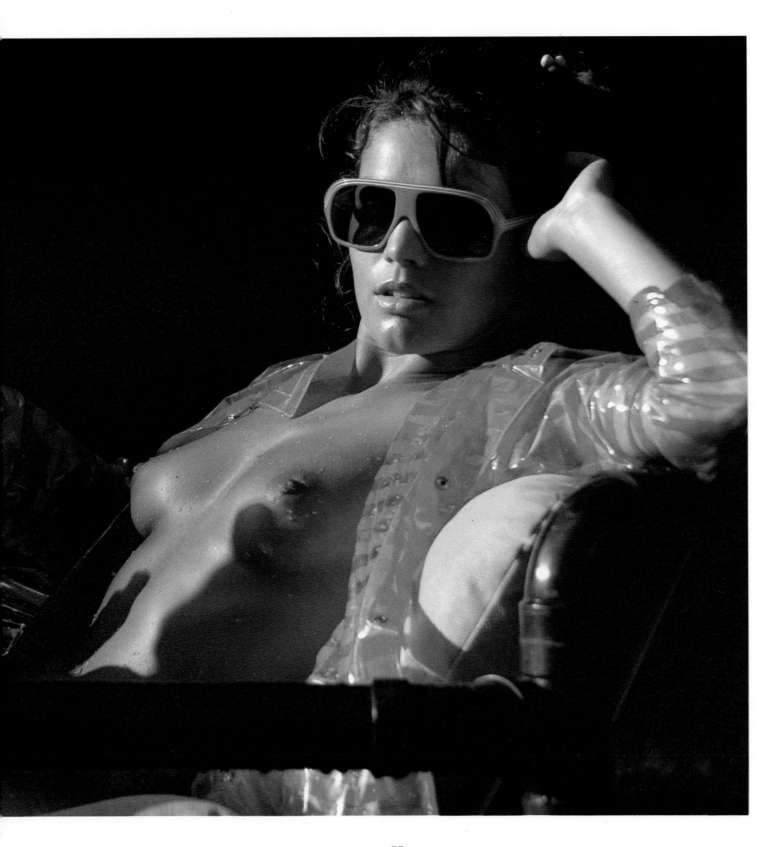

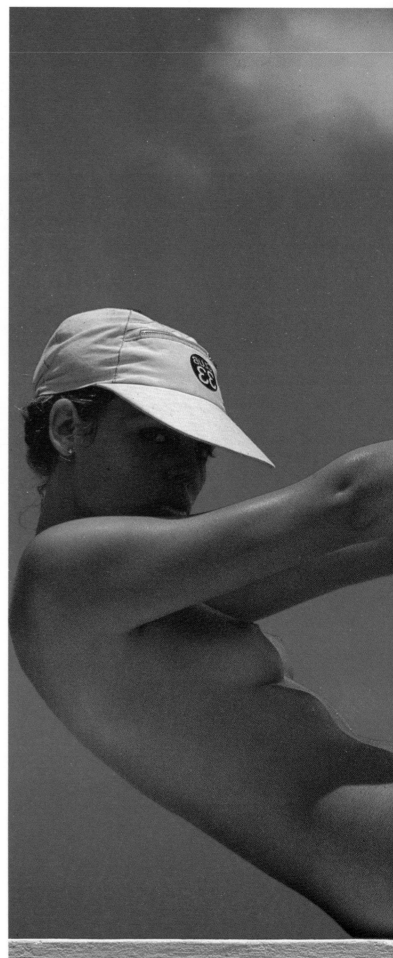

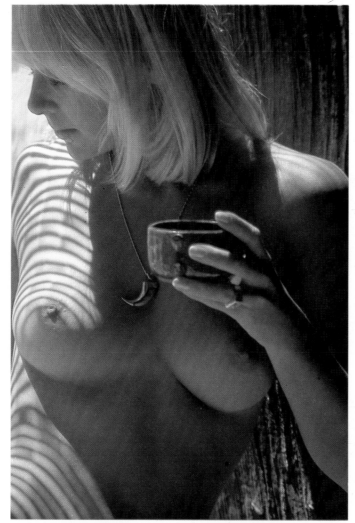

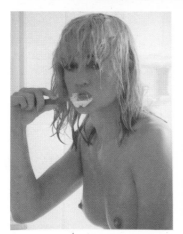

A broken cup (top) in a color that suits the model's skin is enough to add interest to an intimate close-up.
85mm lens, Kodachrome 64, 1/30sec at f5.6
The most unlikely props can help. This model (above) even looks stunning brushing her teeth.
85mm lens, Kodachrome 64, 1/15sec at f4, with fill-in light from a domestic light.

Coordinating the colors of lipstick, lollipop and jacket (above) kept this shot simple and effective.
85mm lens, Kodachrome 25, 1/125sec at f8.
The outdoor healthy look of the model (right) is created by adding simple props – a sporty cap and exercise machine.
85mm lens with polarizing filter, Kodachrome 25, 1/30sec at f5.6

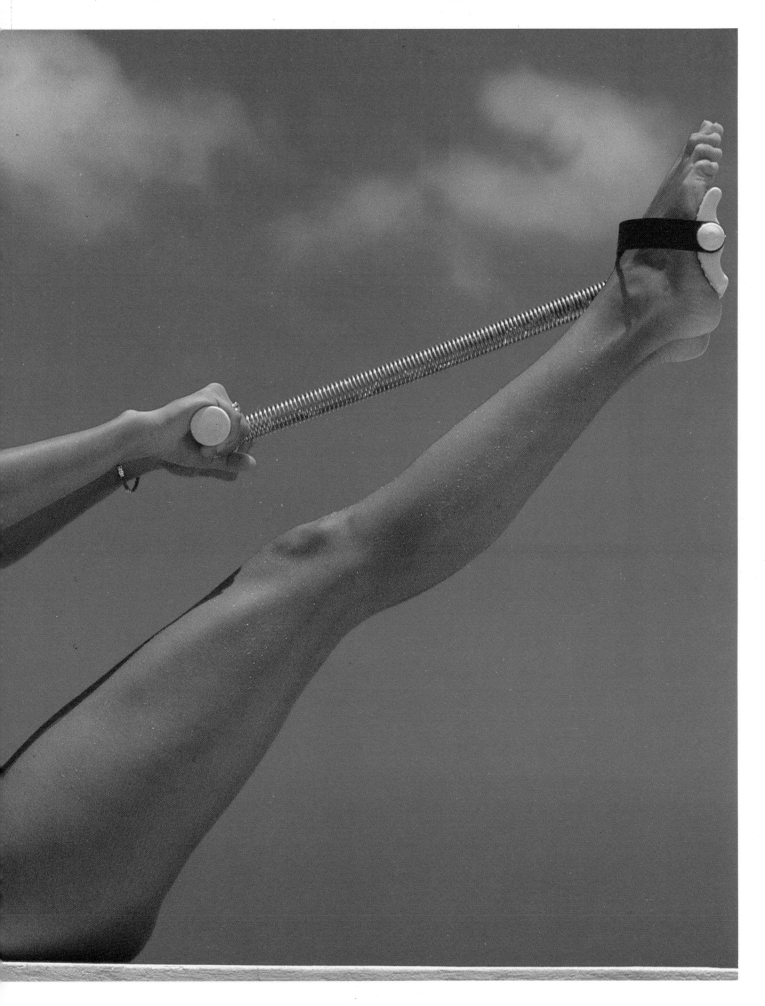

SELECTING A WARDROBE

Not all your models will be the same size, so stock a selection of garments to fit different builds. This, obviously, is less important for clothes that are meant to be loose fitting or can be tucked up at the back with safety pins (you never can have too many safety pins in the dressing room).

Try to develop contacts with owners or managers of local dress and shoe stores. They may either give you, or sell at a reduced cost, rejected items that cannot be sold because of minor flaws, but would be quite suitable for photographs. Some stores will even lend items in exchange for free photographs, or a credit in whatever publication the photograph appears.

If you do borrow clothes that have to be returned, warn your model to be careful not to get make-up or other marks on them. Ask her to wear a sweat shield with dresses or blouses, unless they are see-through.

Wherever possible, select garments that are washable, or, at any rate, easy to keep clean. Your model will feel a hundred times better wearing well-laundered and fresh-smelling garments, rather than grubby ones. It is also a good idea to have an iron and ironing board to hand, so that any creased clothes that are to be used at the last minute can be pressed.

Underwear This is an obvious glamor accessory. There is a wide choice available – from flimsy, next to nothing bras and panties to elaborate 19th-century corsets. Not surprisingly, your model will normally want to wear her own underwear and is likely to have a good selection herself. Nevertheless, be on the look out for especially pretty or unusual items that a model is unlikely to have in her own kit.

Stockings and socks Stockings are an indispensable part of a glamor wardrobe. Any colour or type of stocking can look sensational if used in the right way. Very sheer or silk stockings are perhaps the sexiest of all, because their texture is readily conveyed in a photograph. Dark stockings can slim down heavy legs, while patterned or light-colored stockings will fill out very thin ones.

Garters, or suspenders, certainly can be attractive, but they

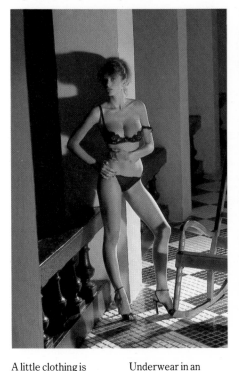

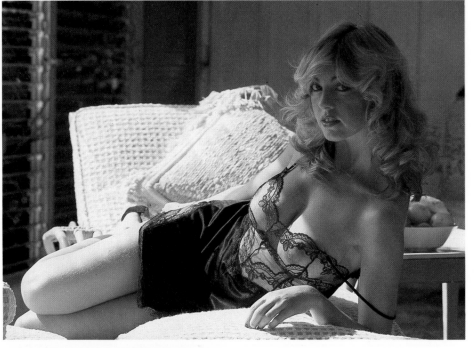

A little clothing is usually much sexier than no clothing at all. The minimal black lingerie worn for this shot (above) transformed a simple standing pose into an intimate erotic occasion.
85mm lens, Kodachrome 64, 1/15sec at f4, with two spotlights.
Fair skin, a langorous pose and a pretty black lace slip, with the model placed in a pool of bright sunlight shining through the window, create a restfully sensuous scene (right).
85mm lens, Kodachrome 25, 1/60sec at f5.6

Underwear in an outdoor setting takes on additional erotic meaning particularly in a seemingly public place. This shot (right) was taken on a balcony overlooking Hollywood's Sunset Boulevard. The black stockings and transparent chiffon scarf contrast with the sunlight reflecting off the white wall – an effect reinforced by the white-framed sunglasses.
85mm lens, Kodachrome 25, 1/125sec at f5.6

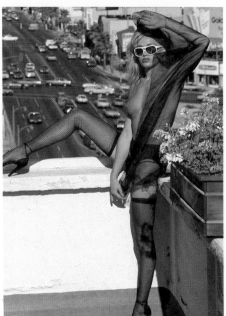

White lace underwear accentuates the softness and femininity of a woman's body (right). Taken in the restricted space of a small room, the mirror image is a useful means for overcoming the shortcomings of a close-up view. Fill-in was provided partly by the mirror acting as reflector and partly by a gold reflector placed in front of the model.
85mm lens, Kodachrome 64, 1/30 sec at f5.6.

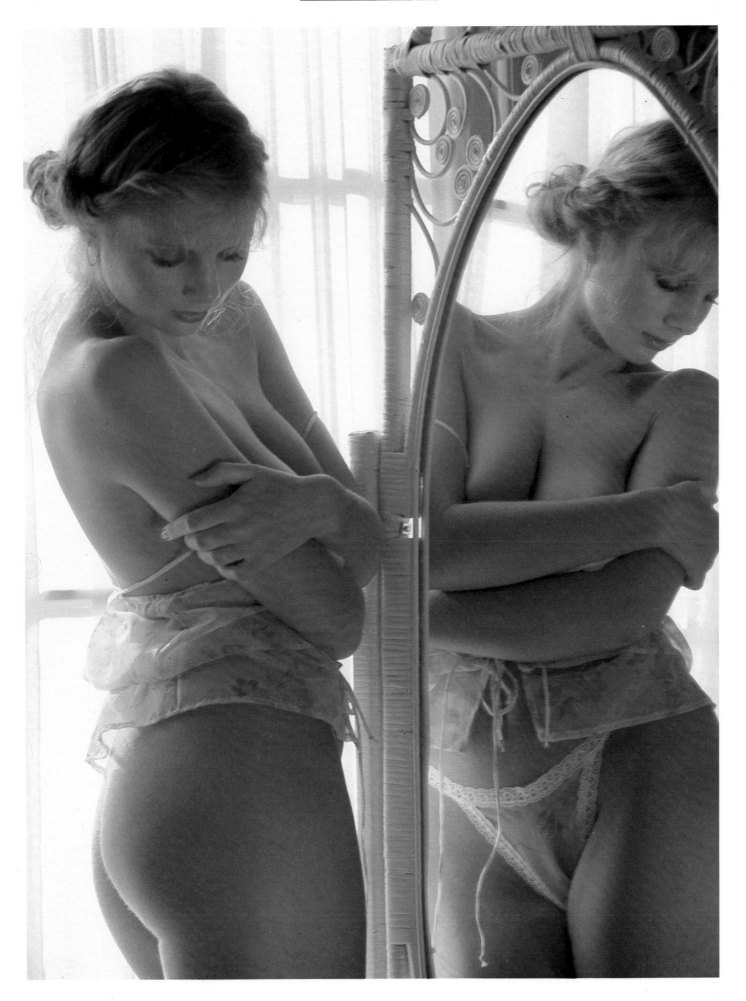

Opportunities to photograph two identical beautiful women together must be few (right). These twins were taken on a modelling assignment to Haiti and this shot is one of the best that resulted. The costume was carefully chosen to add to the impact of the mirror image, with identical bra, pants, suspender belt and stockings – but with one set white and one black. Much of the light was daylight from the windows although a spotlamp and reflectors were also used. 35-80mm zoom lens, Kodachrome 64, 1/15sec at f5.6.

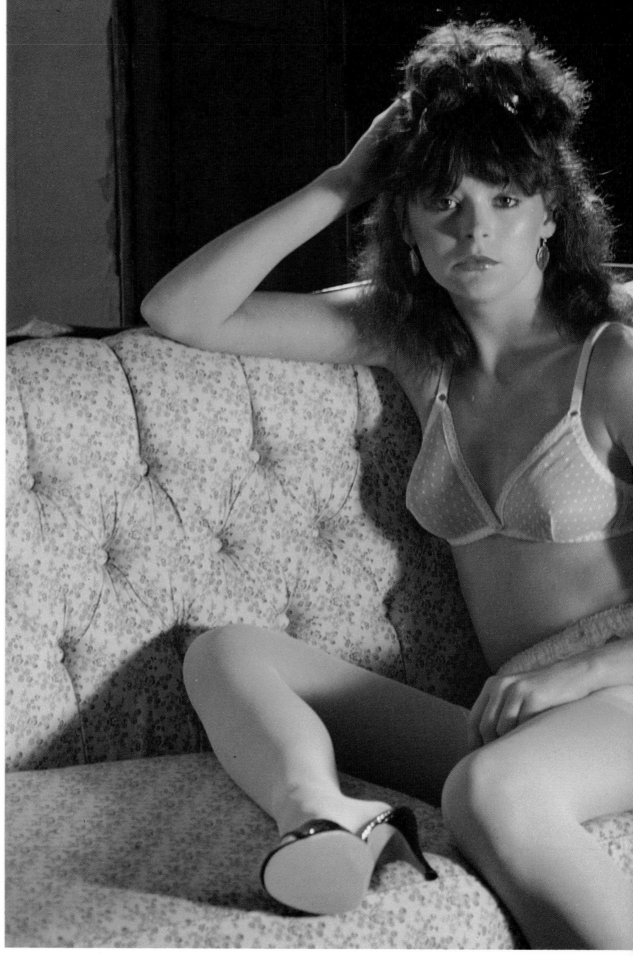

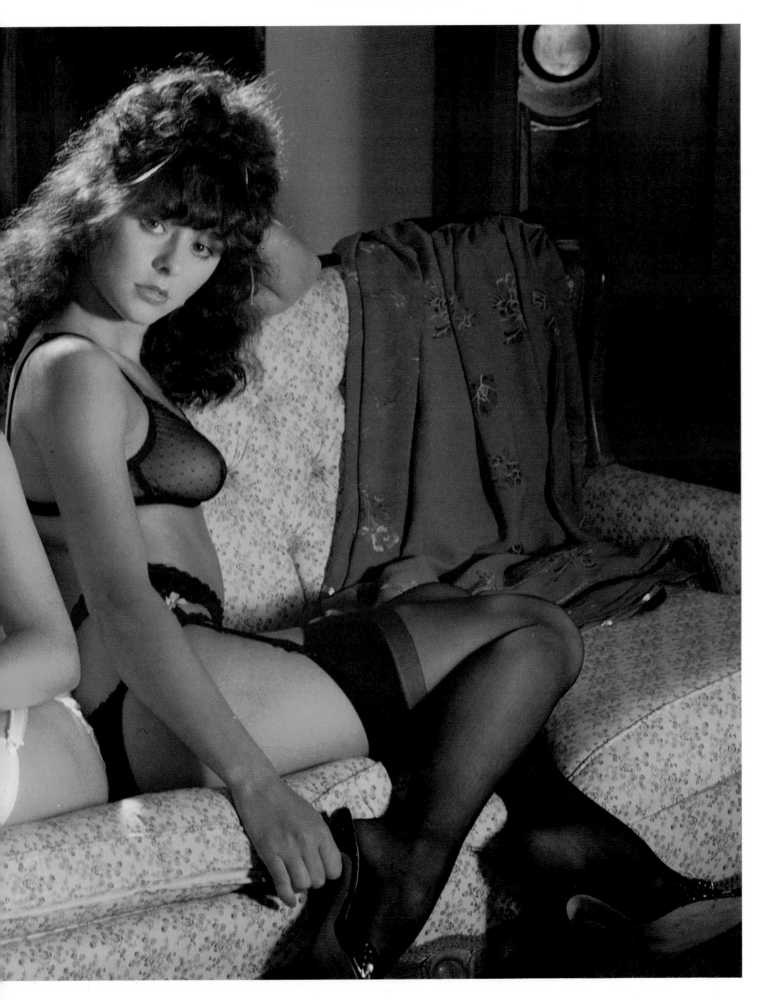

Backlighting is essential if you want to take full advantage of semi-transparent garments (right). With a predominantly dark folding screen as a backdrop, the sunlight shows through the gown and creates a halo effect to silhouette the outline of the body. A reflector was used to provide fill-in light for the face and arm. 85mm lens, Kodachrome 25, 1/60 sec at f8.

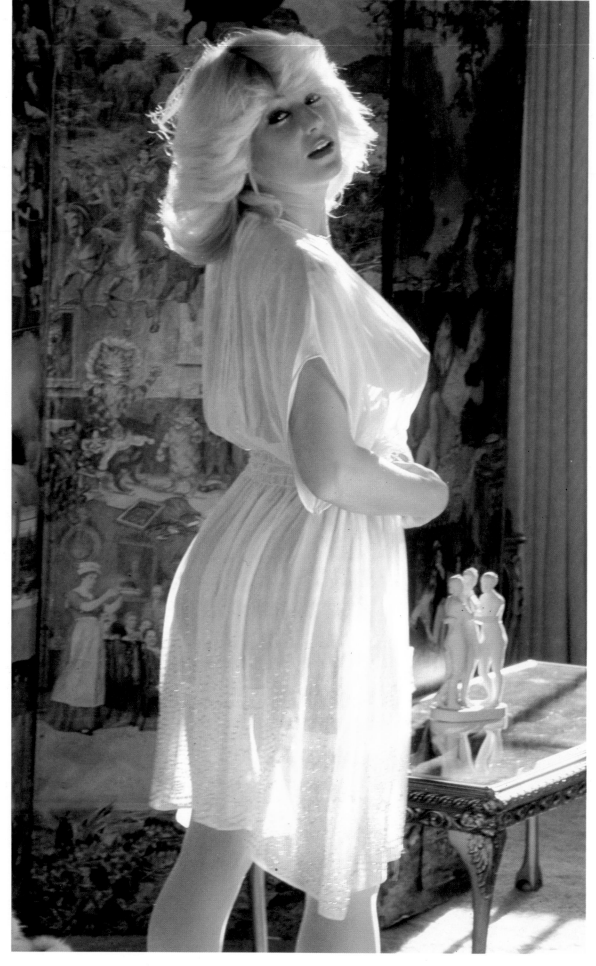

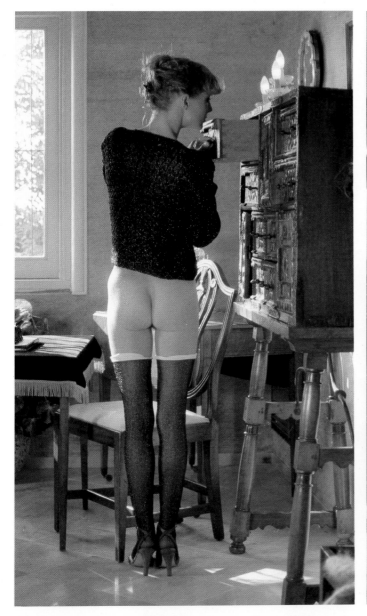

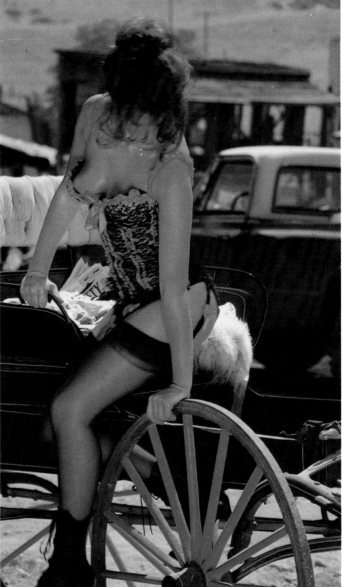

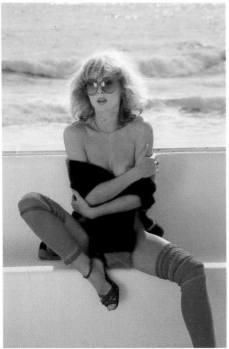

Lurex stockings match the evening jacket (above) in this pretty combination. Spotlights were bounced off gold reflectors to the side and the front of the model.
85mm lens, Kodachrome 64, 1/15sec at f5.6.
Taken on a Hollywood film set (above right) the old-fashioned corset and stocking combination matches the period feel of the wagon.
80-210mm zoom lens, Kodachrome 25, 1/30sec at f8.
Woolly leg-warmers (right), with lipstick color matched, served more than a decorative purpose on a cold winter afternoon.
55mm lens, Ektachrome 64, 1/125sec at f5.6.

can also clutter a picture. Try stockings without the garter and vice versa. Socks are a popular accessory. Consider all the varieties from men's thick woollen football socks to plain white tennis nylons.

Shoes and boots How you dress or undress your model's feet is extremely important. If they do not look good, neither will the model. Uncovered, they should be pretty, smooth and unobtrusive; dressed-up with style, your model may not need any other accessory at all. Decorative shoes should have high heels and be dainty and light. They are also the one accessory that can least afford to ignore the dictates of fashion. Old-fashioned shoes will date a photograph quicker than anything else. While tennis shoes can be less than graceful, they have specific associations that can make them appropriate and often ideal footwear.

Boots dominate a picture even more than shoes and should only be worn if that is the intended effect. Whatever style you choose, it must be extreme – fashion boots, for instance, should be highly polished and well heeled.

Swimwear Like underwear, your model is likely to have her own swimwear and she will prefer to wear it, unless you have some devastating designer swimsuits in your wardrobe. Select medium- to small-sized garments, bearing in mind that the larger sizes would mean larger models who are not, generally speaking, ideal for swimwear shots.

Tennis shoes (right) give a sporty look. Make sure they are clean and perfectly white – even slight marks will ruin the shot. The same is true for the white towel, chosen with the white coffee set to complete a unified color scheme. No reflectors or extra lights were needed to augment the late afternoon Jamaican sun.
85-210mm zoom lens, Kodachrome 25, 1/30sec at f5.6

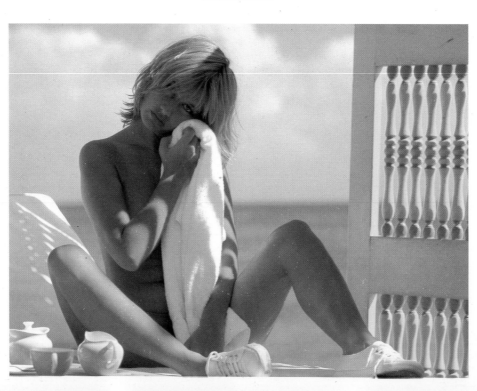

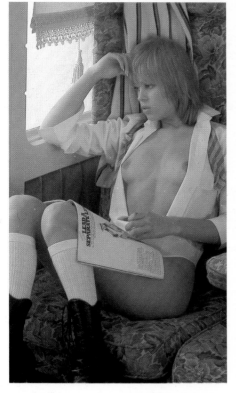

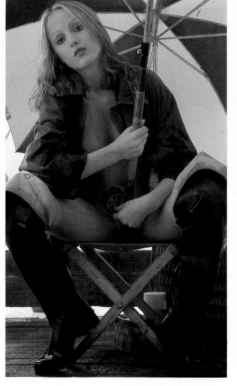

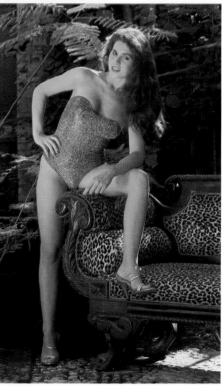

With an old-fashioned train carriage on a film-set for location (above), the Western granny boots add to the nostalgic charm of this scene. The lighting was provided by a spotlight behind the windows and flash bounced off a white reflector to the side of the model.
85mm lens, Kodachrome 25, 1/60sec at f8.

Clumsy rubber boots, wet to suggest rain in this fishing shot (center), contrast appealingly with the model's body. This is, in fact, a studio shot, with backlighting from a flash unit bounced through the umbrella and back to the model from a reflector in front.
85mm lens, Kodachrome 25, 1/60sec at f5.6.

The model chose the gold shoes to match the lurex swimsuit for this slinky shot in an elaborate interior (above). With this type of sophisticated scene, shoes should be light and open – little more than sole, heel and straps.
85-210mm zoom lens, Kodachrome 25, 1/30sec at f5.6.

Shoes are often best used as a single prop (right) without the addition of unnecessary elaboration. The simple act of putting on a pair of shoes gives this shot a real intimacy. The lighting, too, was kept simple – unmodified daylight.
85mm lens, Kodachrome 25 1/30sec at f6.

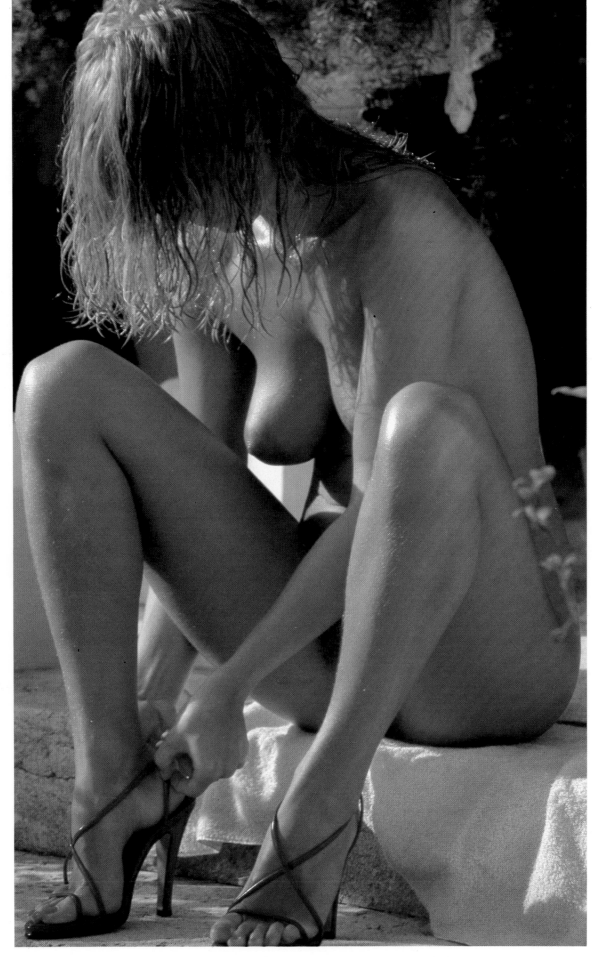

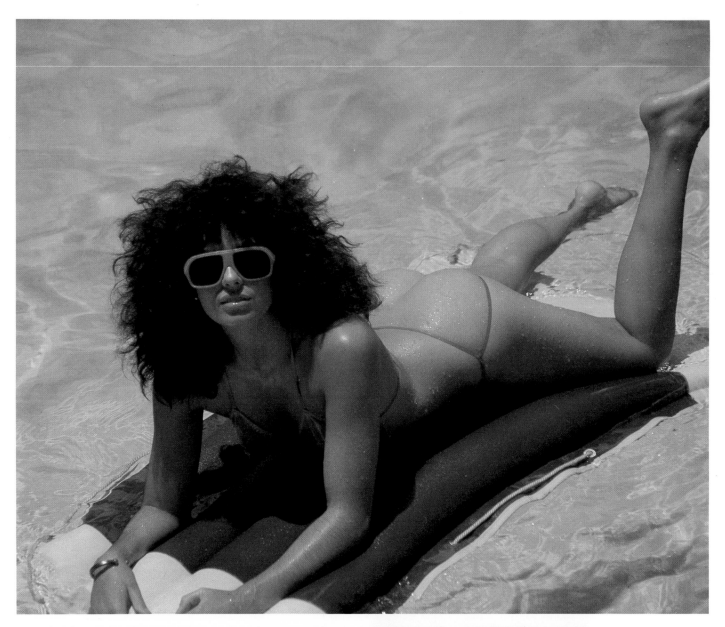

Shirts, blouses and T-shirts How a model wears shirts and T-shirts is as important as the garment itself. T-shirts should be worn without a bra, and blouses must allow a cleavage at the very least (unless the intention is to emphasize the lower regions that are not covered at all). Selecting a specific size is not important, because over-size blouses can be pinned at the back to seem smaller, while very loose shirts (such as men's shirts) can sometimes look extremely seductive. It is often no bad thing if a blouse is too small.

Trousers Trousers must be well fitting; in most cases, your model will and ought to provide her own. If you do want some in your wardrobe, select the smaller sizes and buy the unusual styles that a model is unlikely to possess – leather or suede for example, or leopardskin, if that appeals to you. Most women's trousers fasten in the front nowadays and in glamor photography are usually better left unfastened.

Headgear Any sort of headgear should be used with caution. This is especially true with hats, since psychologists say that these have strong associations with formal occasions. Use headgear with panache and style, or for a specific purpose, such as protection from the sun. Caps, vizors and sun hats all fall into this category. In photography, they are also useful for providing extra shade for the face.

Brightly-colored scarves can give your model a gypsy or ethnic

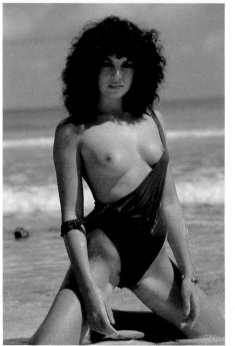

Modern swimwear is likely in any case to be minimal (above). The sunglasses were carefully chosen to match the suit's color, the red ensemble planned to form an attractive combination with the blue and yellow airbed. A polarizing filter reduced the reflected glare from the surface of the water.
85mm lens with polarizing filter, Kodachrome 25, 1/60sec at f5.6.
The same model wearing a one-piece swimsuit (left) shows what can be achieved by an off-the-shoulder pose with a less revealing garment. The photograph was taken from ground level.
85mm lens, Kodachrome 25, 1/125sec at f8.

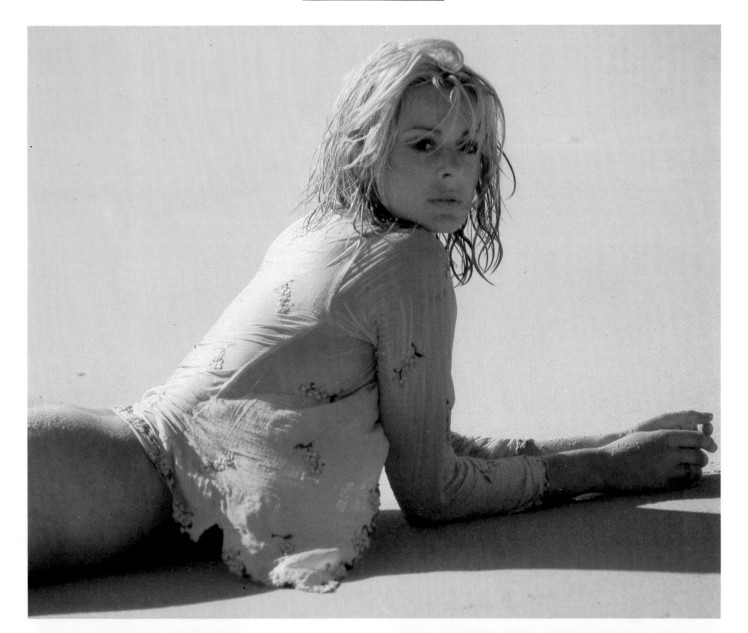

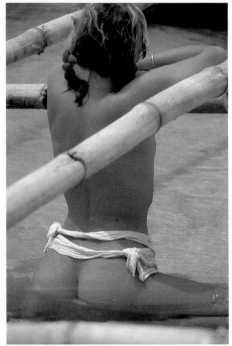

A simple blouse (above) can add a great deal to the appearance of even the most beautiful model – a prop that gives the shot an unposed look.
85mm lens, Kodachrome 25, 1/60sec at f5.6

A white shirt (left) tied loosely round the waist emphasizes the warmth of the model's body and gives life to a shot taken on an overcast and seemingly unpromising day.
85-210mm zoom lens, 1/60sec at f8.

Chosen as the only prop, the strong red of the blouse in this shot (right) immediately catches the attention.
35-80mm zoom lens, Kodachrome 25, 1/125sec at f5.6

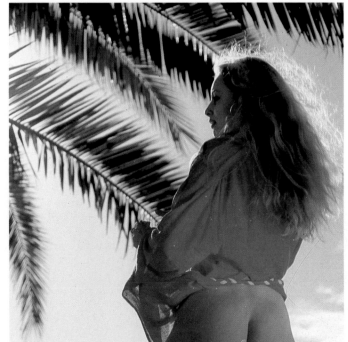

White T-shirt and running shorts flatter a tanned and blonde model (below). Gentle lighting from an evening sun diffused by hazy cloud gave good colour saturation and soft shadows.
85mm lens, Kodachrome 64, 1/30sec at f5.6

The finest cotton top stretched over the model's wet skin becomes almost invisible (right), with only the seams and strap showing the yellow color needed to add interest to the shot. A polarizing filter was used to deepen the blue of the sky and cut out reflected light from the ocean in the background.
85mm lens with polarizing filter, Kodachrome 25, 1/60sec at f5.6.

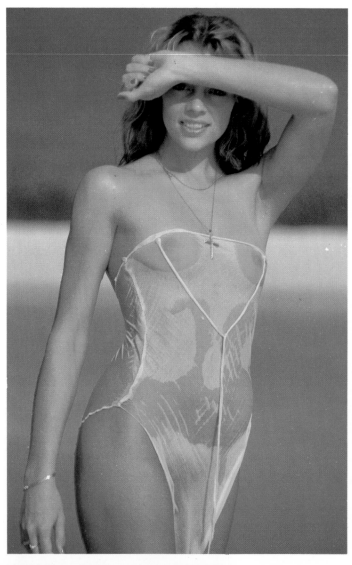

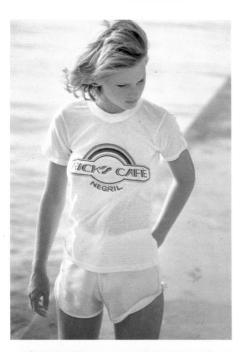

A deep tan contrasts with the white of the blouse, made transparent by the swimming pool water (left). Always choose shirts and blouses to make the most of the model's strong features – a white blouse will emphasize a tan, for example.
85mm lens with polarizing filter, Kodachrome 25, 1/60sec at f5.6.

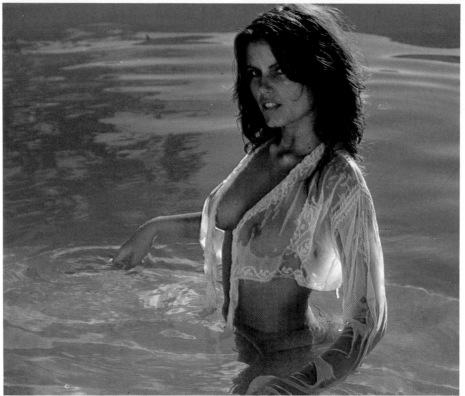

See-through trousers are part of this elaborately staged scene (left), helping create the fantasy of a slave girl in a medieval banqueting hall. Studio lighting was used. Hasselblad, Ektachrome 64, 1/30 sec at f8.

Short shorts make an excellent costume for glamor photography – whether at a Los Angeles poolside (below) or in the English countryside (bottom).
Los Angeles: 85mm lens, Kodachrome 25, 1/30sec at f5.6. England: 85mm lens, Ektachrome 64, 1/60sec at f5.6.

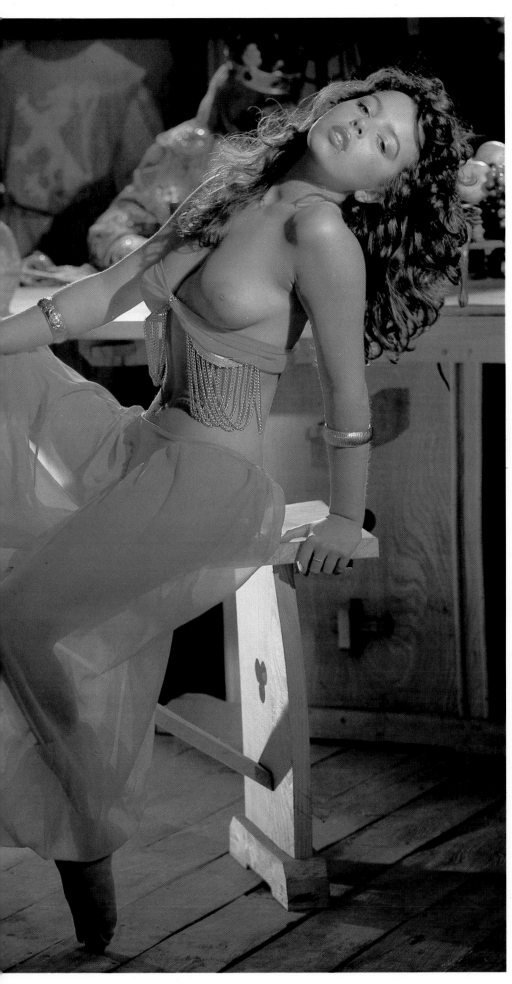

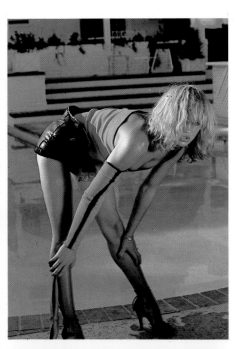

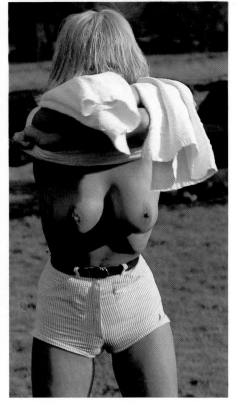

look, but do not overlook the charm and simplicity of ribbons, bows, colorful hair grips and flowers in the hair.

Sun glasses Sunglasses are always associated with glamor. They evoke thoughts of the rich and the famous incognito, or expensive beaches on sun drenched islands. They hide the eyes – the mirror to the soul – and keep the observer guessing. Take fashion trends for sunglasses seriously because they can look ludicrous when outdated. Consider your model as well. If her eyes are her best feature, it may be better for her to push the sunglasses on top of her head, or to use them as something to hold, rather than to wear. Whichever type of sunglasses you select, make a point. It could be humorous, as with the exaggerated plastic variety, or about sport – ski sunglasses for instance. Remember that sunglasses can be worn indoors as well as outdoors – often with more impact for being incongruous.

Costumes Acting is fun. If your model dresses up in some weird and wonderful costume and acts out the role, you will have an interesting time and some first-rate photographs. Pick on any theme – a tribal dancer, a movie star or a historical character, for example. The choice does not matter, providing your model can relate to it.

Most towns have a theatrical costumier, so, if you do have a

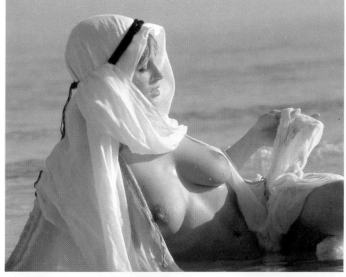

A straw hat to match the model's blond hair (right) creates a very simple color composition, with only the bright red lips standing out. 85mm lens, Kodachrome 25, 1/60sec at f5.6.

An elegant turban (left) establishes the atmosphere of late afternoon on a sultry day on a beach in the Middle East, with the desert coming right down to the cool sea. A telephoto lens was used to close in on the model some distance out in the shallow water. 300mm lens, Kodachrome 25, 1/30sec at f4.

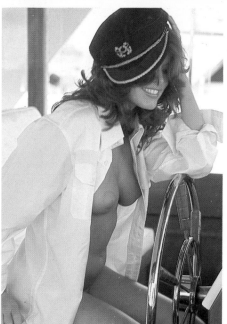

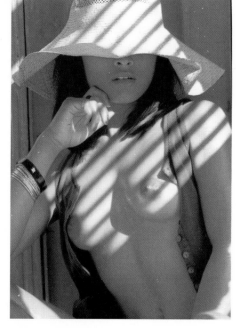

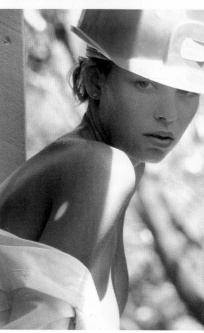

A captain's hat worn at a jaunty angle (above) contributes to the obvious enjoyment in this shot of the model at the wheel of a yacht. 85mm lens, Kodachrome 25, 1/30sec at f4.

Here the straw hat is used to draw attention to the model's perfect mouth and flared nostrils by hiding the eyes (above). Sunlight provided the main lighting with a natural and warm fill-in provided by a yellow blanket acting as a reflector on the floor. 85mm lens, Kodachrome 25, 1/30sec at f5.6.

A workman's hard hat (above) adds interest to the shot by its incongruity, but also throws a soft red glow on the model's face. No reflectors or extra lights were required for this effect – the model just had to be carefully placed to use a shaft of sunlight. 85mm lens, Kodachrome 25, 1/30sec at f5.6.

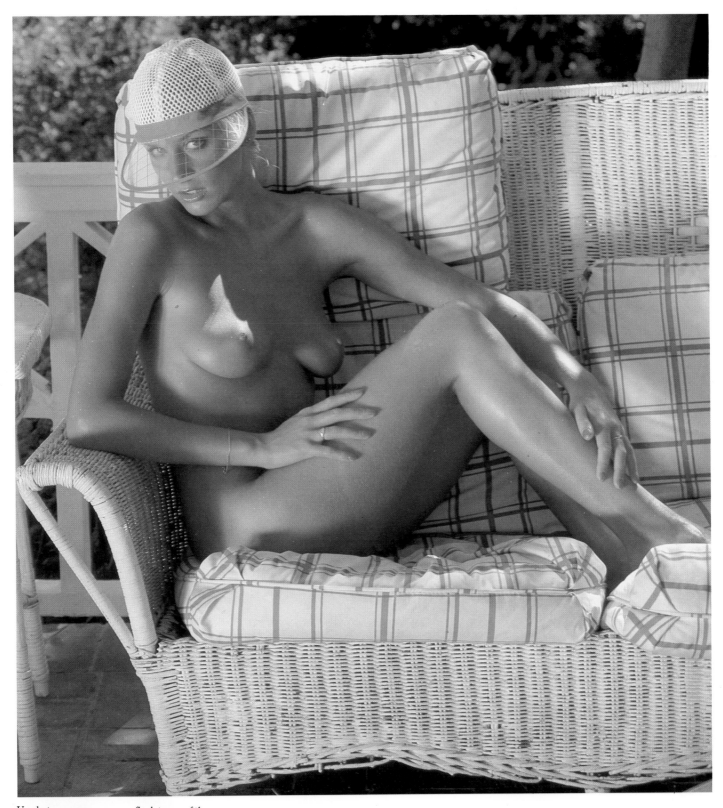

Use hats as props cautiously – choosing them to look natural and informal unless you are attempting to create a special period atmosphere. The simple cap (above) was selected to match the color scheme of the couch so that the only colors in the shot would be white and green, setting off the warm flesh tones of the model. Daylight was sufficient with a single reflector in front of the model to soften the shadows.

85mm lens, Kodachrome 25, 1/30sec at f5.6.

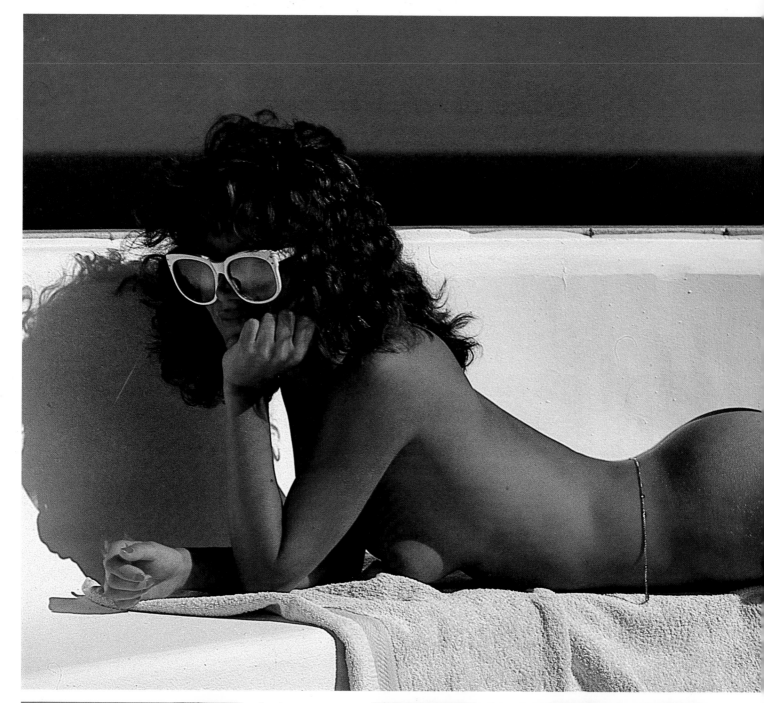

Sunglasses stop the model screwing up her eyes in sun (above). In this shot they were chosen to match the balcony wall and towel. 85-210mm zoom lens with polarizing filter, Kodachrome 25, 1/30sec at f8.

In very strong sun (left) the model will need dark glasses to protect her eyes.

85mm lens, Kodachrome 25, 1/60 sec at f8.

Sunglasses add mystery to this simple shot of a model at the wheel of a car (right). 85-210mm lens, Kodachrome 25, 1/30sec at f5.6.

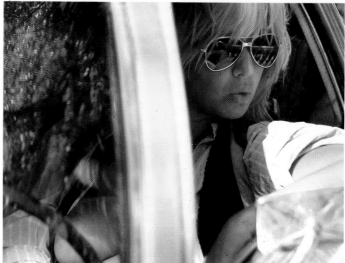

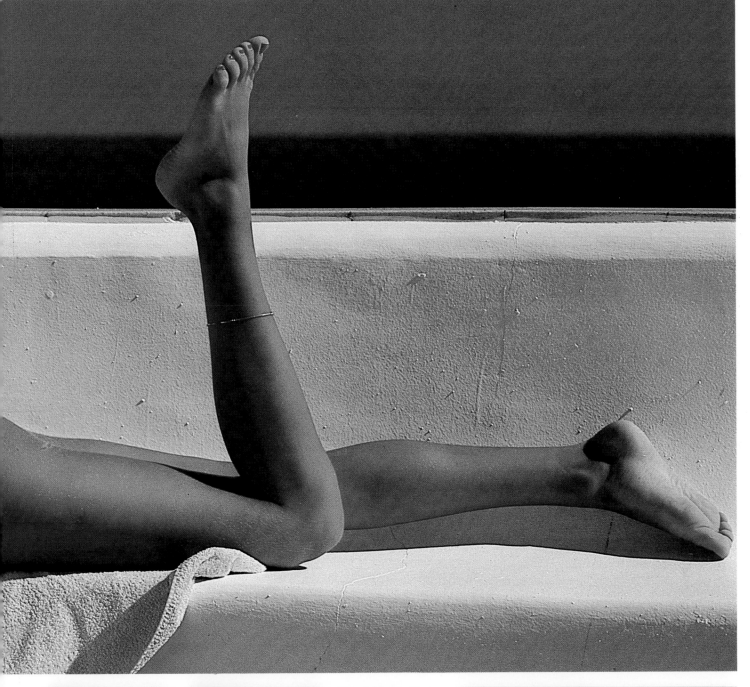

 A model in the same setting looks quite different with and without sun glasses (left). With them, she is in a world of her own. Without them she looks directly at the viewer in a challenging way. Daylight lit the patio on which the shot was taken with a single reflector on the left. 85mm lens, Kodachrome 25 1/30sec at f4.

Looking over the sunglasses directly at the camera (right) gives the model a provocative look. 85mm lens, Kodachrome 25, 1/60sec at f8.

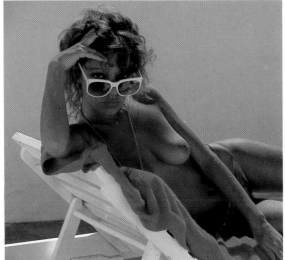

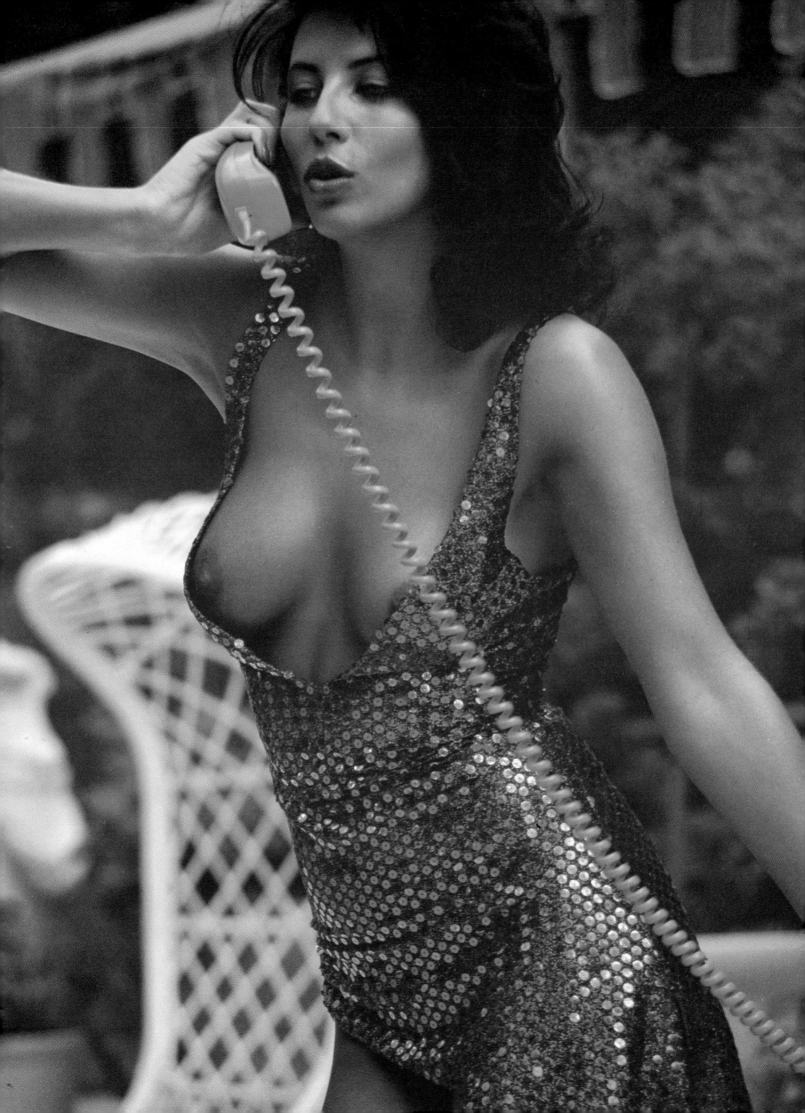

More elaborate costumes set a definite mood in a photograph (left). Here, the sequined evening dress and telephone suggest sophistocation and wealth. Keep color schemes simple – note how background vegetation, dress, telephone and eyeshadow are all in matched greens, and how the single note of color contrast is given by the complementary bright red of the lipstick.
85-210mm zoom lens, Kodachrome 25, 1/30sec at f5.6.

The model's 'tough guy' costume, with stetson hat, thirties suit, gaudy tie and cigar (above right) serve to emphasize her provocative femininity. The shot was used for a jigsaw puzzle.
85mm lens, Kodachrome 64, 1/60sec at f5.6.

Diving gear makes an attractive beach costume (right). Here, the headgear sheltered the model's eyes from the strong sun, allowing her to look openly towards the camera and keeping all her face in the shadow rather than just parts of it. A polarizing filter controlled the glare from the sea behind.
85mm lens, Kodachrome 25, 1/30sec at f4.

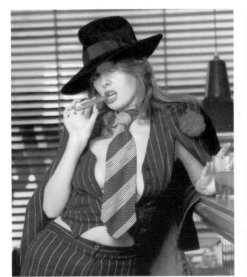

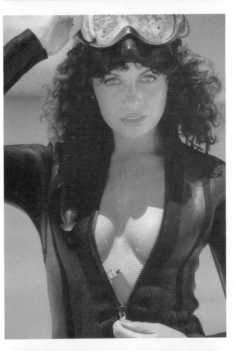

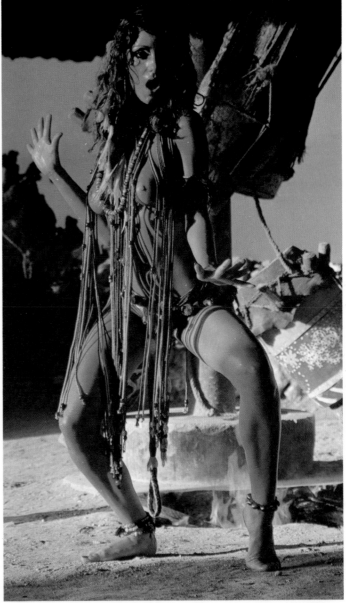

Although the backdrop is plain, with no complex setting, the cocktail and paper streamers combine with the model's pose and costume to suggest a wild party (right).
50mm lens, Kodachrome 25, 1/30sec at f5.6 with

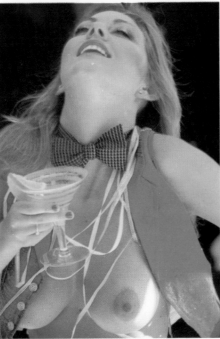

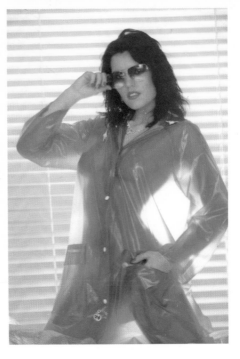

Single color costumes often make for the best shots (left), but be careful that strong colors do not reflect on to the model's skin and create unattractive color casts. Here, a green light was shone on the venetian blind to achieve backlighting to silhouette the model's body through the plastic, but the front lighting was white flash bounced off a reflector.
85-210mm zoom lens, Ektachrome 64, 1/60sec at f5.6.

Dressed and posed as a Haiti voodoo dancer (above), the model has really entered the role, producing an exciting and dramatic image.
85mm lens with polarizing filter, Kodachrome 25, 1/30sec at f4.

Coordination is important with jewelry. The combinations may be quite complex (right), here with the black beads matching the shawl, and gold rings, bracelets, necklaces and earrings going together. 85-210 zoom lens, Kodachrome 25, 1/60sec at f5.6, with spotlights behind and to the side. The simple necklace (below) is a key element in this shot, providing a focus of interest at the center of the frame. 85mm lens, Kodachrome 25, 1/60sec at f5.6.

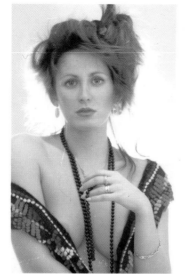

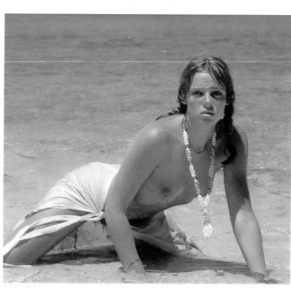

On location, keep an eye out for locally made craft jewelry (left). The model here is wearing a bead necklace bought from a nearby market stall. 85mm lens, Kodachrome 25, 1/60sec at f5.6. Jewelry does not have to be expensive (right). It need not even be jewelry in the conventional sense. This old policeman's whistle was chosen to complement the tent and camping equipment used as a setting. 85mm lens, Kodachrome 64, 1/15sec at f5.6.

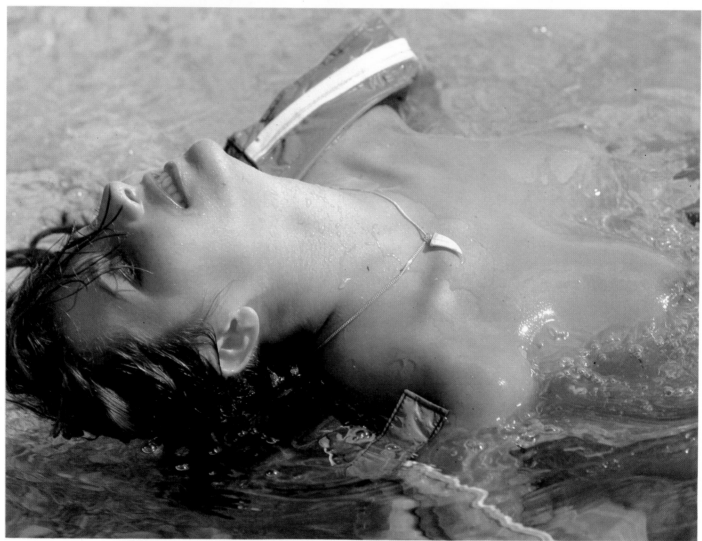

The depth of field is shallow in this extreme close-up using a macro lens (right), and the Star of David necklace in the model's mouth is the point of focus with 55mm macro lens, Kodachrome 25, 1/60sec at f5.6.

A toy deputy sheriff's badge (left) is the focal point of this humorous shot. Use your imagination in choosing and placing jewelry. Sunlight was used with reflectors on either side. 55mm macro lens, Kodachrome 25, 1/15sec at f5.6.

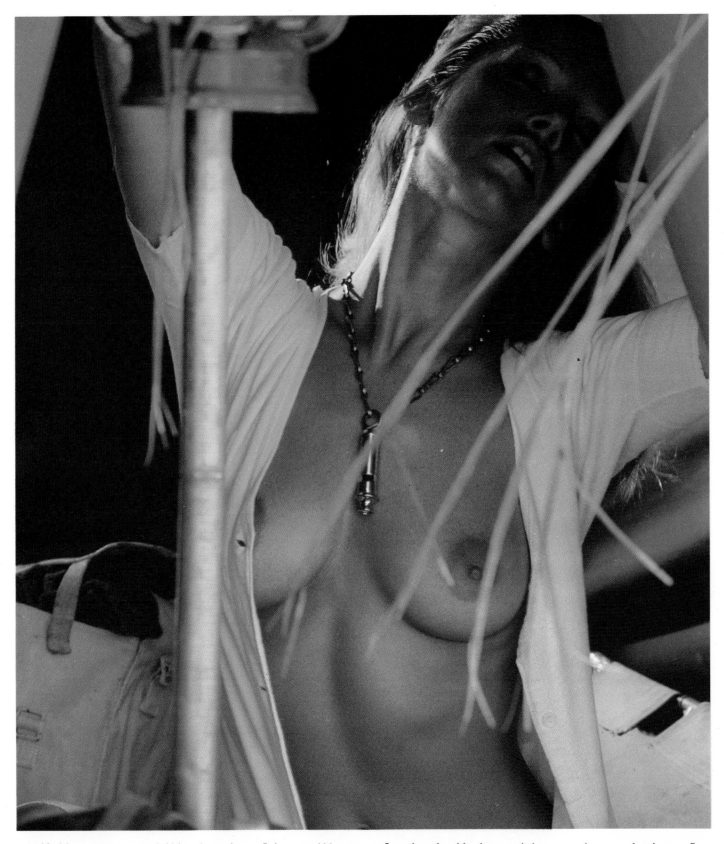

specific idea, get your model kitted out there. It is a good idea to have certain standard items in your wardrobe in any case, such as a gypsy outfit, gymslips, skin-diving gear, grass skirts and plenty of net and lace petticoats. Keep a file on costumes you have seen and liked and may be able to copy or improvize on.

Jewelry. Jewelry can be used to stunning effect and it need not be expensive to look good. A cheap dimestore badge, placed strategically and with humor, can sometimes work far better than million-dollar diamonds worn self-consciously.

Jewelry should adorn and decorate, but not dominate. One earring may be better than two, for instance, while you should never encourage your model to wear lots of rings, unless her hands can warrant the extra attention. A neckchain may look better round the ankle, while a double or single chain wrapped around the waist can look devastating against a sun tan. Put jewelry where you would least expect to see it – a gemstone in the belly button, for instance. Use your imagination – and the model's.

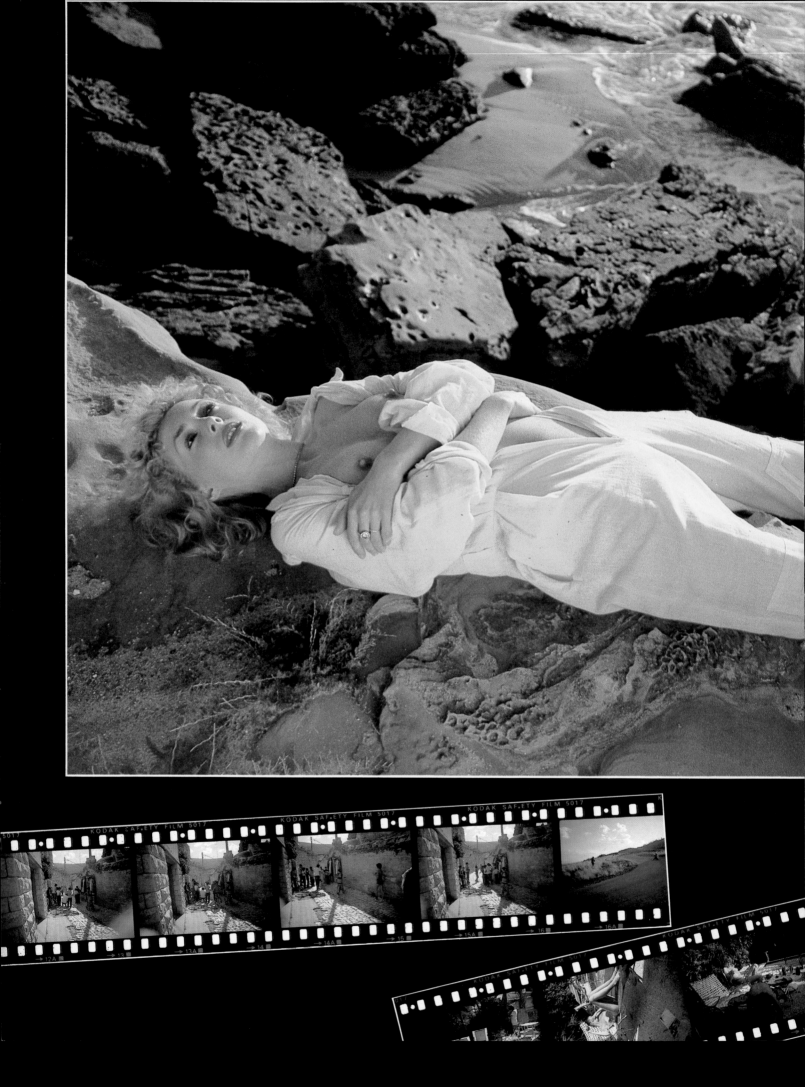

OUTDOOR GLAMOR

 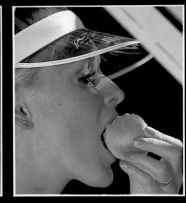

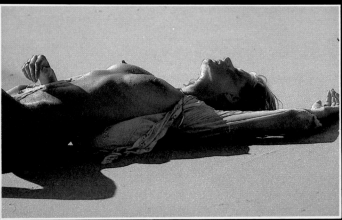

The range of outdoor locations is vast. It is this that makes the open air so good for glamor photography. The techniques are often simpler too. But success depends on an ability to spot and use locations and an understanding of how to use natural light.

Lighting conditions

THE ONE CONSTANT aim in glamor photography is to make your model look her best. Shooting outdoors in natural daylight is often the best way of achieving this, provided, of course, that the light, location and the weather in general are favorable to the end result. Consider the requirements of your photographs carefully. If a special background is essential, your starting point must be the location. If, however, your aim is simply to suggest a certain mood or situation, you can go as far as your creative imagination will take you in your own back yard.

One particular factor you must consider is the question of privacy. A combination of beautiful models and a photographer laden with equipment invariably attracts attention. If you intend taking nude shots, it is safe to say that you will need total seclusion. Even if nudity does not bother you or your model, there is a fair chance it will bother someone else.

WEATHER AND LIGHT

Weather and light are vital factors in all outdoor photography. Both are constantly changing – either for climatic reasons or because of the time of day – and it is important to cultivate an awareness of this in order to adjust your techniques accordingly.

On a clear, cloudless day, for instance, the sunlight is strong and will cast sharply defined shadows; on a slightly overcast, or hazy day, the sunlight will be less intense and the shadows correspondingly softer. If the weather becomes progressively more overcast, the proportion of direct light is reduced still further and the shadows will be light in tone and indistinct in outline. When the weather is heavily overcast, the sunlight is diffused and therefore there are no real shadows.

Light also changes in quality according to the time of day. The early morning sun is low, throwing a warm, soft light and casting long, ill-defined shadows. The light at this time of day changes rapidly, becoming stronger and more constant as the sun rises, eventually reaching its zenith at midday. At this point, the light is flat and formless, with hard, deep shadows.

As the sun starts to set, so the light becomes softer, eventually tapering into dusk, when light conditions are much the same as at dawn. Although moonlight appears to possess a different quality to sunlight, it is no more than weak reflected sunlight.

CHOOSING THE TIME OF DAY

The best time of day for photography depends on the effect you want to produce. Many photographers, for instance, try to avoid light at high noon whenever possible and utilize the magical and beautiful quality of light reflected at dawn or dusk instead. Low sun is highly directional and permits a variety of lighting effects – from flat, full-face light to back lighting. Pose your model in various positions until you find the most suitable angle. In addition to a normal light meter reading, you should also take a reading with a spot meter. This type of light can be very deceptive.

Back lighting can also present a problem in these conditions, since it is easy to create unwanted silhouettes. Avoid this by

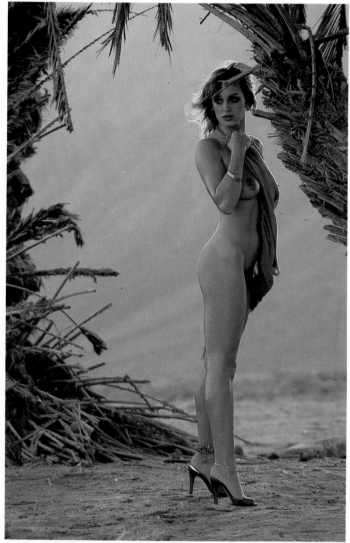

Some of the very best shots are taken without strong sunlight (above). All the elements in this shot contribute to its soft unity and quiet mood. The light, late in the afternoon, was cool, veiled by the trees, but still created a beautiful warm halo for the model's hair and down the curve of her back. The purple scarf and blue shoes match the quality of the light perfectly. Finally, a long telephoto lens was used to compress the perspective, making the cool grey of the mountains into a complete backdrop, almost like a studio curtain.
300mm lens, Kodachrome 25, 1/30sec at f5.6.

Early morning is one of the best times of day for photography – this shot was taken at seven in the morning (right). The sun is low in the sky, bathing the subject in bright but softened light from one direction, emphasizing the rounded forms of the body.
85mm lens, Kodachrome 25, 1/60sec at f5.6.

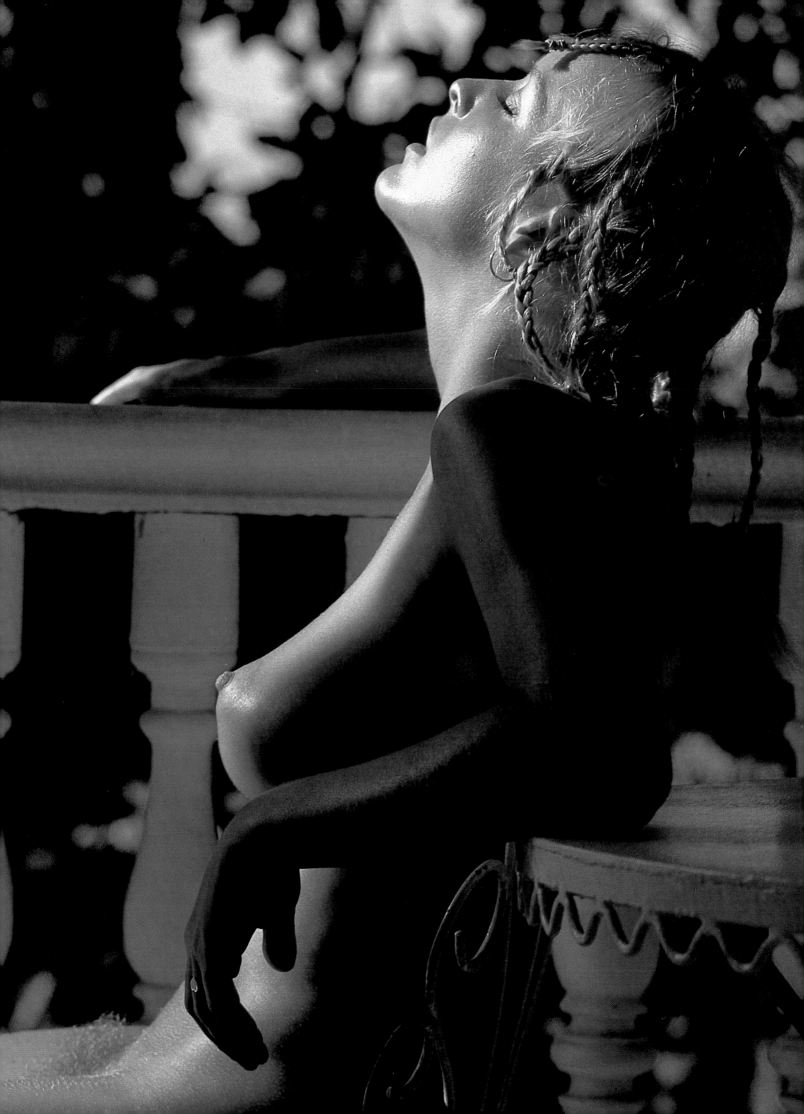

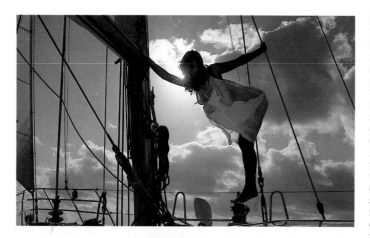

During the morning, before the sun has risen too high in the sky, the model can be silhouetted against it quite effectively (left). The main difficulty is flare, where light reflects off the surfaces of the lens and degrades the image. Here, the photographer waited until the sun was just coming out from behind a cloud and this reduced its glare. The controlled amount of flare over the model's shoulder actually adds to the impact of the shot.
28mm lens, Kodachrome 25, 1/60sec at f8.

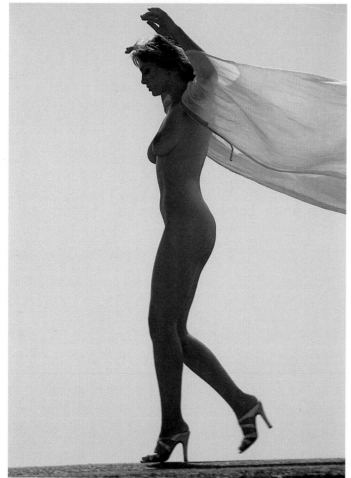

In the strongest sun of the middle of the day (below), the shade may be the best place for the model. The bamboo umbrella threw attractive patterns of light and the blue water provided some color in the background.
85mm lens, Kodachrome 25, 1/30sec at f5.6.

The bright sky in the middle of the day can be used for silhouettes, with the high sun out of shot (above). The model walked along a raised road, with the photographer in a ditch to achieve the low viewpoint used to isolate the subject.
300mm lens, Kodachrome 25, 1/60sec at f8.

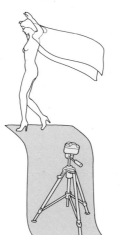

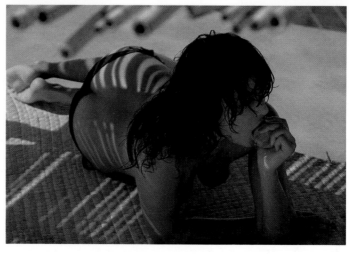

Sunsets make superb backdrops for glamor photography (above). Their warm light creates a mood of romantic fantasy particularly on a beautiful beach with the sun going down behind the sea. It is difficult to judge the exposure for this type of silhouette. Bracket over two or three stops.
300mm lens, Kodachrome 25, 1/30sec at f8.

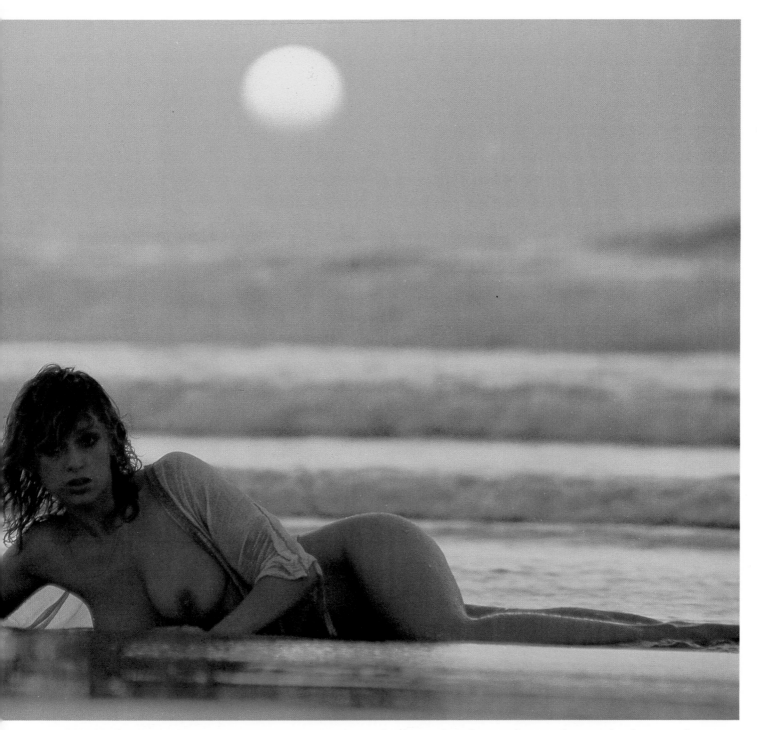

exposing for the darkest areas. If, however, your intention is to produce a silhouette, this is the time of day when results will be the most successful.

Shoot into the sun, or use it as side lighting for portraiture; if, however, you choose the latter method, be sure to take a meter reading in the shadows. If shadows are underexposed, the end product will be dark, with loss of detail and subtlety. If the face is brightly lit, try to balance this with use of shadow to soften the effect.

There are also instances when the bright overhead light of the midday sun can be used extremely effectively. Colors are exaggerated against the background of a dark blue sky to appear richer. If, for instance, your model has a sun tan, the skin will photograph darker than it actually is. A single, brightly colored accessory or carefully arranged garment can be used to good dramatic effect to create contrasts. This particularly applies to sunglasses and sports vizors. Not only do they give real protec-

tion against the sun, but, used correctly, they can also create attractive shadows on your model's face.

Always be aware of shadows and where they fall, taking advantage of any that can be used effectively. It is easy to capture a variety of tones in the shade if you calculate exposure correctly. If necessary, brighten the shadows with a reflector or a fill-in flash.

A reflector positioned just out of the picture area seen through the viewfinder will fill in shadow without adding more light. A hand mirror can be used but the effect will not usually be very subtle. Weaker reflections can be achieved by using crumpled foil glued to card. The most unobtrusive reflections require plain white card or even black card.

Most photographers agree that it is difficult to preserve a natural feeling in the picture when flash is used. If you keep the maximum output of the flash to one-half or even less of the recommended setting, the flash output will not dominate.

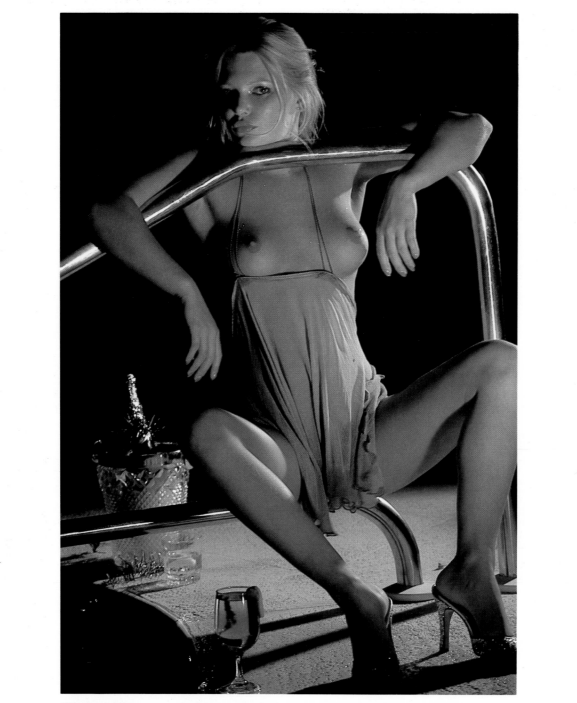

This shot used photographic lights (above) but in such a way as to keep the effect of night. Cables had to be run from the house out to the pool to power the two spotlamps used. One was placed in front and to the right, shining directly on the model; the other behind to give stronger backlighting and create the long shadows that are a key feature of the shot. It was a dark night and all other lights were switched off.
85mm lens, Kodachrome 64, 1/15sec at f5.6.

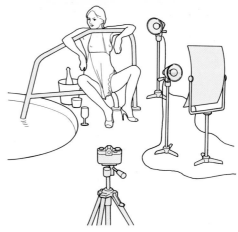

SHOOTING AT NIGHT

You can achieve stunning and unusual effects when shooting at night by using the available light and capitalizing on shapes and patterns. The country by moonlight assumes velvety tones which would be spoiled by using flash. Floodlit areas and pools of light from lamps or electric signs in towns can sometimes throw enough light to produce some·startling results, especially if you capture the essential excitement of night life.

Look for special features when you are shooting at night, such as silhouettes and patterns in iron constructions. Bridges and piers, for example, take on a completely new dimension at night. When you are composing your picture, take account of the horizon – a tree that looks rather ordinary in daylight may possess quite different qualities at night. Reflections at night can often be quite dramatic, whether they are the bright flashes of a neon light or moonlight reflected on the water.

If you decide to shoot on location, study the available light before you use flash. You are unlikely to find yourself in a situation where it is pitch-black. Make use of a full moon on the beach or in the country; in towns you will often find adequate light thrown out by restaurants and shops, street lights and car headlamps.

A high speed film and a large lens aperture (f2.8 or larger) should be used for such shots. Do not rely upon a through-the-lens meter because the readings are unreliable and will not register general illumination. Keep your model in the foreground as much as possible because focusing may be difficult in these conditions.

If flash is used, it is best separated from the camera. You can choose between a flashbar which fastens the flash unit to the camera, or, ideally, a handheld unit or a separate stand. You will need to experiment if you are handholding the flash. Generally, however, remember that the higher you hold the unit, the more the shadows will resemble those created by sunlight or ceiling lights. The further to the left you hold the unit, the more shadow will be formed on the right of the subject and vice versa.

Direct flash tends to give a hard light and create dark shadows. A natural look can be preserved in flash photography in the studio by bouncing the light of the flash unit off the ceiling. A bounced flash will eliminate shadow and give a softer light. You can either direct the flash at the ceiling or invest in an automatic flash unit with a tilt head.

NIGHT SHOTS

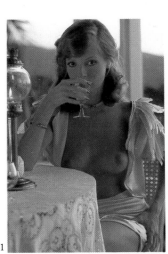 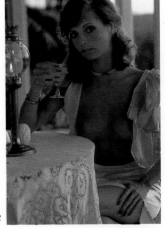

1 2 3 4

As evening falls, the sun goes down rapidly and the light changes can be quite dramatic (above). The first three shots in this sequence were taken over only about ten minutes. An 85mm lens was used, with Kodachrome 64 film. Note how the daylight reflecting off the walls of the verandah at first covers the whole model (1) with the light from the candle looking quite insignificant (1/15sec at f5.6). In the second picture, the reflected light is much reduced (2) and the shadows are deeper and the candlelight more prominent (1/15sec at f5.6). Only a few minutes later (3), the sun began to go down and the reflected light disappeared. The sun's light is directional and has a higher color temperature, giving an orange glow to the subject. The candlelight is now strong enough to contribute to the shot, filling in the shadow on the model's cheek. It, too, has a high color temperature (1/8sec at f5.6). Half an hour later (4), the evening light is barely adequate. Most of the light now comes from the candle (1/8sec at f4).

Live from Las Vegas (right)! Shooting by available light in cities at night is not commonly possible in glamor photography. The model aroused quite a lot of attention from passers by as this shot was taken – even in Las Vegas, where they have seen everything. The whole operation had to be completed very quickly, so a motor drive was used to shoot a single roll of film. A variety of light sources contributed to the shot, and the fluorescent light most commonly found in such circumstances gives a blue cast to the model's skin. In this case, it helps create the dream-like quality of the shot.
85mm lens, Kodachrome 25, 1/15sec at f5.6.

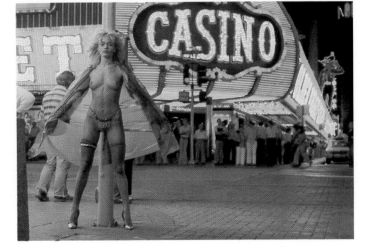

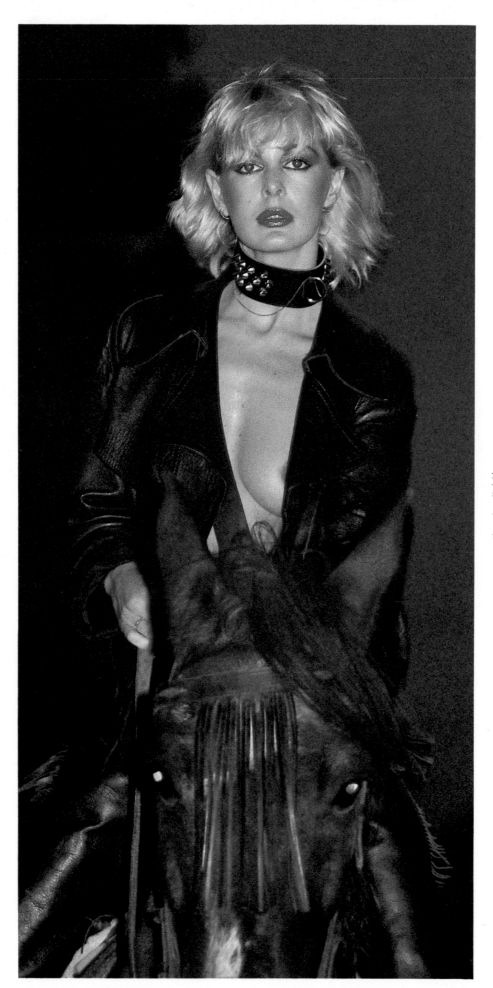

Portable flash occasionally produces remarkable results – especially when a special effect is required (left). This shot was taken on horse-back at night in Majorca, using a handheld camera with the flash mounted on its hot shoe. The black horse and the black leathers all add to the strangeness of the image.
85mm lens, Ektachrome 64, 1/60sec at f5.6.

The hard lighting possible at night (right) can be very effective. Using a single tungsten spot, with a filter fitted to the lens for color balance, this shot with the model's eyes peeping through a lifebuoy is made really dramatic.
85mm lens, Kodachrome 64, 1/15sec at f5.6.

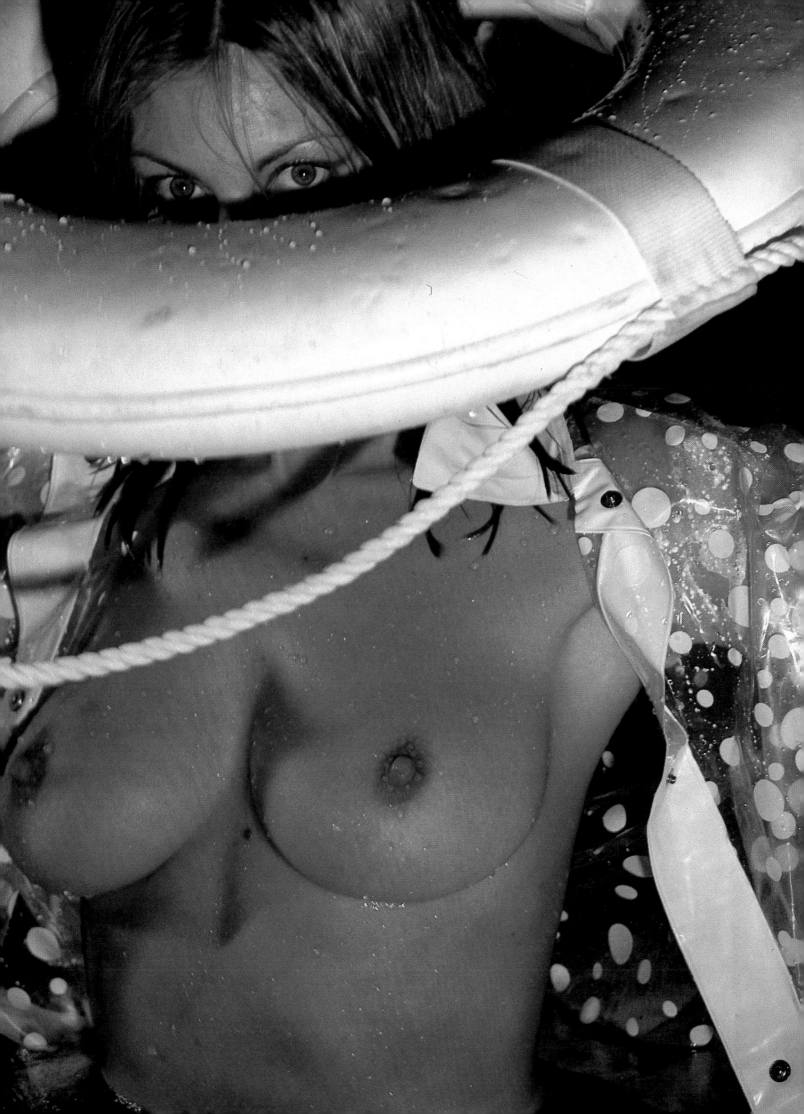

Location shooting

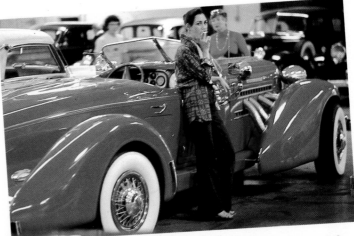

WHEN THE MODEL ARRIVES, be as friendly and welcoming as you can. Remember that this is glamor photography and it is essential for your pictures that she looks as relaxed as possible. Bear in mind, too, that most human beings feel vulnerable when they take all or some of their clothes off. If you are doing a beach shot, for example, try and make sure that you have not selected the busiest part of the promenade.

The model should take off her clothes as soon as she arrives and slip on a loose robe. Unsightly marks caused by underclothes will not enhance any picture. If you are shooting in a hot climate, try and pick a suntanned model to avoid the risk of your model being sunburned on the first day. (Never risk using a model whom you have not seen: ask for her portfolio or 'Z' card first. Even if the model is shapely and healthy, she may not be the type of woman you had in mind.)

Do make sure that the model is warm enough; apart from the fact that it is difficult to relax if you are shivering, goose pimples are not attractive. Once in front of the camera, explain to the model what sort of shot you envizage and discuss poses and arrangement of the props.

Some professional models are easy and relaxed in front of the camera. They will know straightaway what you are trying to achieve and make positive suggestions for a successful end product. Some models, however, have all the potential for successful glamor photography but need to be relaxed and coaxed into the session. It is the photographer's job to generate enthusiasm and persuade the model to respond to him and the camera. It is not always enough to instruct her to 'look haughty': tell her she is a medieval tyrant queen faced with a traitor.

Apart from judging composition and lighting, test shots are an invaluable part of relaxing and directing the model. Take as many as you need to show the model what you want to achieve, and encourage her to take the initiative. You should try and be sensitive to the model's mood: if she is obviously getting tired, break and have some refreshment. If you treat your model well, you will probably be surprised and pleased with the results.

CHOOSING THE LOCATION

Finding the best location demands an anticipation of practical matters just as much as an eye for a picture. A day will have been lost if, for example, you find that you are not allowed to shoot in the selected spot.

When you have selected a potential location, first check that there are no unusual hazards and that no one objects to your shooting. Visit the location at different times of day and make notes about any lighting problems, the horizon, special features (such as hedges, trees, ponds, buildings) and on a record card note the features that you consider undesirable. These may include pylons, hoardings, or smoke stacks, for example. Take test shots and attach them to the record card.

Your record cards can be built up into an indispensable source of reference if you note details of locations not only for a particular assignment, but each time that you discover a potential location.

Locations should offer visual interest and also some sort of special atmosphere. These examples show the kind of thing you could look out for. A car showroom, specializing in classic cars (top), a luxurious boat (above left), a fountain in Beverley Hills (above) and a restaurant decorated in the style of the 1900s are good examples.
A beautiful mansion in Florida, rented for the session, offered superb settings (right). The poolside view was given added dimension by the classical pillars framing the model and the tropical vegetation in the background. 28mm lens, Kodachrome 25, 1/60sec at f5.6.

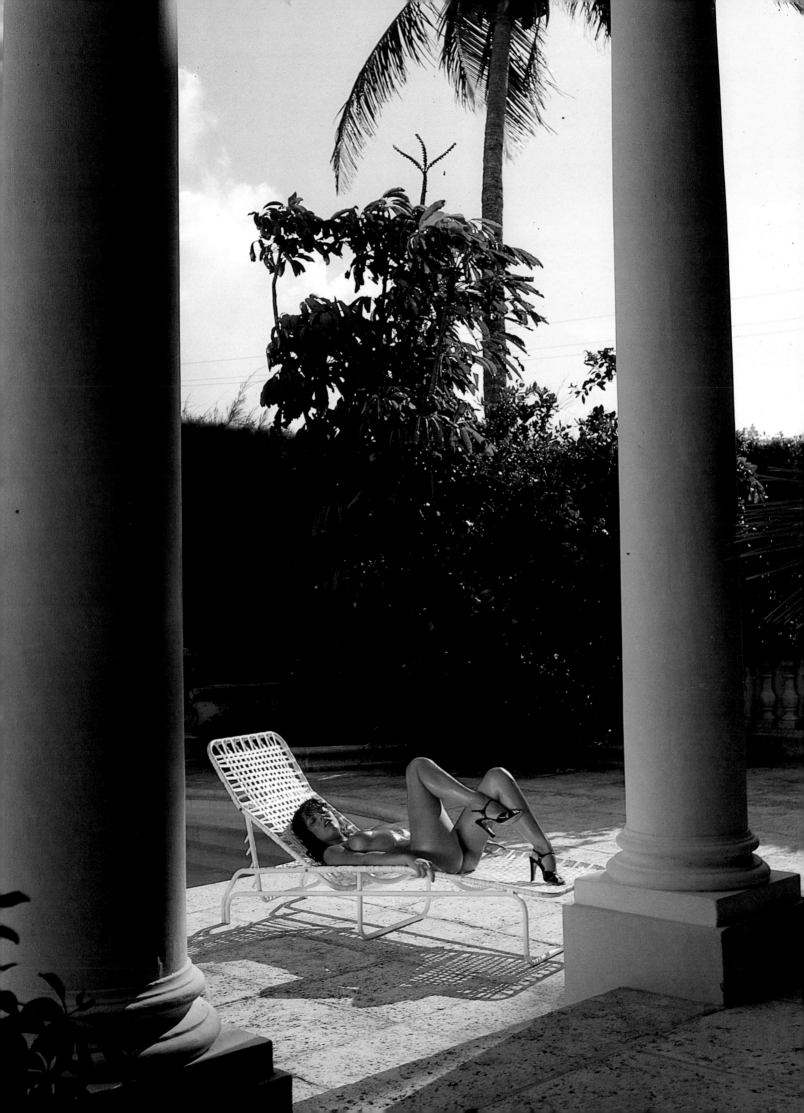

Spontaneous shots of the model behaving naturally in an ordinary location can be very effective (bottom right). The props were carefully chosen, however, with the shorts matching the color of the beach telescope.
28mm lens, Kodachrome 25 1/60sec at f5.6.

Keep your eye open for good backgrounds in a location (below). This mural, for example, could be used in a straightforward way to add interest to the shot. Because it had complicated colors and shapes, the other props were kept simple
35mm lens, Kodachrome 25, 1/30 sec at f5.6.

A tennis club was a good location (bottom). Here, the model sitting in the umpire's chair was shot from below, to achieve a simply sky background. It was important that the floodlights were on, not for illumination but to add interest.
35mm lens with polarizing filter, Kodachrome 25, 1/30sec at f5.6.

Having found this beautiful mansion (right) as a location, all that was necessary was to find suitable ideas for the individual shots. The model dressed as a bizarre and sexy chauffeuse was a good solution.
35mm lens, Kodachrome 25, 1/60 sec at f5.6.

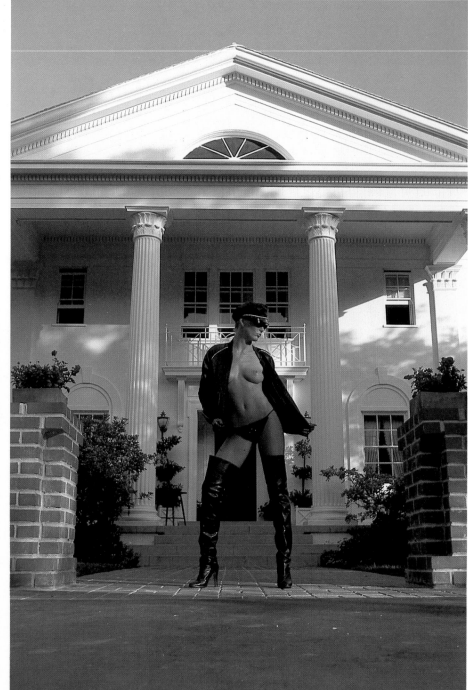

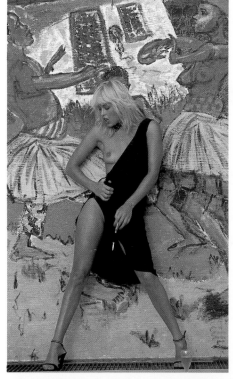

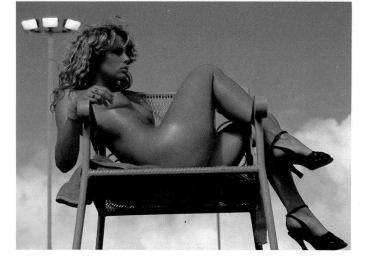

This sort of record-keeping will not only reinforce your interest and commitment to good photography but play a part in developing a good eye for a picture. When you are actually shooting, training of this nature helps you to make immediate decisions.

As the model will be the focal point of your picture, check before you make your final choice that the location is not too 'lively'; too many points of interest will tend to dominate the picture, so that the composition will appear muddled

You may not always have to go too far afield for the right location. Your own house or back yard may offer possibilities for good photography. Keep a lookout for the houses and gardens of friends and note particularly balconies and swimming pools, both of which make excellent locations for glamor photographs.

If you know anyone with an airplane, motorcycle or automobile that has strong visual impact, ask them if it can be used in one of your photographs. They will probably be happy to offer it.

Having selected your location, assessed any problems and resolved practical questions, try and use the site to the full. Consider natural framing devices such as door frames, arches or the curve of a bridge. Any feature should be used to best advantage, so experiment with unusual camera angles and exploit reflections and silhouettes.

EXOTIC LOCATIONS

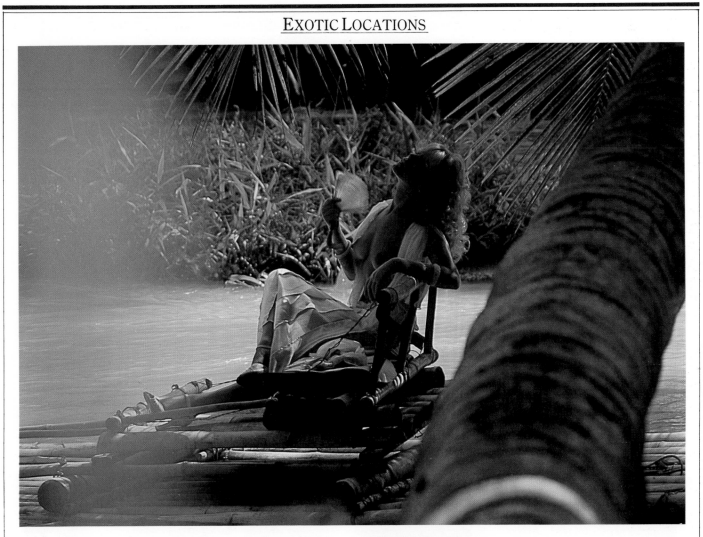

Locations that are truly exotic will probably require considerable time and expense to reach, but it is worth bearing in mind that there may be several beauty spots quite near you which look far from ordinary. It does not matter where you are in reality if the picture succeeds in evoking the mood you wish to create.

When you are looking for this sort of location within a reasonable radius of your home, look out for any stretch of water, whether it is sea, river or lake, that has inlets, coves or secluded corners.

As few of us live in really exotic places, the information concerning such locations is in the section on professional glamor photography (see p. 140).

Shooting through the foliage of Jamaican forest (above) created just the jungle effect. 85mm lens, lKodachrome 64, 1/60sec at f4.
A coconut plantation provided this surreal location (right). A long focus lens was used to keep the crowds of curious onlookers out of the shot, but the dust they stired contributes to the weird quality of the location. 300mm lens, Kodachrome 25, 1/125sec at f5.6.

This superb location (right) was discovered by chance while in Israel. Keep an eye open for likely spots when on your way to the planned site – they may turn out to be even better than the place you are aiming for. Here, the model leant against the fantastically weathered rocks and the shot was taken with a long-focus lens from about 40 yards so that the compressed perspective would make the mountains a complete backdrop. 300mm lens, Kodachrome 25, 1/60sec at f8.

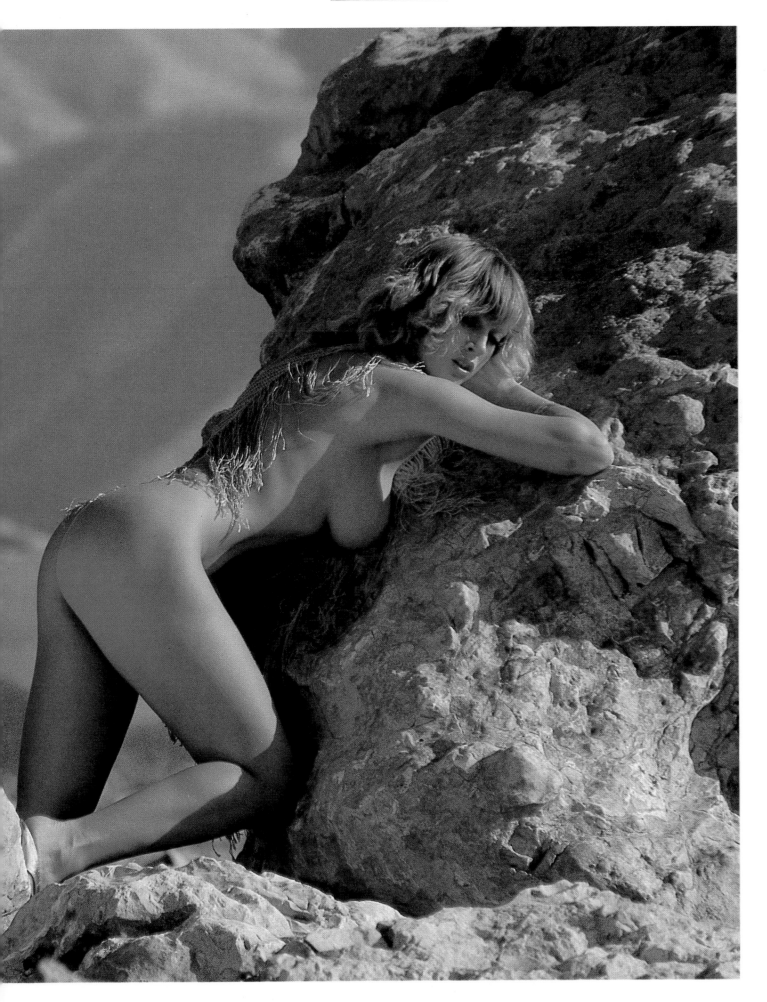

Think out the shot in advance and define the mood that you wish to create. The session should be planned in as much detail as possible, so that any hitch is not compounded by bad organization. You should bear in mind particularly the props and accessories and what you would like the model to wear.

IN THE BACK YARD

Although beautiful and exotic locations can provide stunning backdrops for your pictures, glamor photography is primarily about women. If you couple a sound knowledge of your subject with enthusiasm, you will find that it is possible to take good photographs under most circumstances.

You will find it helpful if you start in familiar surroundings with a model you know reasonably well. You will then have fewer unforeseen problems.

One of the easiest locations to consider for a first photographic session is your own back garden or patio. If you do not have one or it is not suitable, then that of a friend who will leave you to get on with the assignment will do equally well.

When you are selecting the location, look for any details that will provide an interesting background. Remember that your model could be standing, sitting or lying down, and so bear in mind that details other than those at eye level should be checked. Consider as many camera angles as possible, using as many different lenses as you have access to. When taking a portrait, it is often preferable to have a very shallow depth of field, focusing on your model so that the background is blurred. If you use this method, almost any background will prove satisfactory provided that the colours are neutral.

When shooting pictures in your own back yard, make sure that any domestic or suburban elements which would detract from the glamor of the picture are excluded. Examples of these include fences, common flowers and clothes lines. The trees and shrubs in your back yard may be rather ordinary, too, so it would be preferable to use a shallow depth of field so that they are blurred. Tropical pot plants, provided that the pot is not within the picture area, give a feeling of the exotic and can be placed in the foreground around the model.

ON THE TRAMPOLINE

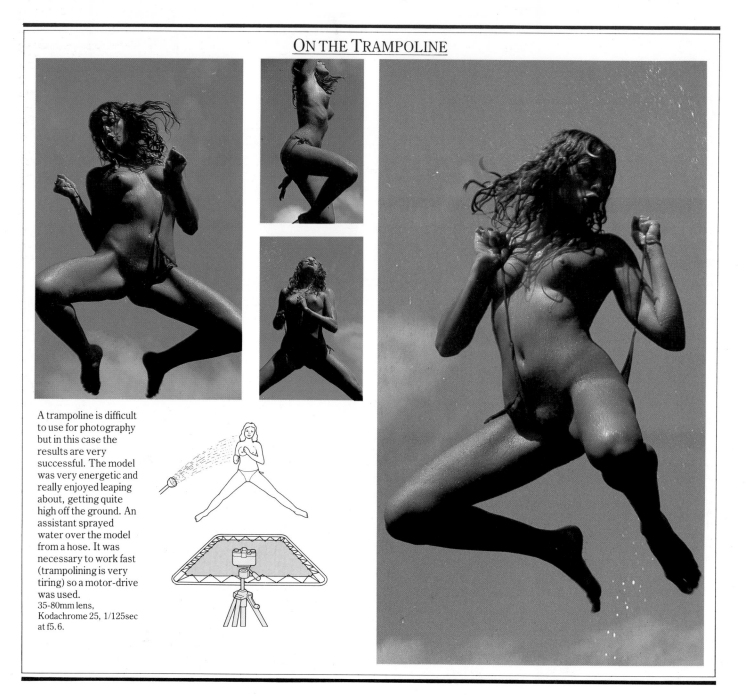

A trampoline is difficult to use for photography but in this case the results are very successful. The model was very energetic and really enjoyed leaping about, getting quite high off the ground. An assistant sprayed water over the model from a hose. It was necessary to work fast (trampolining is very tiring) so a motor-drive was used.
35-80mm lens, Kodachrome 25, 1/125sec at f5.6.

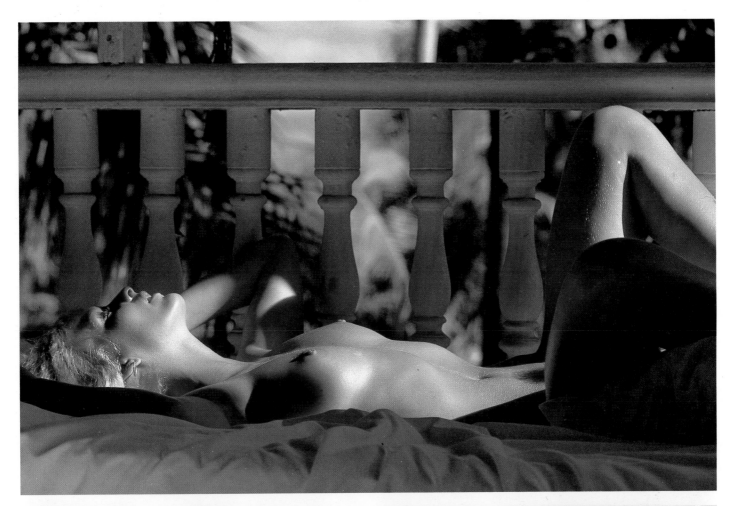

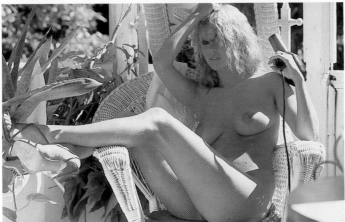

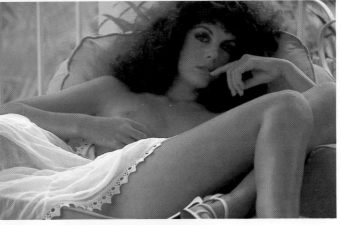

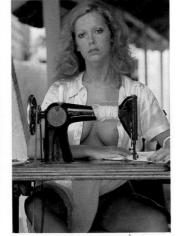

The back yard is all you need for a location – particularly with an attractive balustrade and leafy plants (top). A shaft of sun coming through the trees lit the model.
85mm lens, Kodachrome 25, 1/30sec at f5.6.

An early morning shot on the patio (above left) strikes a pleasantly informal note, with the model drying her hair. If the chairs and woodwork had not been all white, the setting might have looked confused.
85mm lens, Kodachrome 25, 1/60sec at f5.6.
Skilfully framing makes a garden plant look like a jungle location (right).
85mm lens, Kodachrome 25, 1/125sec at f4.

Low light under a cloudy sky on a late afternoon (above right) gave good color saturation to this shot, with the white petticoat contrasting effectively with the warm orange cushion and the model's tan.
85-200mm zoom lens, Kodachrome 25, 1/15sec at f8.
An old sewing machine moved to the patio (left) gives a shot added interest – even a nostalgic atmosphere.
85mm lens, Kodachrome 25, 1/15 sec at f5.6.

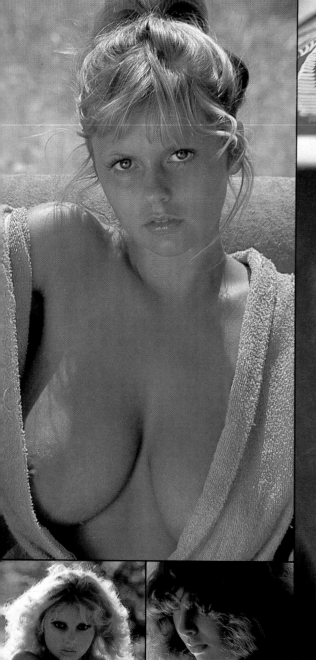
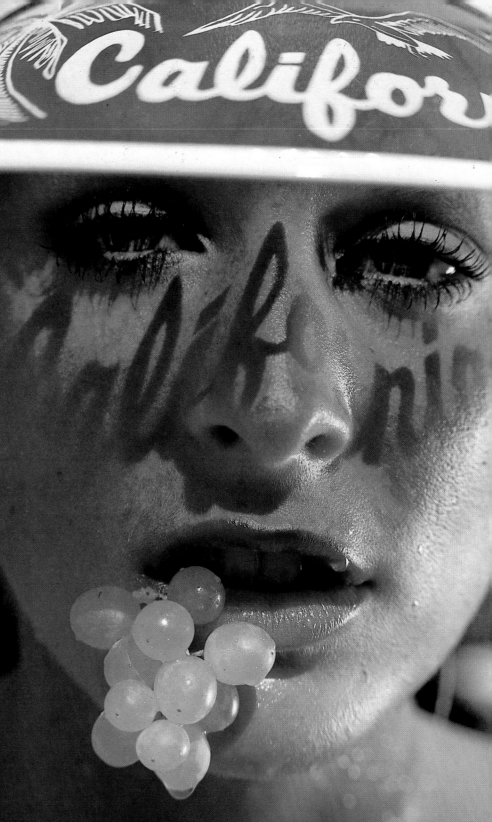
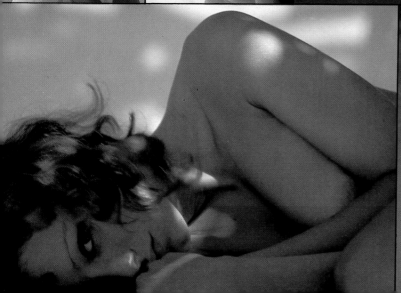
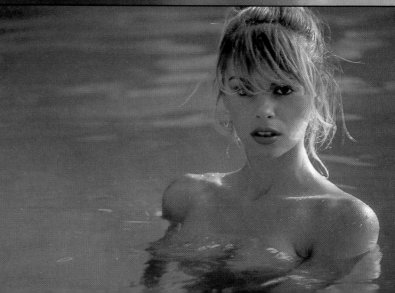

PORTRAITS

Lighting is the single most important factor in portrait photography. When used correctly, daylight can prove the kindest and most flattering light to the face. This is especially true if you wish to project a strong sense of natural beauty.

Even the most professional of models may find the camera inhibiting at first, so do everything you can to make her feel comfortable. You may find it helpful to use a long lens so that you can work at a distance; working in this way, the model will probably feel more relaxed and therefore more likely to vary her expressions and poses. Any tension in the model's face is nowhere so apparent as in a portrait.

The camera tends to magnify any tension as it does the elements that make every face individual. Build on these elements so that you draw out each model's particular characteristics and personality. It is worth studying the model's face carefully and deciding which side is the most photogenic. If she has well-balanced features, she may be able to take a straight-on shot. It she does not, and you nevertheless want a full-faced portrait, draw in as close as possible, so that the picture is tightly framed. You will discover that this method will produce some very dramatic photographs, particularly if the girl has beautiful eyes or a sensuous mouth.

If you find that the model tends to narrow her eyes when she looks directly into the camera, suggest that she lowers her head slightly and looks up. A slightly low camera viewpoint will shorten a longish nose, and will also improve the appearance of a narrow chin or prominent forehead.

The other advantage of using a long lens for portraiture is that it will soften forward projections, such as the nose. By focusing on the eyes, the viewer finds himself drawn into the picture. Focusing on the lips enhances the sensual quality of the model.

The essential factor to remember in choosing the background is that it should be a neutral colour. The background in a portrait must not detract from or dominate the model.

CHOOSING A THEME

A theme gives a framework to work within and you will probably find this helpful at first so that you can concentrate on the more technical aspects of glamour photography. As time goes by, you may find this method of working a little restricting, but at least you will be able to focus on one idea and explore all the possibilities.

Your model will be an essential factor in determining the theme, so discuss different ideas with her and find out what she enjoys doing. If she is the sporty type, she may look good in tennis or riding clothes. Alternatively, she may enjoy water or playing around on a trampoline. If you discover that she naturally inclines to being more passive, try her playing cards, reading a book or simply sunbathing.

Closing in on a beautiful model's face (left) can produce results every bit as alluring as the whole figure.
1 Lighting is the most important element. Avoid hard shadows.
2 Backlighting gives an attractive halo effect to the hair.
3 Three-quarter views with the model looking away from the camera can have a restful, romantic feel.
4 Look for unusual angles – here the model is lying down, with light reflecting back from a white floor.
5 For close-ups on the face, use lenses with longer focal lengths to keep the nose in proportion.
6 The rich blue of the pool provides an ideally simple background for this delightful shot. Backlighting with natural fill-in from reflections off the surface of the water contribute to the effect.

1		5
2	3	
4		6

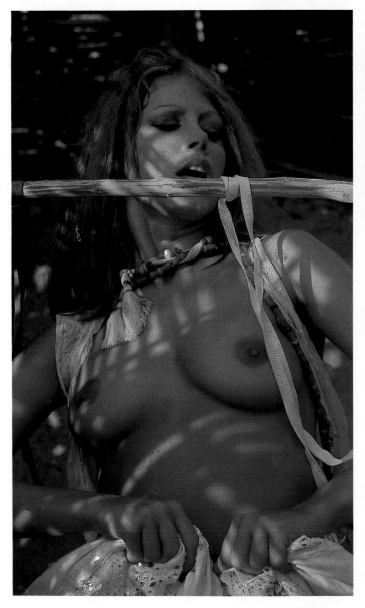

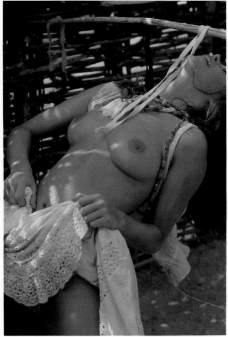

The assignment called for limbo dancing (left and above), so a genuine West Indian location was found. The model had to learn the dance for the shot and plenty of music was played to help her into the mood. The costume was chosen to suggest the vigorous movement and the heat and energy of the dance were made more apparent by coating her skin in baby oil and spraying it with water. When photographing movement with a necessarily slow shutter speed, look out for the natural pauses in the movement – the technique was used here quite effectively. 85mm lens, Kodachrome 25, 1/30sec at f5.6.

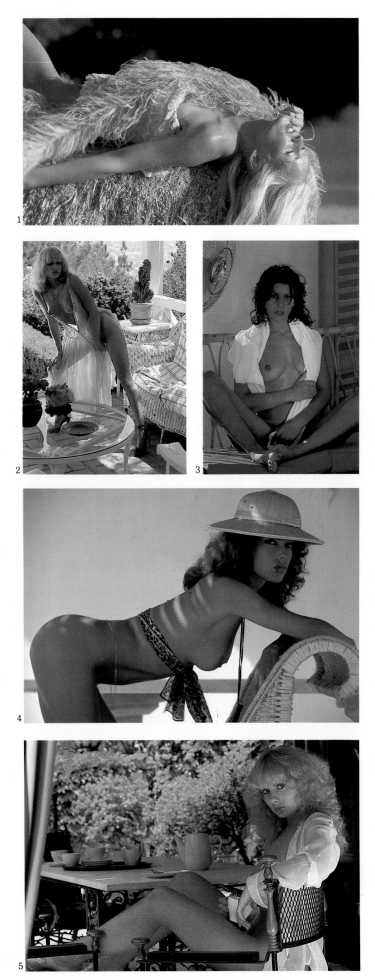

DESIGNING THE SET

A shot taken in your back yard will obviously not require such elaborate set design as, for instance, a shot in a studio would. The two main points to bear in mind are the disguise or elimination of any undesirable features, such as the domestic surburban elements mentioned previously, the best use of anything intrinsic to the landscape and the addition of furniture and props.

Realism in a photograph is achieved by capitalizing on the existing features, which might include a tree, porch, steps, arches or windows. A porch or an arch, for example, very often works well as a natural framing device.

Before you add furniture or props, think out the type of shot you are taking and, in particular, the feeling or mood you wish to create. It is worth discussing this with your model in advance, to choose a theme and ask her to dress accordingly.

CLOSE-UPS

A close-up can be of any part of the anatomy, but, as with portraits, it should fill the frame and possess a single component that draws the viewer into the picture. The visual impact can be created by adding a single item, such as a piece of jewelery or a flower, or by the juxtaposition of one part of the body with another: the hands could be placed on the knees, for example, or the arms folded across the breasts.

Some very striking photographs can result from drawing attention to one particular aspect of your model. The important thing to remember when photographing close-ups is that by isolating a detail, you are conveying texture and the feeling of touch. Ensure that your model has the sort of skin that bears the scrutiny of a close-up. It must be soft and smooth, without blemishes or goose pimples. Colour is not significant, although it would be difficult, for example, to convey a healthy, natural look with a really pale model. Body make up and baby oil will invariably improve skin texture.

The key factor when designing sets is to keep them simple.
1 A bale of hay was all that was needed, with the background plain and out of focus. The golden hair and feather boa complete the unified color and textural scheme.
2 A well kept patio makes a good location. Make sure everything is tidy and remove objects that will not contribute to the shot.
3 Well designed rooms or balconies make good sets. Here, the cushions match the walls and shutters.
4 The safari look! The cane furniture seemed suited to this idea, particularly with the sun hat and leopardskin scarf added.
5 For this 'breakfast' scene, white was used for all the props – table top, coffee set and blouse. Early morning daylight was sufficient, with a gold reflector by the model's elbow.

Right: Never neglect close-ups – make them a part of every session, to balance shots of the whole model, portraits and wider frames that include the setting.
1 For this shot to advertize a cigarette lighter, the lighter had to be the focus of attention. Closing in on the model's cleavage, with the black diving suit and red lipstick matching the color of the lighter, achieved the desired result.
2 The forms of the body contrast effectively with the flimsy material, creating a softly erotic effect in abstract.
3 Almost the same composition has a quite different mood with the addition of some sexy underwear. Here, the contrast is between the crisp bra, pants and warm skin.
4 This spontaneous shot was taken during a break in the photography, when the

model was absorbed in a book. Closing in on the face, arm and knee created an interesting composition.
5 & 6 Two similar shots show the advantages of careful composition in close-up work. The left hand picture has too many elements, with the knee intruding at the bottom of the frame and the neck cut off just below the chin in an unsatisfactory way. The right hand shot, however, has none of these distractions, just the gentle angle of the arm and elbow and curve of breast and hip. A flash of color is added by the delicate blue of the bracelet.

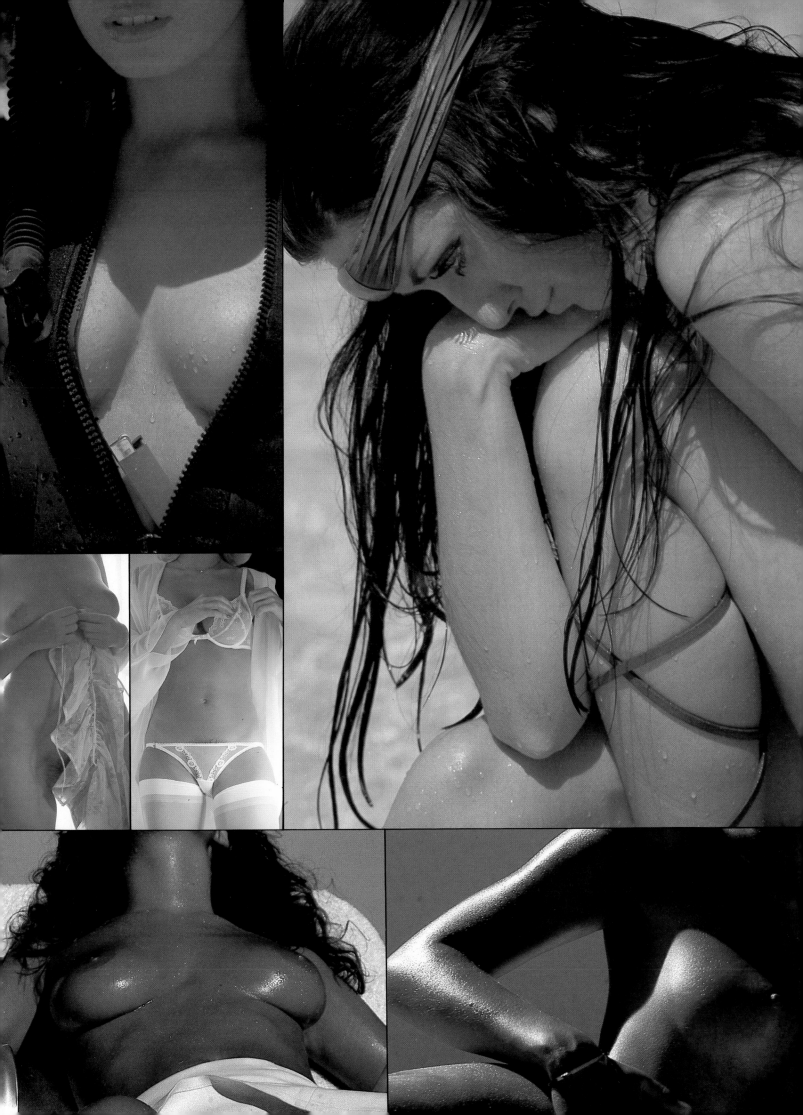

On The Balcony

Private balconies with a view can often prove to be interesting locations for glamor photographs. The position of the camera will obviously be restricted, but you can experiment with different lenses, shooting from all angles until you have found the most suitable combination. If you are shooting the model on a low balcony, you could experiment with shooting from the ground using a zoom lens.

The landscape will tend to dominate the photograph unless you are concentrating on a close-up, so it is important to assess it. Height usually suggests danger and will also lend the model an aura of aloofness, so do exploit these factors if the balcony is a high one. If the backdrop is a busy street with a lot of detail, your model will appear to be part of the scene, which in nude shots can be particularly dramatic. Balconies in hotels or blocks of flats often provide enough privacy, while creating an intimate atmosphere.

In Public

The need for privacy when taking glamor shots cannot be overemphasized. You have to contend with the reactions of the public as well as reassuring the model. However, a photograph that has obviously been taken in a public place, suggesting everyday activity, has an essential excitement. Main streets, promenades, motels and car parks are all locations that can convey such a feeling if they are used imaginatively.

The best results when taking glamor shots in a public place are usually achieved without much planning. By attempting to control a situation that is unpredictable, some of the immediacy is lost. Successful shots are often the result of photographer and model setting out with little preconceived idea of the session; if the feeling is right, almost any location will work.

A sense of intimacy or fantasy is essential to a glamor shot and this is often achieved not by a naked model but by one who has loosened her buttons or zips. In any case, it is only on beaches where topless bathing is allowed that naked or semi-naked pictures can be shot in public. You will otherwise have to choose a very secluded beach or country area.

Fantasy can also be conveyed by overdressing or underdressing the model for the setting. Fur coats under a blazing sun or just a slip in the snow, for instance, make an unlikely, but sensual, combination.

Spontaneity often works well for glamor shots in public places, but it is worth being prepared for the foreseeable eventualities. You should take as wide a range as possible of equipment as well as several changes of clothes and accessories for your model.

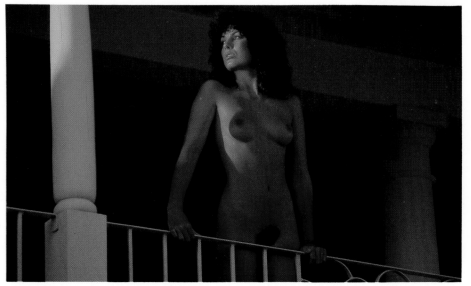

The sense of drama on a high balcony can be really effective (top left). Here, the model seems poised above an immense drop to the Los Angeles streets below.
85mm zoom lens, Kodachrome 25, 1/125sec at f5.6.
Beautiful old buildings sometimes have good balconies on which to pose the model when shooting from below (left). Here, a warm glow from the late afternoon sun highlights the model's face.
85-210mm zoom lens, Kodachrome 64, 1/30sec at f5.6.

The busy street below a balcony can make a good backdrop (above) – as with Sunset Boulevard in this example.
85mm lens, Kodachrome 25, 1/125sec at f5.6.

The regular balconies of a modern hotel in Tel Aviv make a stunning backdrop for this early morning shot (above). The concrete reflects plenty of light around the model – a useful advantage on many modern balconies.
85mm lens, Kodachrome 25, 1/60sec at f5.6.

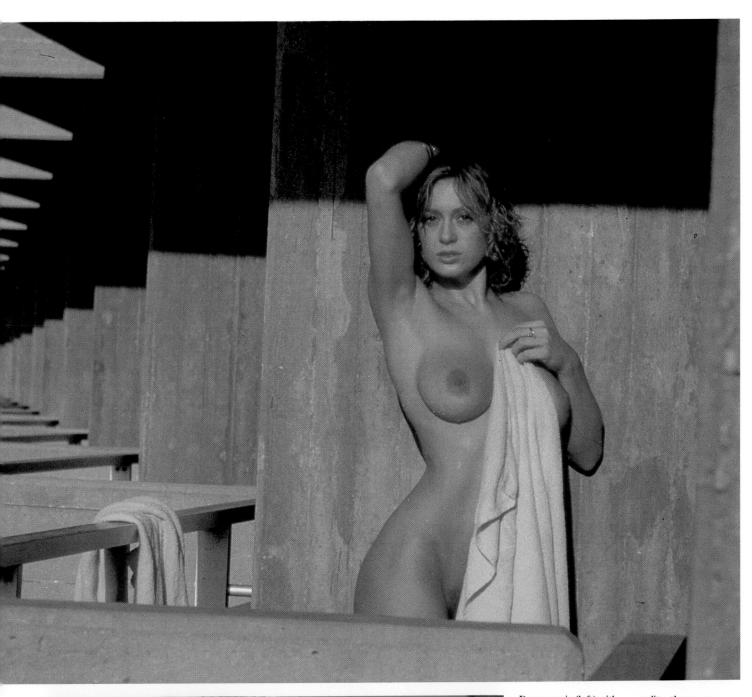

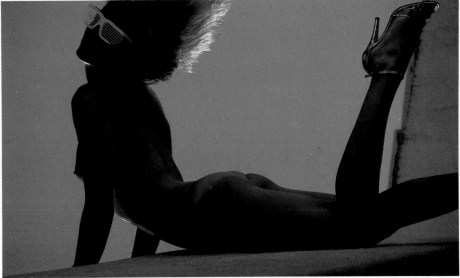

Drama again (left) with the model's seemingly dangerous pose silhouetted against the sky, stressing the sense of height. In reality, there was a ledge below the wall on which the model was lying.
85mm lens with polarizing filter, Kodachrome 25, 1/30sec at f5.6.

Glamor on the beach

A WOMAN SUNNING HERSELF on an exotic beach far away spells glamor and pleasure. Beware, however, of too ordinary a shot. Look for interesting natural features such as a curved coastline or one with coves and cliffs. Trees provide a focal point in beach photography particularly if caught at an imaginative angle or in an interesting light. A moonlit beach must be one of the most evocative locations.

Beach photography needs to be planned in as much detail as possible since the difficulties can be magnified by the inacessibility of the location. The ideal location, of course, is a secluded beach close enough to a road to allow access for your car. This combination often proves difficult to find, so take with you as wide a range of equipment as possible.

Your preparation should include necessities such as a couple of large umbrellas to provide shade for the model and the equipment; sun tan oil and skin protection; food and refreshments; and a first aid box. Possible props and accessories would be beach robes for the model; straw and cotton beach hats; sunglasses; beach balls; a beach bed; deckchairs; diving gear; fishing equipment; and perhaps a picnic basket with wine, salads and fruit.

It is important that the beach is secluded for otherwise you will be beset by onlookers and the model may well find it difficult to make it a successful session.

Do ascertain from your model that she can withstand the heat if you intend spending a day photographing on the beach. It is best to take a model who is already suntanned, so that the risk of unsightly sunburn is minimized. You must take into account for

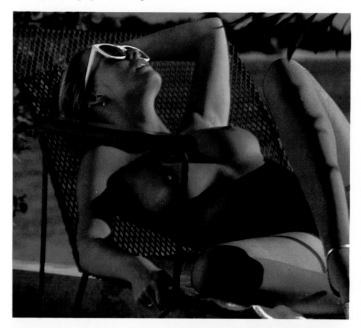

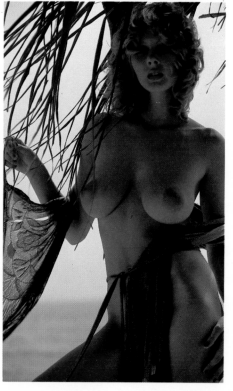

The late afternoon sun provided soft, directional lighting for this shot with sea and palm trees as an exotic backdrop (above left). 85mm lens, Kodachrome 25, 1/30sec at f5.6. Use props that are suited to the beach location (left), such as this inflatable boat. 85mm lens, Kodachrome 25, 1/125sec at f5.6.

The beach can be a good location even on overcast days (above). 85mm lens, Kodachrome 25, 1/60sec at f5.6. Look around for interesting features of the location such as this fallen tree (right) to achieve variety in beach shots. There is no point in taking 20 or 30 identical shots. 85mm lens, Kodachrome 25, 1/30sec at f5.6.

glamor photography the question of the model's bikini marks. It is for you to decide whether it is more or less attractive to choose a model who is completely suntanned. Lastly, remember that even when the sun is at its weakest, either early in the morning or when it is hidden behind clouds, it can still be quite powerful. Have plenty of sun tan oil available, as well as beach robes, hats and sun glasses for the model, and remind her that the effect of the sun is even greater when she is in the water although she may not feel it.

Sun, sand, wind and waves are the natural hazards of beach photography. Everything that needs protection from the sun should be kept under a beach umbrella, on top of large white towels weighed down at the corners. Not only will this reflect the sun, but it will also reduce the possibility of sand creeping into everything. Your equipment should be kept in white or silver containers, and should only be taken out when you need it. Film should be kept in refrigerated cartons because excessive heat would damage it. Padded thermal bags are ideal for this purpose.

Above all, remember to safeguard your equipment from the sand. If there is no protected area in which to change film, always do it sitting down, with the wind behind you so that your body acts as a shield. Check that no sand has got into the back of your camera and that the lenses are clear of spray.

You will probably find it easier to handhold your camera rather than using a tripod on the beach, since sand does not usually provide a stable base.

With well-organized advance planning and preparation, you will be free once you have reached the site to take full advantage of an evocative and sexy location.

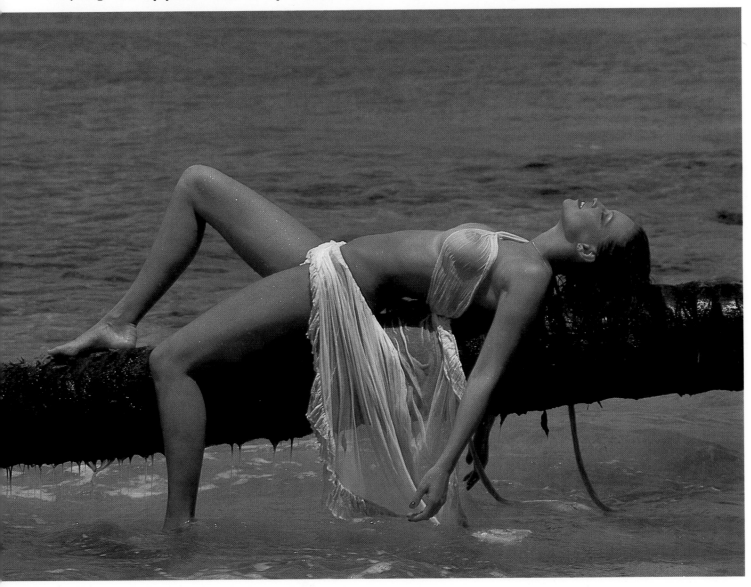

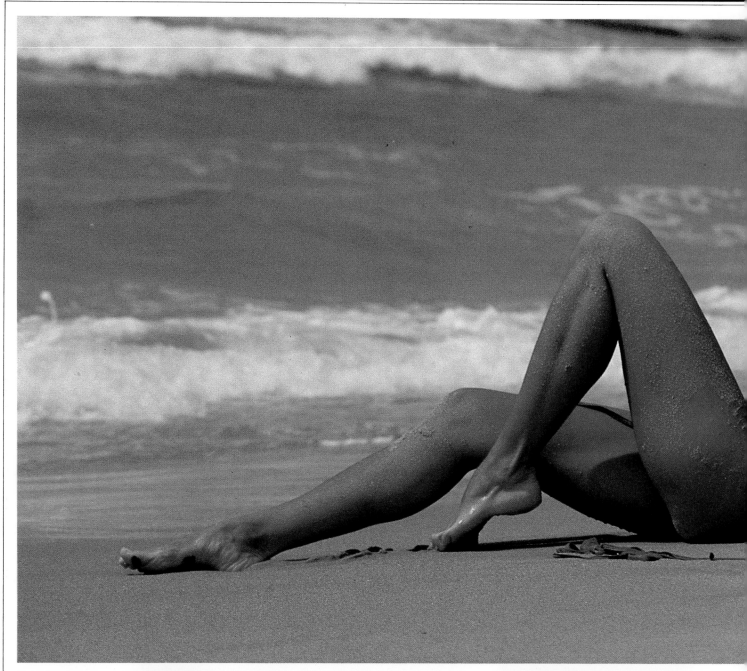

Waves breaking over the model can make really exciting shots (right). Take care to protect the camera from spray – it can be ruinously corrosive. A slow shutter speed gave the sense of movement.
85mm lens, Kodachrome 25, 1/15sec at f5.6.
Wind may seem a hindrance but it can be made into an advantage (far right). Have the model wear clothes that will billow out like her hair.
85mm lens, Kodachrome 25, 1/60sec at f5.6.

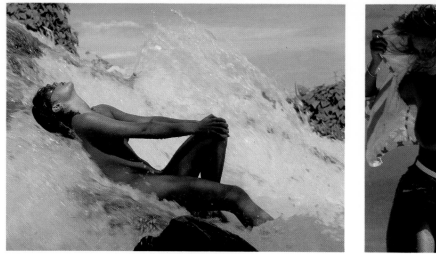

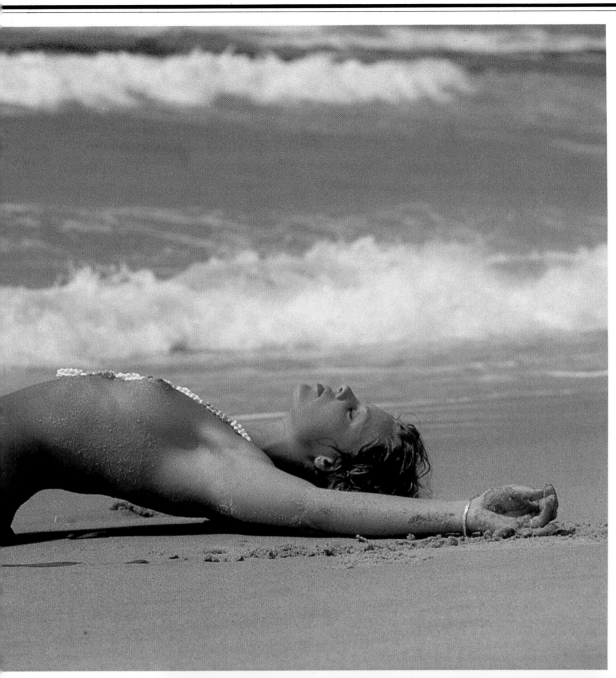

GLAMOR ON THE BEACH

Rocks A beach landscape broken up by rocks can provide an interesting background to a glamor shot. Rockpools and seaweed can lend points of interest, too. Rocks near water can be treacherously slippery and it is not worth taking chances with your model.

Wind There is usually a wind or breeze on the beach even on a hot day. You can use the effect of wind to suggest life and even the passivity of the model. Long hair, lightweight clothing or palm trees are all sensitive even to a light breeze

A beach offers more opportunities than most locations to conjure up a world of fantasy. Warmth and indolence means luxury and a freedom that can only be delightful.

Examine the landscape and the relationship between land, sea and sky. If it is windy or cloudy, anticipate the changes in the light and the weather and use to best effect the action of the wind on the waves.

Waves The power and movement suggested by waves are invaluable to a glamor shot. Try shooting the model jumping in and out of the waves or resting on a beach bed.

As waves are usually accompanied by wind, be sure to protect the camera lens from spray and sand. Watch how the waves break for a while so that you understand their pattern. If they are strong, ensure that the model can cope

If your model has her back to a rogue wave, warn her, but try to keep things lighthearted or the shot will suffer. A long lens is required for this type of shot combined with a fast shutter speed and wide aperture.

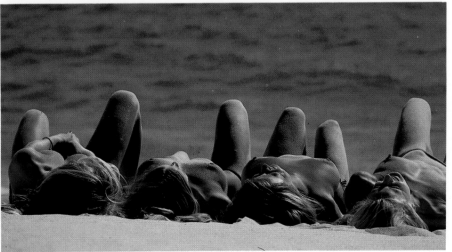

Wet sand will stick to the model's skin (above). In some cases this adds an extra dimension of texture to the shot. The luxurious pose makes use of the location to the full.
85mm lens, Ektachrome 64, 1/60sec at f5.6.
Four beautiful models, sand and sea – this shot has all the ingredients for a fine glamor photograph, with no props needed.
85-210mm zoom lens, Kodachrome 25, 1/30sec at f5.6.

The wet look

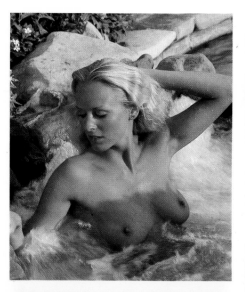

WATER PROVIDES a natural environment for nudity. In glamor shots women in, around or simply soaked in water make an unbeatable conbination. Water adds spontaneity to any session because it immediately gives your model something to respond to. She can float in it, paddle in it, jump and splash around in it or be sprayed by it.

The section on Beach Photography will have given you some ideas on how to use water, but this section describes ways to photograph women and water under the more controlled conditions found in swimming pools, jacuzzis and showers.

Swimming pools Private swimming pools make an ideal location, regardless of their size and surroundings. If you do not have access to a private pool, you may find that a hotel or club will be prepared to negotiate for the hire of theirs, particularly if you can offer some sort of credit or other publicity.

Consider all possible camera angles the pool possesses before actually shooting, making a mental note of the best positions. If the background is uninteresting, build a set with garden furniture or tropical plants. By drawing in close to your subject, using water as the only background, you will create an impression of a vast expanse of water.

Successful swimming pool shots demand a sunny day, so artificial lighting will not be required. Reflectors, however, will be useful because water creates glare. Polarizing filters reduce glare, but these should only be used when absolutely necessary as they tend to deaden textures and colours.

Jacuzzis Relaxing in a jacuzzi is a very pleasurable experience and one that your model will certainly enjoy. Jacuzzis tend to be small and functional, so it is best to concentrate on close-ups or to shoot the model from a downward angle.

Showers, fountains and sprinklers Such simple props used with a model who enjoys playing with water can create some very evocative photographs. Showers, particularly, convey a sense of intimacy.

Timing is crucial and you will get most of the action shots in the first few minutes of the session. Not only will the sensations from the water be novel and exciting to the model, but she is likely to get cold quicker than in a swimming pool, where the body temperature remains relatively constant.

When photographing in fountains or powerful showers, it is practically impossible to give directions to your model. It will be noisy and she will probably get water in her ears, too. The best thing to do is to let your model enjoy the situation for as long as she wants, encouraging her with gestures if possible. Remember to take frequent breaks and make sure the model keeps warm.

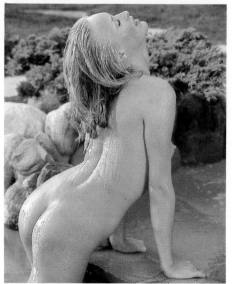

These three shots were taken during the same session set in a jacuzzi with the evening sun low in the sky and warm in color. An 85mm lens was used with Kodachrome 25. The jacuzzi was quite small, so the shots had to frame closely on the model to exclude the distracting surroundings. At first (top: 1/30sec at f5.6) the model was tentative about the new experience. But she soon began to enjoy the rushing water (above: 1/30sec at f5.6). Finally (right: 1/15sec at f4), the model's enjoyment of the jacuzzi was totally spontaneous. The shutter speed was too slow to freeze the movement of the water, with a really effective result – the ecstatic model in sharp focus against turbulent water.

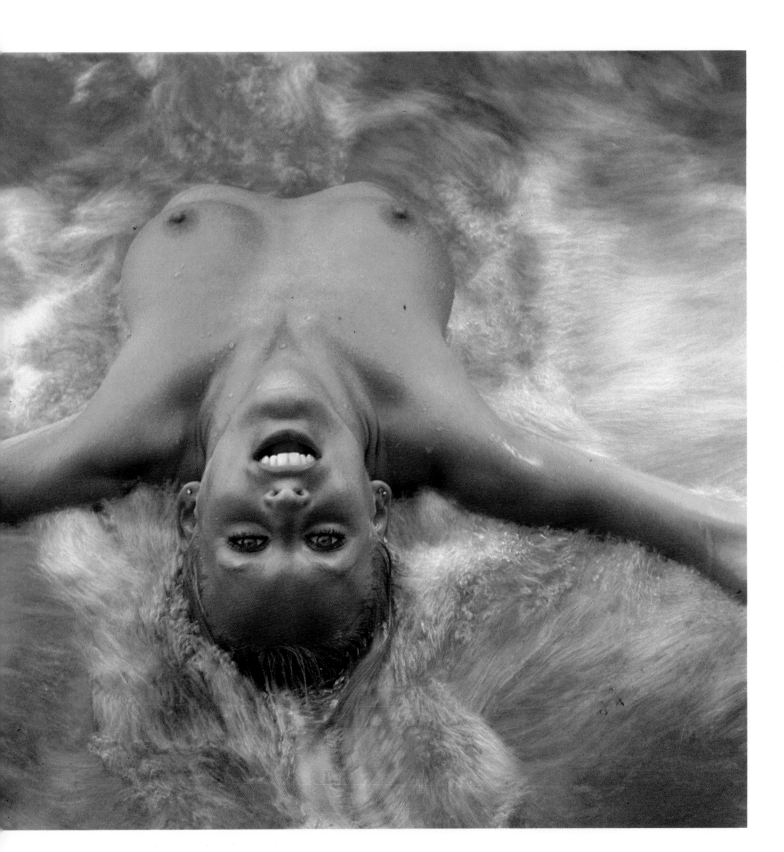

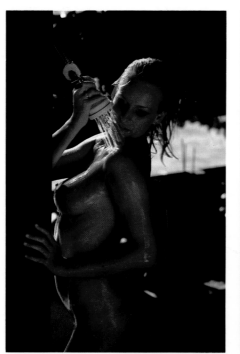

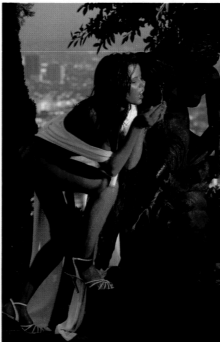

UNDER THE SHOWER

Showers make good settings – and props – particularly when situated outside (above). You will have to work quickly, though, for the model will become cold and bored with the shower after a short time. The backlighting in the shot was augmented with reflectors to the front.
85mm lens, Kodachrome 25, 1/30sec at f5.6.

Even small quantities of water can help (above right). The model wet her hair and allowed the water from the fountain to run over her as she drank.
85mm lens, Kodachrome 25, 1/30sec at f4.

Portable photographic lights achieved the shot of the model in a fountain at Caesar's Palace, Las Vegas (right). A blue color correction filter balanced the light to the film. The champagne bottle added to the uninhibited atmosphere.
28mm lens, Kodachrome 64, 1/30sec at f5.6.

This really spectacular shot was achieved with a simple shower and minimal props – a see-through jumpsuit and a large glass (right). The secret is the backlighting from a powerful spotlamp which picked out the drops of water as a rain of bright streaks. It also lit up the jumpsuit and outlined the model's body. Another spotlamp, bounced off a reflector, provided softer frontal lighting. This shot took careful planning in the studio – remember that it is extremely dangerous to allow water near photographic lamps.
85mm lens, Kodachrome 64, 1/15sec at f5.6.

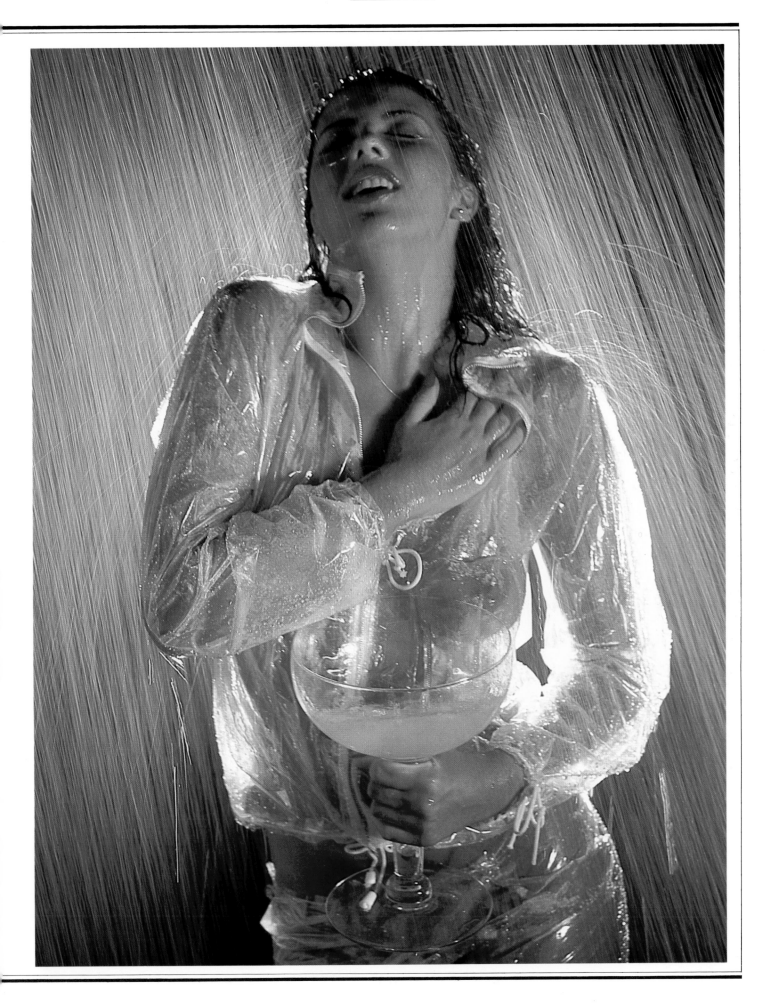

Kelly at work by a poolside in Portugal. Note the use of the tripod for perfectly sharp results and how the afternoon light is used for interesting shadow effects. The model is lying on a white plastic sheet – reflecting light into the shadows on her body and providing an interesting shiny backdrop. The art director of the magazine that commissioned the shot is pouring the water, thus adding excitement to the scene and helping to relax the model.

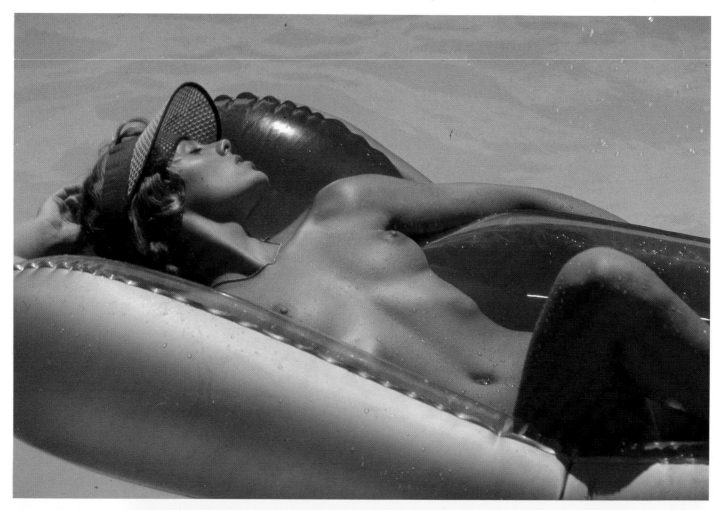

Blue is the predominant color of swimming pools, and here it is used to advantage (above) with an airbed of the same color providing a single, undistracting backdrop for the model's tanned body. A polarizing filter was needed to control the reflections from the surface of the water. 85mm lens, Kodachrome 64, 1/30sec at f5.6.

The low lighting of the evening sun adds to the langorous mood associated with a beautiful woman relaxing by a pool (right). Reflectors to fill in the deep shadows would only have reduced the effect. 80-210mm zoom lens, Kodachrome s64, 1/30 sec at f5.6.

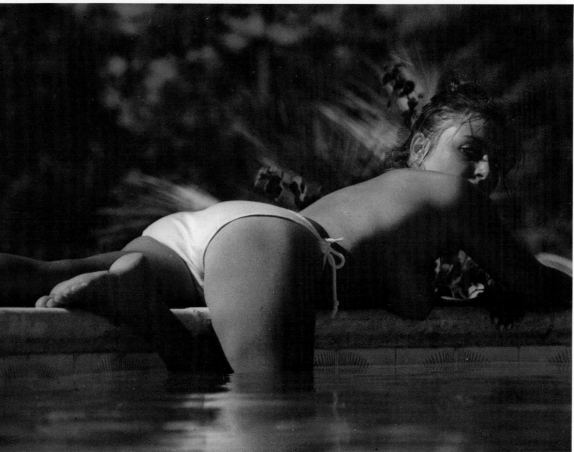

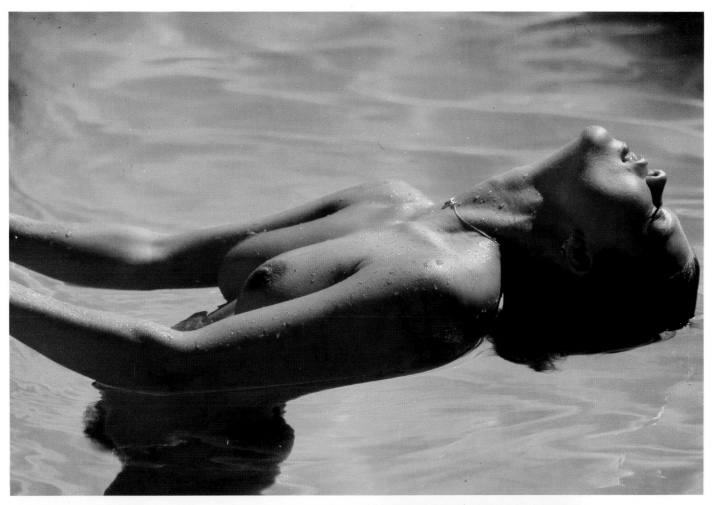

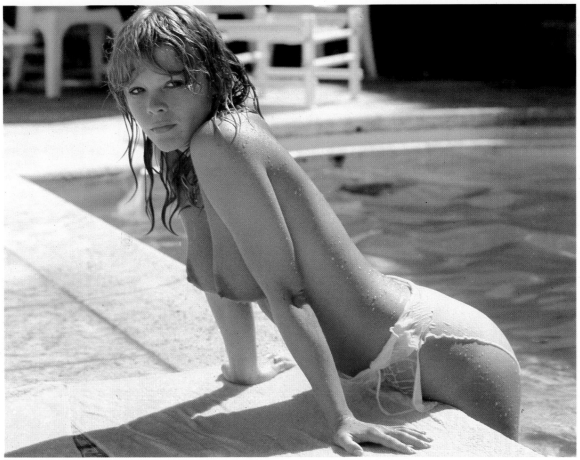

By framing tightly on the model (above), the impression of a large expanse of water can be achieved in quite a small pool. The obvious pleasure of the model gives this shot its impact. The swimming pool is a good setting because it can distract the model from the photographer's presence and lead to really natural shots. 85mm lens with polarizing filter, Kodachrome 25, 1/30sec at f5.6.

This spontaneous shot (left), taken as the model started to climb out of the pool was more carefully staged than is immediately apparent. The towel and costume are both yellow, chosen to match the color of the pool chairs in the background. 85mm lens, Kodachrome 25, 1/60sec at f5.6.

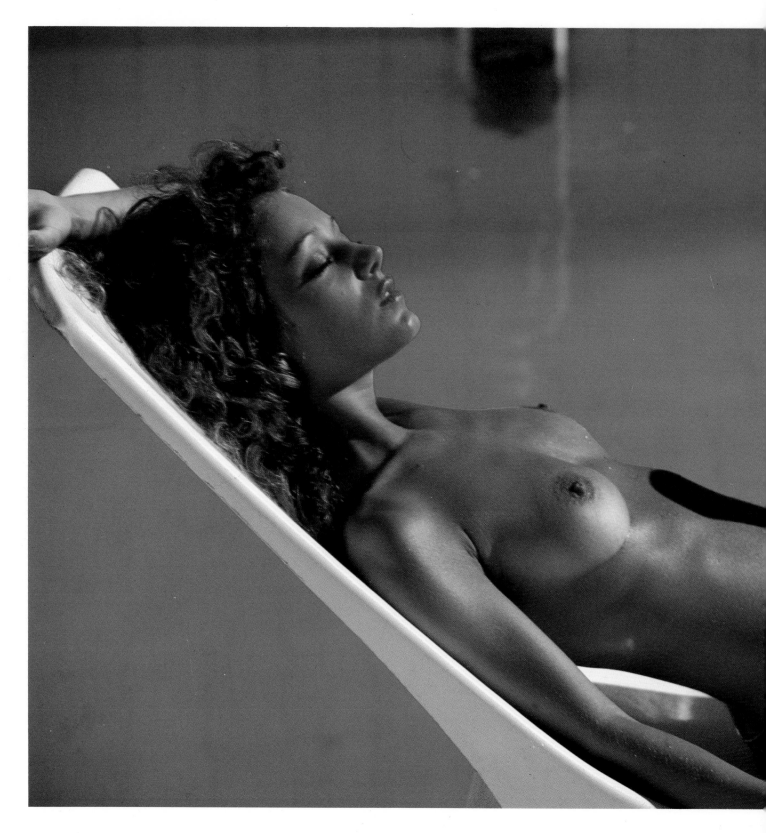

Encourage the model to display her enjoyment of the sun and water (right). Such pleasure is one of the strong points of a pool as location. But be careful of hot sun, for concentration plus the cool of the water may distract from the dangers of sunburn. 85mm lens, Kodachrome 25, 1/60sec at f5.6.

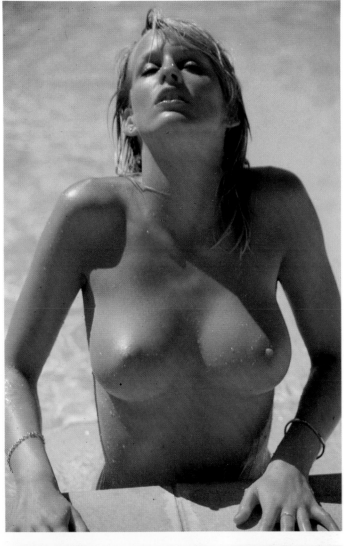

Swimming pools make excellent backdrops (left). The strong clear blue of the water works well with the warmer flesh tones of the model. For the best effects, avoid intrusively colored props in the foreground – here, the white chair is no distraction – and keep everything else out of the shot. A polarizing filter may be needed to control the reflected light from the water's surface, although the flesh colors will be better, as in this example, without one. 85mm lens, Kodachrome 25, 1/60sec at f5.6.

Look for interesting views around the pool (above), using its rails and steps for some shots. In this example, the steps echo the striped swimsuit. 85mm lens, Kodachrome 25, 1/60 sec at f5.6.

INDOOR
GLAMOR

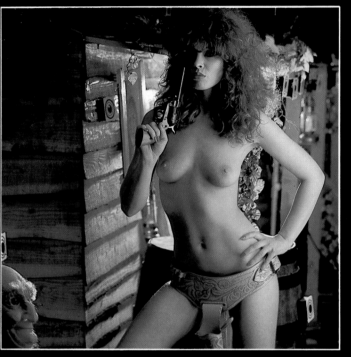

Indoor photography uses
both available light and
photographic lamps – and
the range of effects is as
extensive as your
imagination. Indoor
photography is by no means
as difficult as you expect.
On the contrary, these
conditions can enable you to
achieve the highest quality.

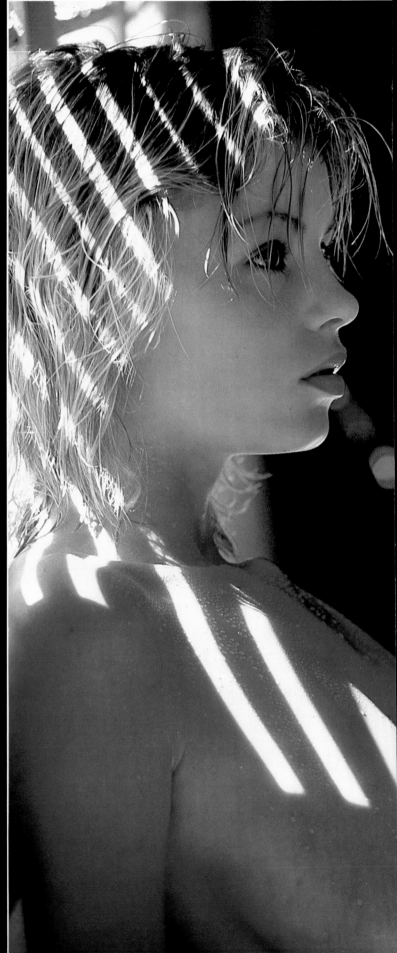

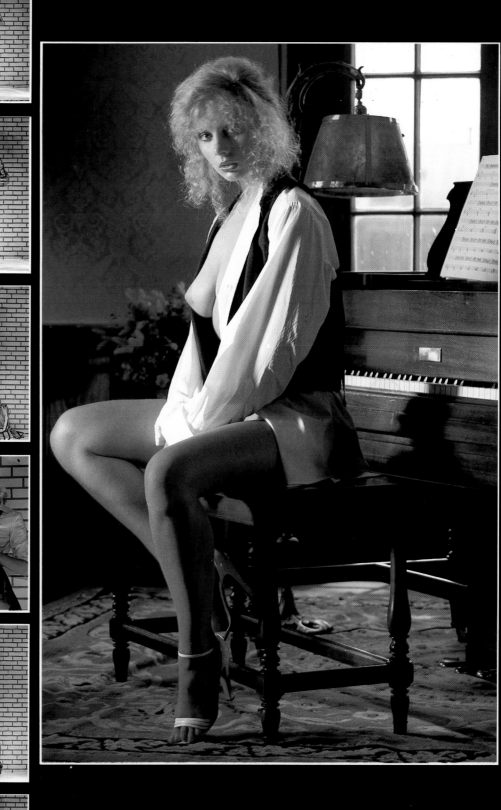

Natural and available light

E VERY GLAMOR PHOTOGRAPHER should be aware of the virtues of indoor photography. Not only can working indoors be just as satisfying as working on location; if approached methodically and with patience, it is often the preferable location for certain types of glamor shot.

Indoors, for instance, you will frequently find that you are able to build up a closer working relationship with your model than is possible on location. In addition, once you have mastered the use of available, mixed and studio lighting, your photography itself may well display a greater sense of freedom, since you will have far better overall control of the situation. Most importantly, you will no longer be dependent on the weather; dull light or bad weather will no longer be a reason for putting your camera away for a sunny day.

WITHOUT A STUDIO

At the start, you may decide not to go to the expense of setting up a studio, but, instead, to use your own house or apartment as the setting for your photographs. There are obvious advantages to this; working on ground you know well, for instance, means that you can quickly size up its atmosphere and so create the mood for your shots. Secondly, close acquaintance means that you will quickly realize the disadvantages, particularly where space and lighting are concerned.

In most interiors, lack of space is usually coupled with poor lighting conditions. There is no denying that the former can present considerable technical problems, but these can usually be overcome by careful planning. Remember, too, that, for certain glamor shots, the very intimacy of the environment can be a considerable advantage.

NATURAL LIGHT

If you are fortunate enough to be able to rely on a good source of daylight, there is no doubt that your photographs will benefit as a result. Though it is always possible to set up studio lighting, nothing can duplicate the delicate and subtle qualities of good natural light. Because it can be unpredictable, using it successfully requires skill and imagination; however, used to best advantage, it will lend realism and charm – both extremely important ingredients in glamor photography – to the end result.

Working with daylight has its problems. The most important thing to remember is to correctly assess the best time of day at which to shoot, though this, of course, depends to a certain extent on the result you wish to obtain. The ideal position for shooting indoors is under a traditional studio skylight, which gives a large, direct source of soft light, without harsh shadows or unpleasant contrasts. Otherwise make do with the light provided by windows, glass or open doors and conservatories. Study where and how the light falls at different times of day and decide accordingly on the best positions from which to take your photographs.

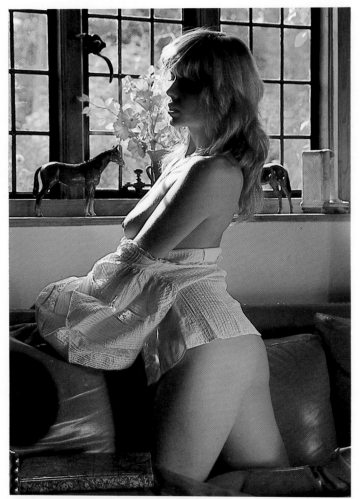

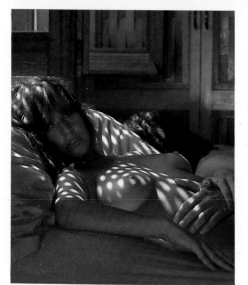

Daylight provided most of the light for this shot of the model looking pensively out of the window (above). 50mm lens, Kodachrome 64, 1/30sec at f5.6.
A white sheet, on the floor out of shot, sufficiently increased the level of illumination in a bedroom (left). 85mm lens, Kodachrome 64, 1/15sec at f5.6.
Large windows, as in this Hollywood penthouse, often produce more than enough light for indoor photography (right). 85mm lens, Kodachrome 25, 1/30sec at f5.6.

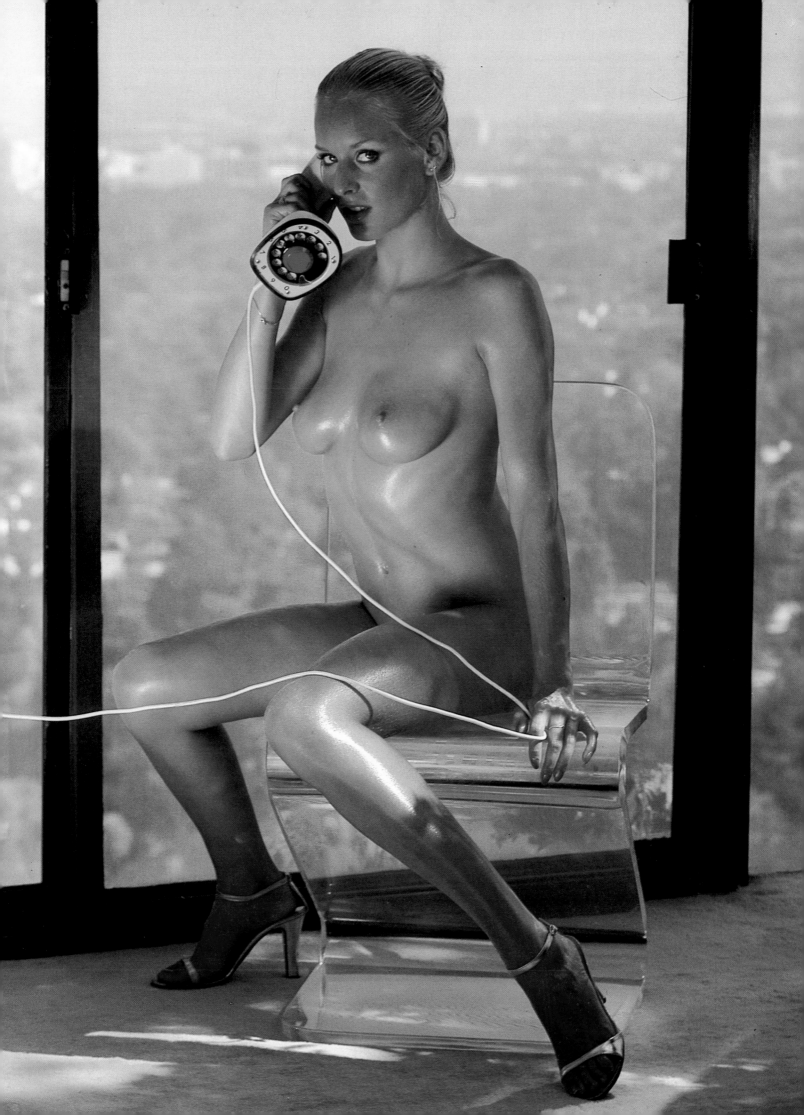

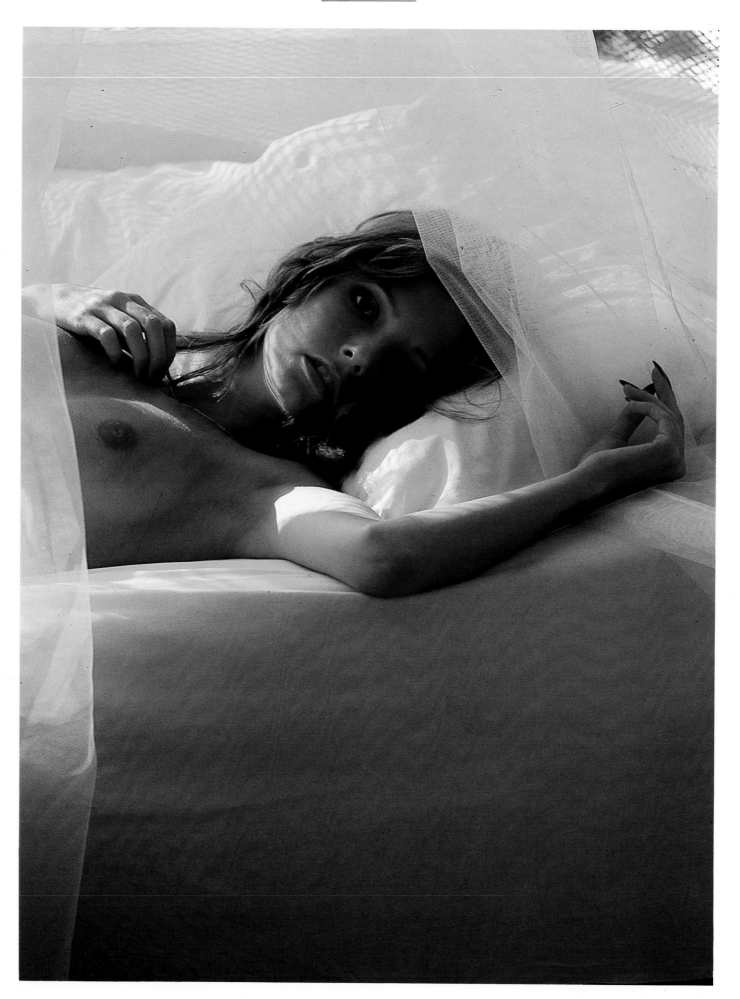

White or other light colored sheets make excellent reflectors (left), spreading the patches of sunlight from the windows into the shadows. The mosquito nets also helped, by diffusing and reflecting the light. 85mm lens, Kodachrome 25, 1/30sec at f5.6.

The sun poured through the window for this shot in Portugal (right). This is most likely early or late in the day when the sun is low in the sky. A reflector softened the deep shadows to a controlled extent. 85mm lens, Kodachrome 25, 1/30sec at f5.6.

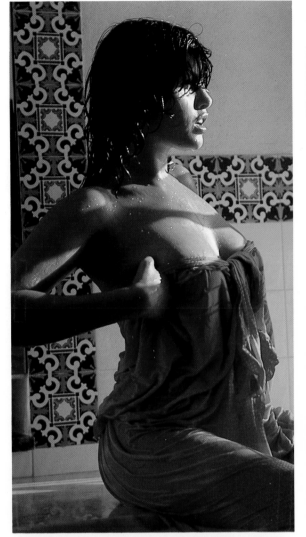

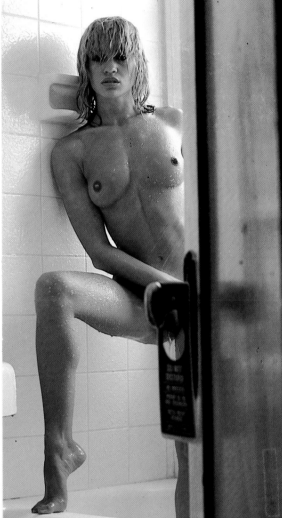

The natural light reflecting around the white-tiled bathroom (above right) was sufficient. Never take photographic lights into bathrooms – it can be very dangerous. The opportunities were limited by the confined space, but the model's pose and the suggestive positioning of the 'do not disturb' sign made for a good shot. 85mm-210mm zoom lens, Kodachrome 64, 1/30sec at f4.

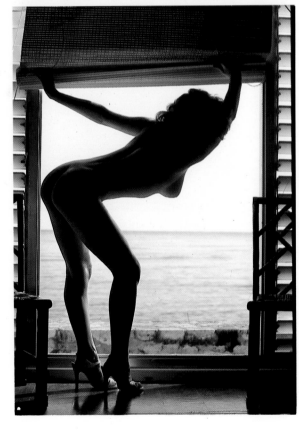

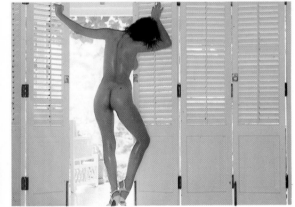

These two shots (left and above) show very different uses of a similar pose. In one the model is silhouetted against the window, with the shot exposed to include background detail of the ocean. In the other, more light and a reflector filled in more of her body. Both shots used the same exposure. 85mm lens, Kodachrome 25, 1/15sec at f5.6.

121

AVAILABLE LIGHT

However, not every house or apartment possesses an acceptable source of natural light, or the right amount of it for top-quality photography. Assuming that you do not want to use flash or studio lighting, the trick is to use the available light to its best advantage.

Photographs taken with available light must create mood and atmosphere. Though you have less control over the final quality of the shot, you still have plenty of scope to create a subtle and sensitive picture. Remember that, in most rooms, the general level of illumination will be low and the contrasts high, with localized pools of light around the lamps or windows. Multiple shadows are common, so be aware of where and how they fall, particularly if they fall directly on to the model, or obscure an object to which you would like to draw attention.

Under such conditions, the film you choose is vital. Many daylight color films are not fast enough to be used. Choose one, therefore, at the higher end of the rating scale; in color, this runs at present to ASA 400, though it is increasing all the time. Remember, though, that, with higher-rated film, the image quality can suffer.

You may also find it necessary to use a fast lens and a slow shutter speed. Unless precautions are taken, the results are often quite grainy, with a shallow depth of field and image blur from subject or camera movement. Deal with the last by always using a tripod for indoor shooting, unless lack of space prohibits its use; in such a circumstance, bracing the camera against a wall will reduce the risk of camera movement.

Remember, too, that you can use reflectors to improve light availability. Though most domestic interiors are only moderately reflective, light-colored surfaces on walls, furniture, fabrics and so on produce natural reflections which will reduce the contrasts to some extent. Place the reflectors in direct line with your light source and at right angles to the point on which you want the light to fall. If this still is not sufficient, you can experiment with ordinary center and side lights, standard or bedtable lamps.

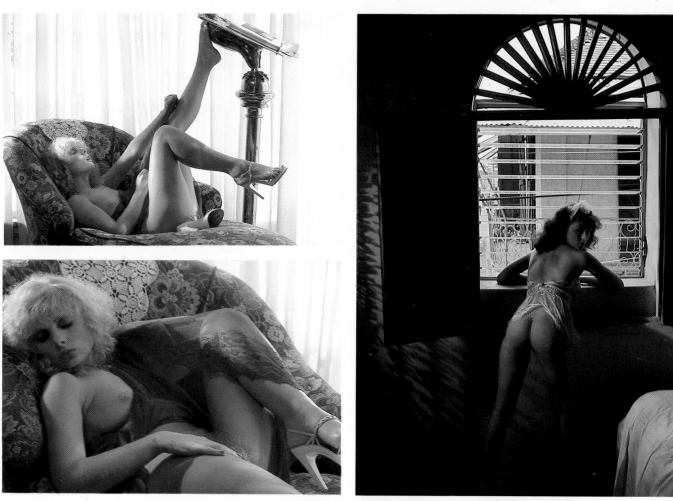

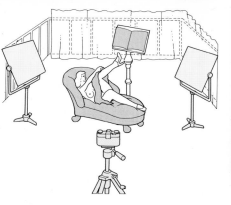

A wide window provided the light for these two shots (top and above), with reflectors at either end of the balcony. The light was diffused attractively by the net curtain, although this was pulled back at the left for the highlight on the model's hair.
85mm-210mm zoom lens, Kodachrome 25, 1/60sec at f8.

This attractive window in silhouette contributes a great deal (above). By exposing for the outside, furniture in the room (left) was in the dark and did not clutter the shot. A spotlamp lit the model's back.
35mm lens, Kodachrome 25, 1/15sec at f5.6.

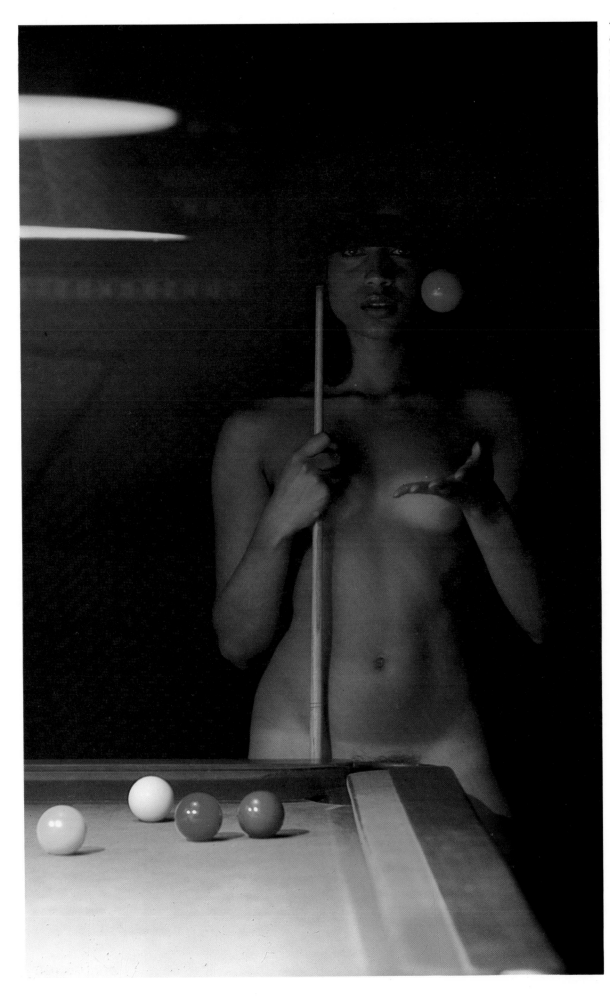

This shot had to be carefully posed and several exposures taken to get hand and ball in the right positions. Some daylight and the lights of the pool table lit the model, although flash was used for the table in the foreground. 85mm lens, Kodachrome 25, 1/60sec at f5.6.

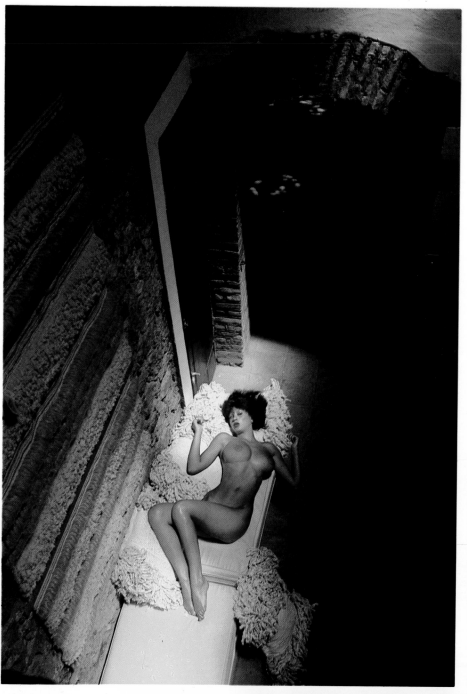

With good daylight reflecting off the light-coloured walls, this room (below) was well lit throughout. The overhead lights and table lamps also helped. Three large reflectors concentrate light on to the model to focus the composition.
85mm lens, Kodachrome 25, 1/15sec at f4.

Candlelight (right) is very effective in glamor photography: it is warm in color and its soft light is romantic and flattering. But candlelight is also weak and about 200 flames were required. With a patient model and an imaginative willingness to experiment, the results can be excellent. Great care should be taken with naked flames – they can be a fire risk.
85mm lens, Kodachrome 64, 1/8sec at f4.

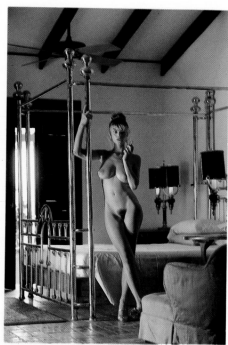

For this shot taken from a stair (above), the daylight was sufficient but for a dramatic effect a single spotlamp was bounced from a gold reflector onto the model, leaving the surroundings darker.
28mm lens, Kodachrome 25, 1/30sec at f5.6.

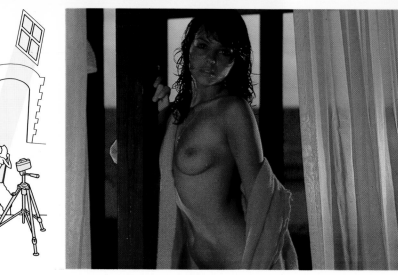

There was only very little dull daylight for this shot (left), so two lamps were used, bounced off gold reflectors. These warmed the shot up effectively.
85mm lens, Kodachrome 64, 1/15sec at f4.

124

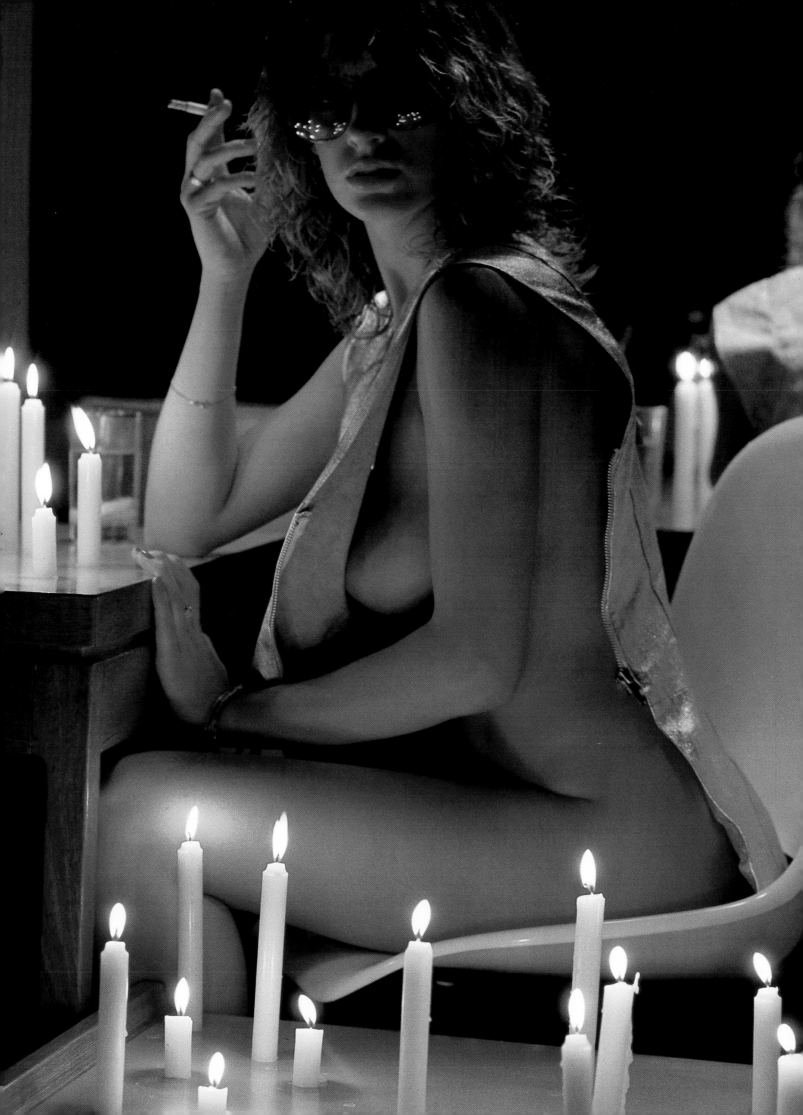

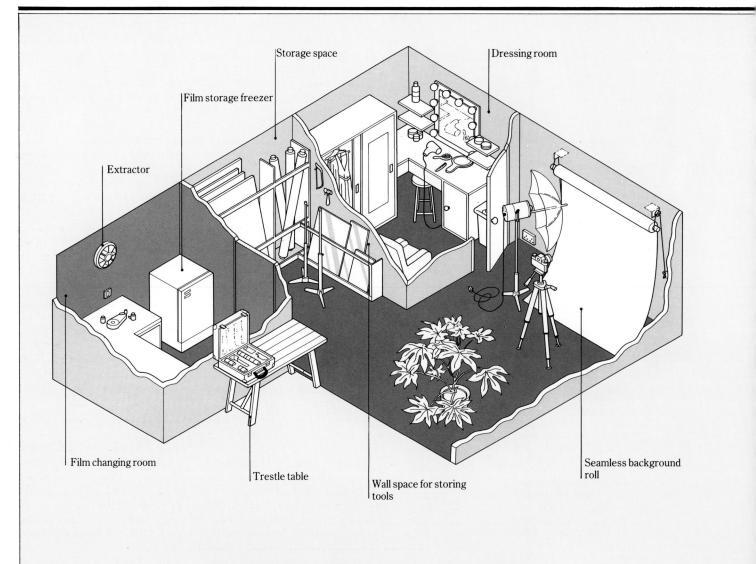

Storage space

Film storage freezer

Dressing room

Extractor

Film changing room

Trestle table

Wall space for storing tools

Seamless background roll

A permanent studio for glamor photography will need to be quite large – you will have to be able to include furniture and even whole sets in the shot. Space can be expensive, so make sure you really need this facility before taking it on. The studio can also, of course, be taken to mean an ordinary room temporarily converted for the purpose, with the windows blacked out and photographic light introduced.

If you do decide to design a permanent studio, make sure there is enough space. You should also be able to cut out all daylight with light-tight blinds. Ordinary room power may not be sufficient for photographic lights, so check and install extra power lines if necessary.

A changing room will be essential, ideally with a well lit mirror for the model to apply make-up. Adequate storage space for equipment and props is also important.

A studio of your own

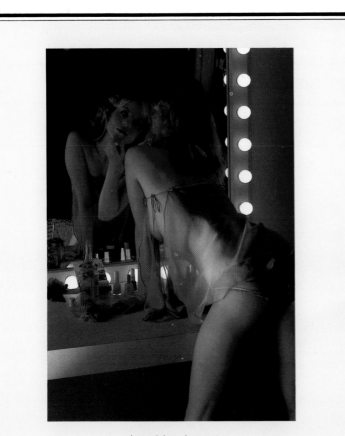

A good dressing room (above) is essential. Light bulbs around the mirror will make it easier for the model to apply make-up. Note the full supply of cosmetics and make-up equipment. Here, the dressing room is actually the subject of a glamor photograph that is successful in its own right. Some daylight came through the doorway and was also reflected from the mirror. A large photographic reflector was placed just behind the model.
85mm lens, Kodachrome 64, 1/15sec at f4.

IF, IN COMMON WITH the professionals, your aim is to have the ability to manipulate every step in the picture-taking process, a studio is really the only answer. Taking photographs with daylight or available light presents its own challenges, but invariably the final results are dependent to a certain extent on factors beyond your direct control. In the studio, on the other hand, you have almost complete freedom; you can design a set to your own specification and adjust the lighting until it is exactly the way you want it. For better or worse, the end product is entirely your own responsibility.

But, while studio photography offers you more freedom, it also requires a greater initial commitment. Whereas out of doors, you have an abundance of natural light and possible backgrounds, a studio is a dark, confined space within four walls until you transform it into something else.

Setting up a studio requires space, money, time and effort. You will have to learn new techniques and how to design a set. You will also have an additional task – of discovering how your model reacts under studio conditions.

PLANNING YOUR STUDIO

When you decide to set up your own studio, the most important thing is to ensure that you have sufficient space in which to work. For glamor photography, your space requirements will be greater than, say, still life or portraiture, so try and get as large a room as possible. The minimum requirement is about 12ft (3.6m) by 18ft (5.4m); this will allow you to take a full-length figure shot with a normal lens. A high ceiling is also an advantage; it facilitates a greater range of camera positions and can be used to 'bounce' lighting.

The walls and ceiling should be painted with a matt, washable white finish; colored paint is the enemy of good photography, since it will produce a cast on the film. Paint over existing windows, or black them out with purpose-designed roller blinds, to ensure the studio is light tight. You will need to install an extractor fan or air conditioning; sealed windows coupled with the heat built up by camera lights will make the studio impossible to work in, unless there is adequate ventilation.

In the beginning, it is not necessary to invest in a great deal of expensive paraphernalia. Build up your equipment slowly, buying only items for which there is a specific need. Wind machines, for instance, are used in quite a few glamor shots, but, unless you are really going to specialize in such subjects, it makes far more sense to hire a machine when it is required. In all studios, space is at a premium; an excess of unwanted or under-used equipment means precious workspace wasted. If at all possible, try to keep items that are not in use out of the studio.

Dressing room However, there is one additional facility that all glamor photographers should provide – a dressing room for their models. Make sure that this is well lit and that it has a properly-designed theatrical make-up mirror, correctly lit. It must have adequate hanging space for clothes, plus storage room for shoes and other accessories. Provide an emergency supply of face and body make-up, creams, towels, a hairdryer and heated rollers.

Studio equipment Normal set furniture includes folding flats, a step ladder (useful for high-angle camera shots), trestles and background. One of the most useful forms of background are the seamless paper rolls, aptly known as hanging rolls. These are ideal for portraiture or for whenever you require a plain background. The rolls, usually 9ft (3m) long and available in several different colors, can be slung on a cross bar, supported between expanding poles.

When it comes to complex set construction, however, the requirements are obviously as complex or as simple as the idea you have in mind. In addition to the usual do-it-yourself equipment for the actual business of construction, you should also have a basic kit for emergency on-the-spot repairs during shooting. This should consist of some basic modelling tools, small drills, fixing agents and an antistatic gun for removing dust from the set.

STUDIO LIGHTING

Artificial light is more consistent and generally easier to deal with than daylight, but only if you understand how to use it. One of the chief faults of beginners is to place lights randomly, correcting mistakes by using additional lamps, rather than by diffusing or changing the position of the main light source. The result is often harsh, uneven illumination, with an effect of a shallow, crowded space.

Always remember that it is the area of a light source that counts. A large source, such as strip lighting or a reflector, will produce soft light, characterised by indistinct shadows or low contrasts. A point source, such as a flood or quartz halogen lamp, will produce sharp-edged shadows, with high contrast. The closer a light source is positioned to a subject, the softer will be

STUDIO EQUIPMENT

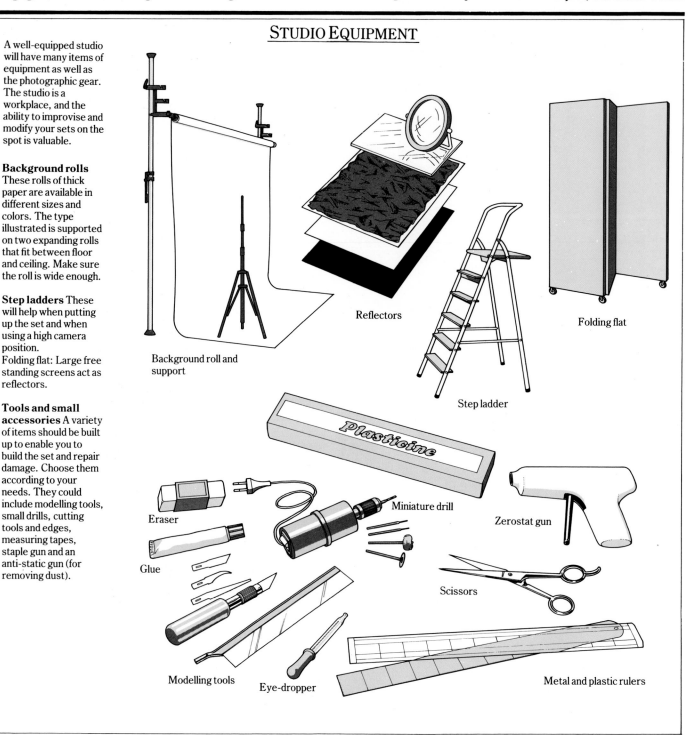

A well-equipped studio will have many items of equipment as well as the photographic gear. The studio is a workplace, and the ability to improvise and modify your sets on the spot is valuable.

Background rolls These rolls of thick paper are available in different sizes and colors. The type illustrated is supported on two expanding rolls that fit between floor and ceiling. Make sure the roll is wide enough.

Step ladders These will help when putting up the set and when using a high camera position.
Folding flat: Large free standing screens act as reflectors.

Tools and small accessories A variety of items should be built up to enable you to build the set and repair damage. Choose them according to your needs. They could include modelling tools, small drills, cutting tools and edges, measuring tapes, staple gun and an anti-static gun (for removing dust).

Background roll and support

Reflectors

Step ladder

Folding flat

Eraser

Glue

Plasticine

Miniature drill

Zerostat gun

Scissors

Modelling tools

Eye-dropper

Metal and plastic rulers

the shadows; the further away it is, the more distinct the shadows will be. The overall lighting effect, however, becomes more uniform as the distance increases.

There are two main types of studio lighting available – tungsten and electronic flash. The latter is more expensive, but preferable to the former. Electronic flash is more reliable, has a longer life, is heat free and unsurpassed for stopping motion. Tungsten bulbs heat up a studio uncomfortably and normally require fairly slow shutter speeds.

Lighting techniques Lighting techniques depend as much on the personal taste of the photographer as on the technical requirements. Although any lighting arrangement can be used, providing the desired results are obtained, it is best to follow a few basic rules until you are completely familiar with studio lighting.

Above all, remember that you should constantly refer back to the camera and be guided by what it sees. No matter how skilled the photographer, the human eye cannot match the camera lens for objectivity. Always assess your lighting through the viewfinder and, as a final check, take test shots with a Polaroid before embarking on the actual session.

One of the main techniques used by professionals is 'bounced' light. This is the next best thing to natural light; if the technique is used skilfully, it is barely possible to tell the difference between the two in the end photograph. The trick is to direct the light against a flat wall at an angle; the light bounces back, producing a diffused result, without strong shadows. If you want to light one side of your model, aim a light directly at the wall nearest to the point you want to illuminate.

Light can be bounced off ceilings as well as walls. The use of this

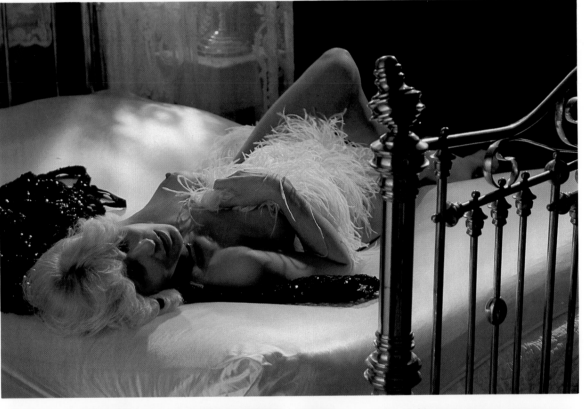

The studio shot (left) achieves quite a natural effect, with directional lighting. It has an 'after the party' atmosphere. Two lamps at the foot of the bed were bounced off reflectors at the side.
85mm lens, Kodachrome 64, 1/15sec at f8.

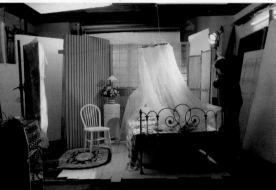

The lighting (above) includes a broad light for filling in shadows at the front, a studio flash with its modelling light at the left, spotlamps at the right and several large flat reflectors which can be easily moved around the set.

Another set (above) is also constructed to look like a bedroom. In reality it consists of a mocked-up floor light for reflection, a bed and moveable areas of wall. The bed is the main item of furniture although other props

are included to make the 'room' natural. The mosquito net could be included in the set or used to diffuse the light.

STUDIO LIGHTING CONTROL

With a fully equipped studio, a great variety of lighting effects are possible. Moving the lights and using more or fewer light sources radically alters the appearances of the shot and its atmosphere.

1 All-round lighting is here achieved with two back window lights, underfloor strip lighting and a single diffused front spot. Reflectors above and to the front further spread the light. 85mm lens, Ektachrome 64, 1/60sec at f11.

2 Backlight/underlight gives a slightly more silhouetted effect. The window lights bathe the model from the sides and behind, with fill-in from the underfloor light. A single diffused spot near the camera position puts some light on to the front of the model. 85mm lens, Ektachrome 64, 1/30sec at f8.

3 Front light gives a harder more dramatic result, with stronger shadows. A single diffused spot at the front was used, with some fill-in from the side and overhead. 85mm lens, Ektachrome 64, 1/30sec at f5.6.

4 Backlight with no lamps in front of the model, achieves greater silhouette with a bright background and a halo effect. Reflectors to the side and overhead give sufficient light to the model. 85mm lens, Ektachrome 64, 1/30sec at f11.

5 Backlight/reflected front light is similar to backlight but has a slightly more directional result. One window light provides the backlighting and another is reflected back from a flat at the front. 85mm lens, Ektachrome 64, 1/30sec at f8.

6 Front reflected light above is more directional. Reflectors above and to the sides soften the effect. 85mm lens, Ektachrome 64, 1/30sec at f8.

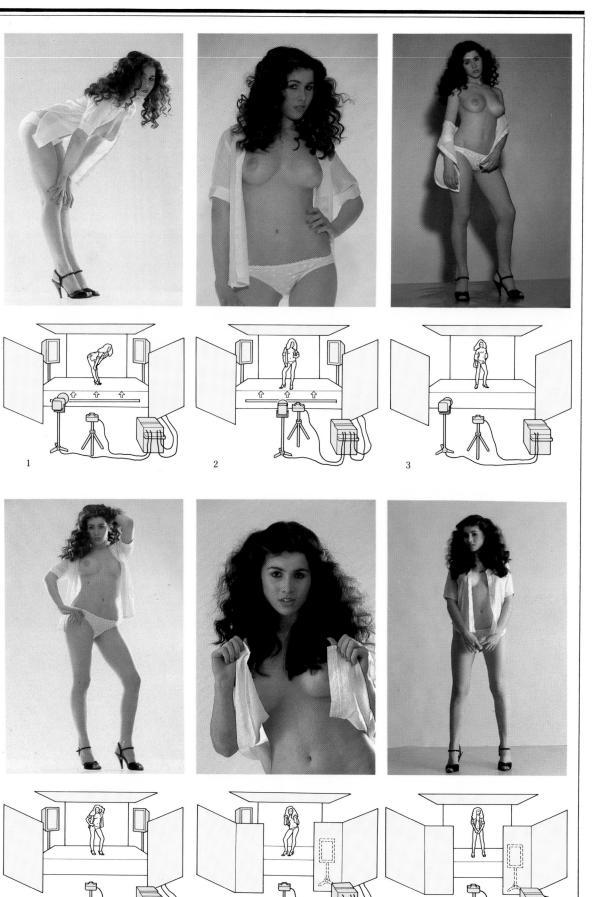

1

2

3

4

5

6

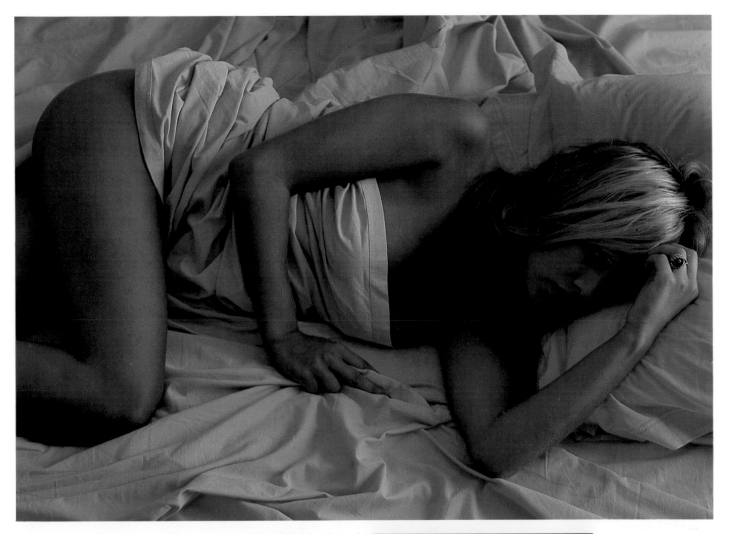

effect means that you can achieve a soft, uniform illumination of your subject. Build up the light until it is sufficiently intense to make an exposure and then direct one main light at your model. Adjust the position and strength of the light source until you are satisfied with the overall effect.

By placing your subject between a pair of strong floods or strip lighting, you will produce flat, overall illumination that is rarely flattering to a model. To bring out shapes and textures, you must create shadows and highlights. Omit one of the floods and add a spotlight. Place a reflector behind your model to provide some backlighting and give a sharper definition to the outline. If you want to emphasise a specific area, add another spotlight.

If you want to soften the borderline between light and shadow, cover the light source with suitable diffusing material. For trimming down or controlling the beam of a flood or spot, attach barn doors to the light.

LIGHTING EQUIPMENT

Lighting equipment is divided into several categories – the lights themselves, their supports and various accessories, such as reflectors and diffusers. Although professionals almost always prefer electronic flash, tungsten floods are still largely used by amateurs, since they are less expensive. The lights are basically up-rated versions of domestic lamps.

The main problem with tungsten floods is inconsistency. As the bulbs darken with age, the light output and color temperature are reduced accordingly. Quartz-halogen lamps overcome this problem. The vaporized tungsten is dispersed in the halogen gas and redeposited on the filament. The light output and color temperature therefore remain constant. The lamps also last ten

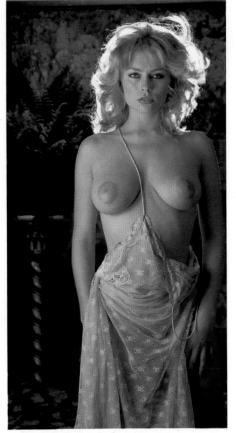

This set (above) was simplicity itself – a mattress with plenty of blue sheets. Two window lights were placed on either side and the entire set was surrounded with tall, white reflectors. 85mm lens, Ektachrome 64, 1/60sec at f5.6.

Here, a bedspread was hung behind for the 'wall' and a single plant stand was placed next to the model (left). Two backlights were used for the halo effect, with a single spot near the camera at the front. Several reflectors were placed around the set to spread the light evenly. 85mm lens, Kodachrome 25, 1/30sec at f5.6.

times longer than floods, though they are more expensive.

There are many reasons for the use of electronic flash by professionals, but one of the most important is that the color quality closely approaches that of daylight. The only significant disadvantage is that the exact effect of the light cannot always be judged before exposure. However, many designs now have built-in tungsten lamps to give representative lighting.

The principles of studio flash equipment are similar to those of hand-held units, but the handling characteristics are quite different. Studio flash is house-current operated, with high voltage capacitors and sufficient output to meet the needs of small aperture work. It is possible to adjust the output, so that fractions of the total can be used. There are two main types available; the power pack can be a separate unit, connected to several heads, or the pack and head can be combined. In the first case, a good unit should be able to handle up to four separate lights from its power pack. Although designed to enable each power head to be individually adjusted, the unit should also be able to deliver 300 watts to each head when operating at full power.

The integrated unit is becoming increasingly popular. It is convenient and highly portable. Although the power output is limited, it is usually sufficient for most 35mm lenses, since these

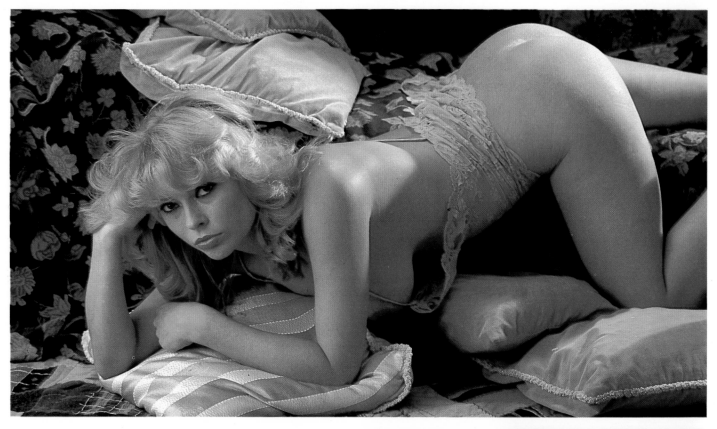

A luxurious effect is created by the use of velvet cushions (above). Rich materials can be used effectively in studio shots. The lighting was supplied by a diffused window light just behind and above the set, with directional light from a spot to the right.
85mm lens, Ektachrome 64, 1/15sec at f5.6.

This set (right) was designed to look like an elegant, slightly oriental living room. Plants, fabric, the green background and the model's shirt were chosen accordingly. A blue filter was used, with tungsten lights on either side of the subject and a gold reflector close to the camera.
85mm lens, Kodachrome 64, 1/15sec at f5.6.

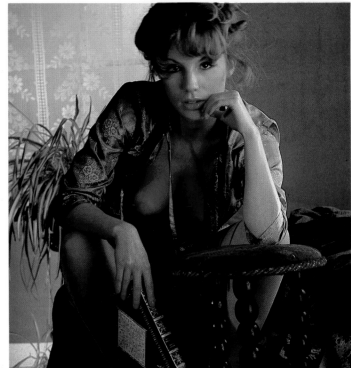

STUDIO LIGHTS 1

Modern studio lights are both powerful and versatile. Studio flash has none of the drawbacks of small portable flash units. In combination with the diffusers and reflectors, the light from studio flash units can be broad and soft, and can be closely controlled. Such units now usually have modelling lights to show the effects they will have. Modern tungsten-halogen lamps last much longer than the old photofloods and give light of a much more consistent quality.

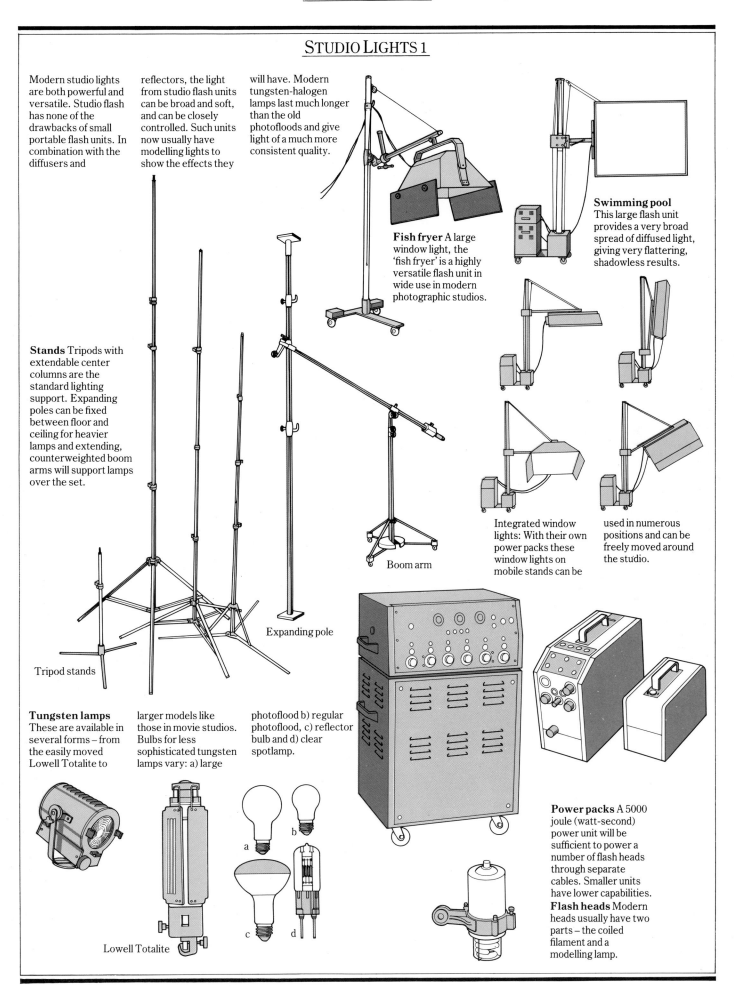

Fish fryer A large window light, the 'fish fryer' is a highly versatile flash unit in wide use in modern photographic studios.

Swimming pool This large flash unit provides a very broad spread of diffused light, giving very flattering, shadowless results.

Stands Tripods with extendable center columns are the standard lighting support. Expanding poles can be fixed between floor and ceiling for heavier lamps and extending, counterweighted boom arms will support lamps over the set.

Integrated window lights: With their own power packs these window lights on mobile stands can be used in numerous positions and can be freely moved around the studio.

Boom arm

Expanding pole

Tripod stands

Tungsten lamps These are available in several forms – from the easily moved Lowell Totalite to larger models like those in movie studios. Bulbs for less sophisticated tungsten lamps vary: a) large photoflood b) regular photoflood, c) reflector bulb and d) clear spotlamp.

Lowell Totalite

a

b

c

d

Power packs A 5000 joule (watt-second) power unit will be sufficient to power a number of flash heads through separate cables. Smaller units have lower capabilities.
Flash heads Modern heads usually have two parts – the coiled filament and a modelling lamp.

STUDIO LIGHTS 2

A variety of diffusing and reflecting devices will modify the quality of the light in the photographer's control.

Reflector attachments This flash tube, with an integrated modelling light can be fitted with general purpose, or wide dish, reflectors to direct the light. A barn door can be fitted for precise control or different shapes of snook to concentrate a beam of light if required.

Diffuser attachment For a more gently and broadly spread type of light, opal and gauze discs can be fitted to the front of the flash heads. Alternatively a shallow bowl reflector with a blocked center will have a similar result.

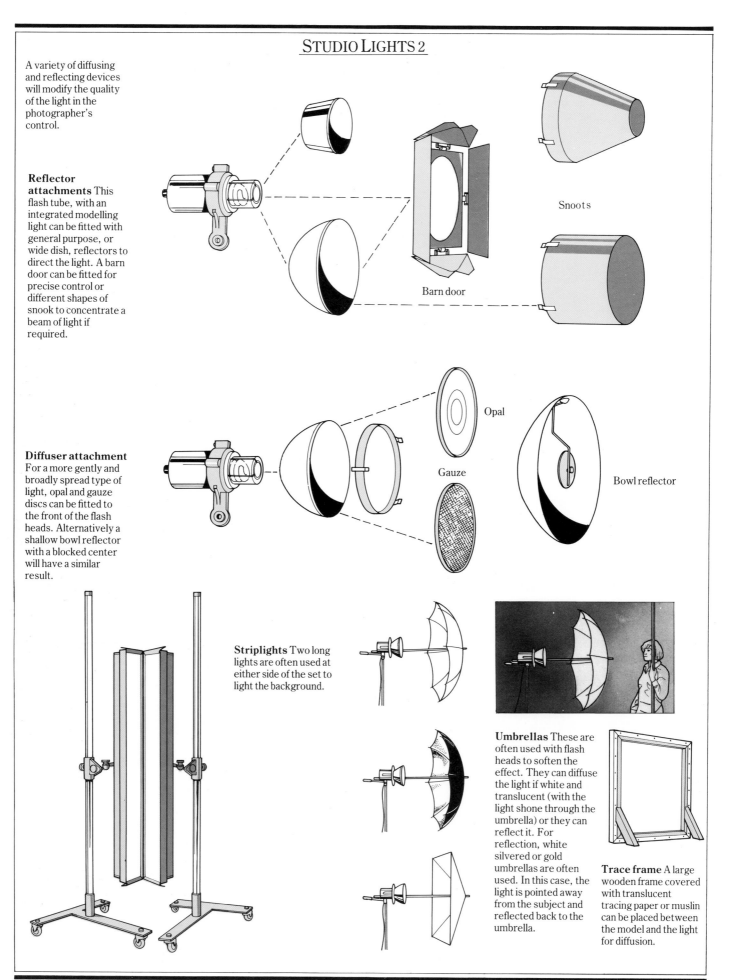

Snoots

Barn door

Opal

Gauze

Bowl reflector

Striplights Two long lights are often used at either side of the set to light the background.

Umbrellas These are often used with flash heads to soften the effect. They can diffuse the light if white and translucent (with the light shone through the umbrella) or they can reflect it. For reflection, white silvered or gold umbrellas are often used. In this case, the light is pointed away from the subject and reflected back to the umbrella.

Trace frame A large wooden frame covered with translucent tracing paper or muslin can be placed between the model and the light for diffusion.

do not stop down as much as large-format lenses.

If you are planning to use studio flash frequently, an incident light meter is an essential, though expensive, investment. Point the meter towards the light source. When the flash is fired, the reading will register on the meter with a memory circuit.

Stands and supports For most purposes, lights can be mounted on simple tripod stands. These are available in different heights and sizes. If space is at a premium, an expanding pole can be used. Expanding poles are held by tension against the floor and ceiling, but are awkward to move once they are set up. For extra mobility, use a boom stand.

Spotlights and strip lights If you need to highlight specific areas, small spotlights are essential. These can be handily attached to super-clamps, which are specifically designed to be attached to doors, step ladders, chair backs and so on.

The best way to light backgrounds evenly is with two purpose-built strip lights. These are trough-shaped and fitted inside with flash tubes. Though they are an expensive investment, they vastly improve the result if a large area has to be illuminated.

Reflectors and diffusers Reflectors and diffusers are an essential part of any studio equipment list. Mirrors are extremely effective reflectors and can be especially useful for selectively

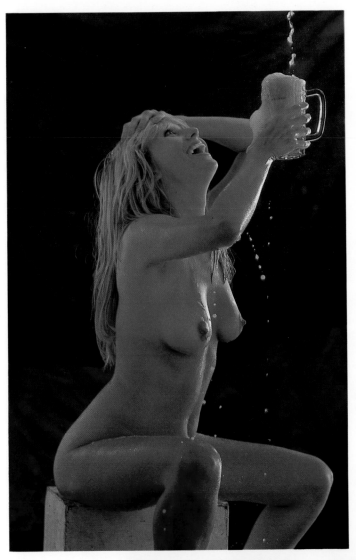

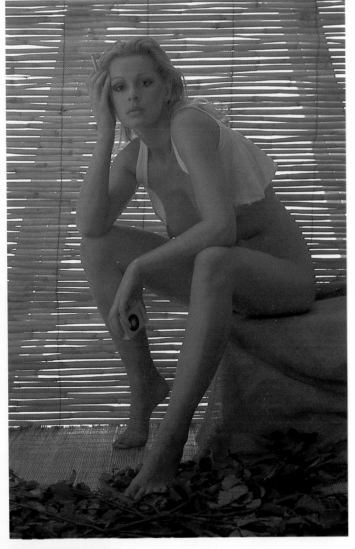

This shot (above) used up a lot of beer and gave rise to great hilarity in the studio. Two large window lights were used at the sides, with a spot at the front.
85mm lens, Kodachrome 25, 1/60sec at f5.6.

To make the most of this shot (left) of a model drinking iced water, a spotlamp was carefully positioned behind her shoulder and pointed at the drink for backlighting. Another spotlamp to the left added to the effect.
85mm lens, Kodachrome 25, 1/15sec at f5.6.

A convincing beach set was created in the studio (above) by the use of backlighting with window lights, directed

back to the model by a large reflector at the front.
85mm lens, Kodachrome 64, 1/60sec at f5.6.

MIRRORS AND SCREENS

Interesting effects can be obtained with the inclusion of glass or other materials in the shot – either between the lens and the subject or reflecting the subject. Screens in front of the camera distort the image. The effect is much greater when the screen is close to the subject (therefore in focus) than when it is close to the camera. A gauze or muslin sheet in front of the lens, for example, may become almost invisible.

1 Here, the model soaked herself in water and pressed against the dimpled glass of a shower door. Be careful to avoid unattractive distortion of the face.
135mm lens, Kodachrome 64, 1/60sec at f5.6.

2 Gauze can be used to create a hazy, romantic atmosphere. It also reduces harsh lighting and cuts out obtrusive backgrounds.
85mm lens, Kodachrome 25, 1/15sec at f5.6.

3 Mirrors can be included in glamor photographs very effectively. Focus on the model rather than the reflection, and be careful to position camera and lights so that neither photographer nor equipment appears in the shot by mistake.
85mm lens, Ektachrome 64, 1/60sec at f8.

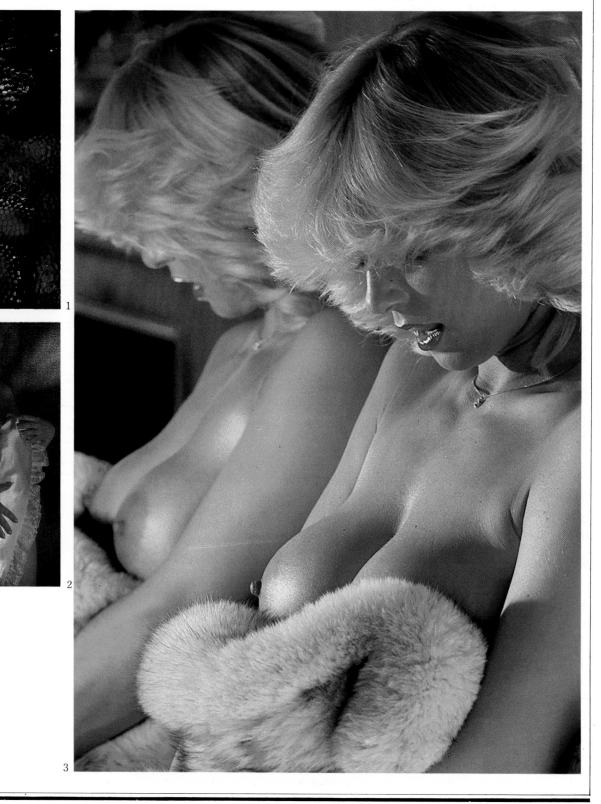

filling in dense shadows. Cooking foil is also strongly reflective. It is easier to control if it is first crumpled and then pasted down on to a piece of card. Free-standing folding flats are used as reflectors for lighting large areas.

Spotlights and floods can usually be controlled with reflector attachments, such as snoots, barn doors, wide angle or general purpose reflectors. Their principal purpose is to direct the light to where it is wanted and to keep it away from areas, such as the camera lens or large reflective surfaces, where it is not required.

As the name implies, diffusers are used to diffuse light. Umbrellas are invaluable for studio glamor photography. A white finish will throw a soft light and shadows, a gold finish will cast a warm glow, a silver finish will increase light intensity, but produce harder shadows, while a translucent umbrella will diffuse a flash. Black umbrellas will absorb extraneous light, which might otherwise cause harsh contrasts of light and shadow.

Lights can be fitted with diffuser attachments, too. These vary according to the degree of diffusion required. They range from plastic opalescent discs to large, shallow bowls fitted with a cap that blocks off direct illumination from a flash tube. If you need to diffuse light over a large area, use a trace frame. The wooden framework is easy to make ; it can be covered with tracing paper, muslin, or other types of translucent cloth.

COLOR IN THE STUDIO

In studio photography, satisfactory color organization is rarely accidental. If you do not pay particular attention to color combinations when composing your photographs, any errors will probably scream out from the transparency or color print. At the very least, you will feel dissatisfied, even if you are unable to identify the precise reason for the failure of the picture.

Teach yourself to be aware of color, shades and tones in everything around you. Examine the color changes that take place in artificial and natural light and experiment by placing the same object against backgrounds of different colors. Analyze the results and identify what does and does not work and why.

Naturally, your decisions will be subjective, but remember the guiding rule in glamor photography – everything around your model must complement her. Avoid clashing and discordant colors and tones that compete for attention with the subject of the picture. Anything that detracts from this should be eliminated from the set.

You should first take into account the hair and skin color of your model. Very pale skin will often absorb colors; while this may occasionally create an effect you desire, it tends to be unflattering in general. This is especially true if you are using solid blocks of strong colors. The darker the model's coloring, the more you can afford to use brilliant colors and bright contrasts.

Soft blues and pinks will create an intimate, cosy atmosphere; bold reds and yellows are aggressive colors that demand action. Your model will naturally respond to the environment you create for her, so do not expect her to look or feel demure and sensitive if she is surrounded by vibrant colors that call for a more positive response.

Once you have found the right color combination for your photograph, use lights of the precise color temperature to match your film. Unless you are able to reproduce on film what you see through the lens, all your careful preparations will have been wasted. Try to avoid using filters whenever possible.

Choose a film that gives maximum color saturation, such as Kodachrome (this has to be processed by the manufacturer). If you select a brand that can be developed individually, you can sometimes ask for the film to be pushed a couple of stops in the development. This will increase the color saturation of photographs that have been evenly lit; however, it will give excessively hard results if you have used contrasty lighting.

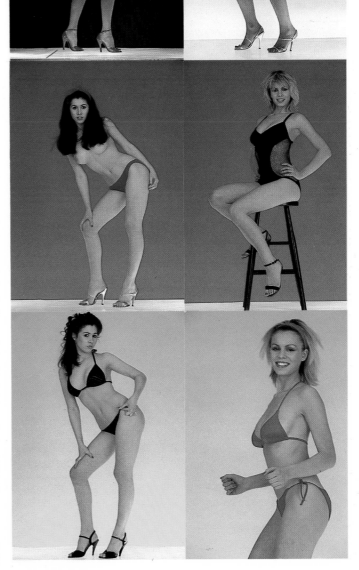

It is not necessary to create elaborate sets in the studio – a plain seamless backdrop will sometimes produce the best results (above). Choose props to complement the background color or contrast with it – concentrate on simple schemes rather than over-elaborate combinations. Notice in these shots how dark and fair haired models look quite different against different toned backgrounds. The dark background accentuates blond hair, although the yellow gives it a sunny, healthy look. In the same way, the yellow is effective with dark hair A black costume on black also looks good – particularly with the red accessories added for a note of contrast. One of the best combinations is the white on white, delicately accentuating the model's skin color.

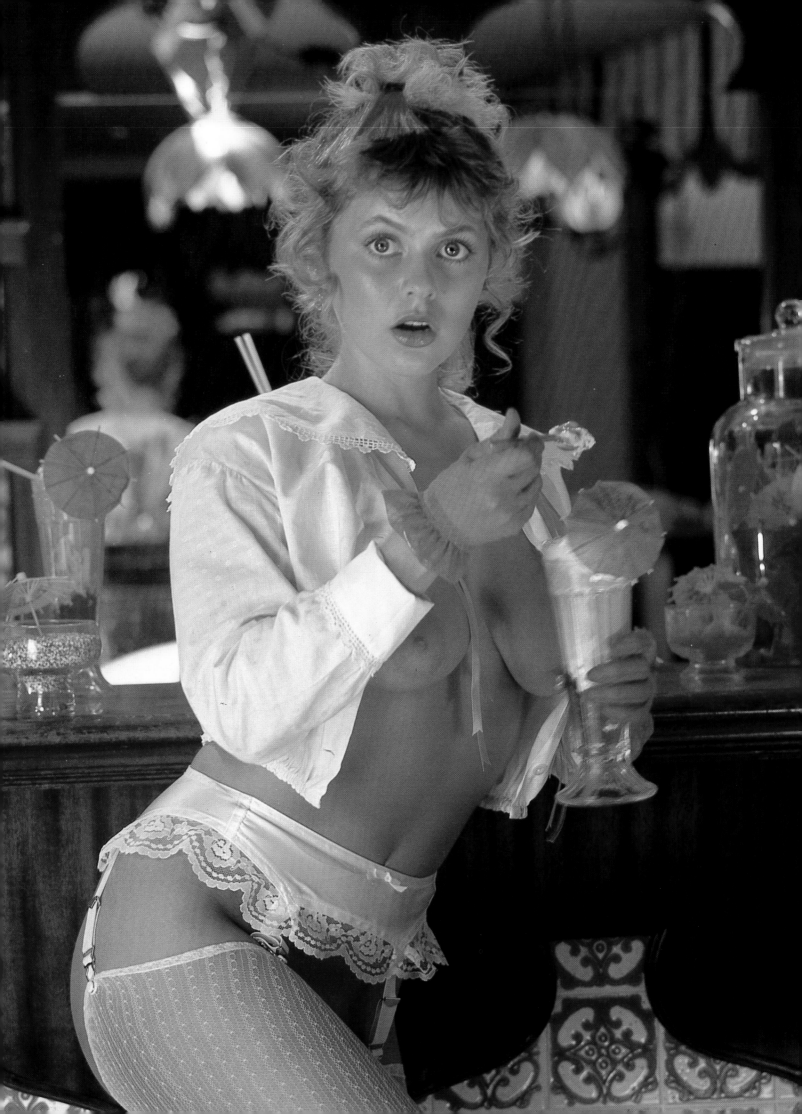

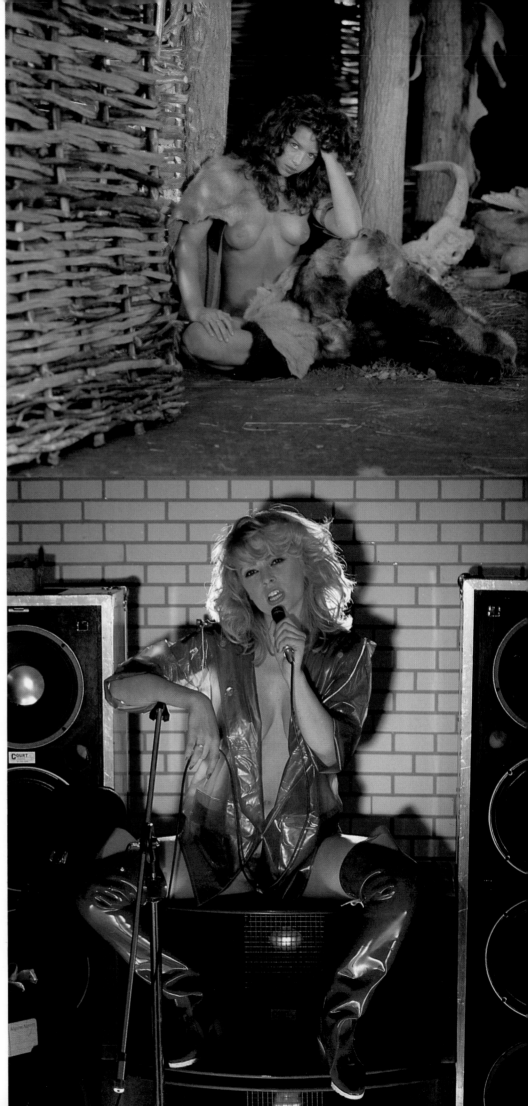

A good location can be turned into a studio for a session with portable studio lights (left). Here, two 800 watt lamps were placed above the model and slightly behind for the backlight, with pink filters added for the color effect. A 3000 watt diffused light and reflector added the frontal lighting. Props were chosen to enhance the pink mood. Hasselblad, Ektachrome 64, 1/30sec at f5.6.

Sets can create an impression of almost any location – or even time. The primitive hut (above right) just needed a wild hairstyle and a few animal skins to complete the illusion. Three 800 watt lamps were used for the shot, one behind the fence, one lighting the background and one bounced off a reflector at the front. Hasselblad, Ektachrome 64, 1/15sec at f8.
Some rock concert sound equipment and a shiny wall with a subterranean look (below right) set the model in a punk music scene. Bright colored plastic clothes helped. One light above the model backlit the hair and bounced back off a low reflector, while another next to the camera added to the frontal light. 80-210mm zoom lens, Ektachrome 64, 1/60sec at f8.

PROFESSIONAL GLAMOR

Good professional glamor photographers are in great demand – but they have to combine photographic skill with the ability to work well with models. Photographs can be undertaken to commission, for magazines or advertising purposes, or done on spec.

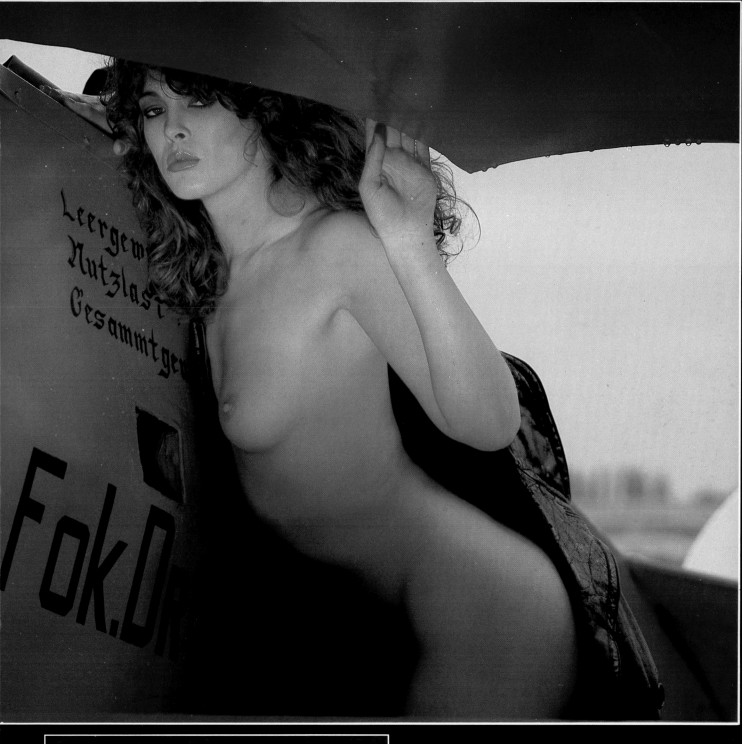

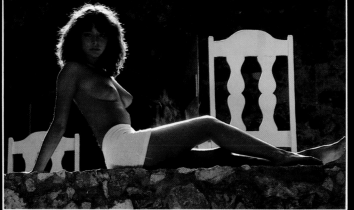

Glamor on location

AN OVERSEAS ASSIGNMENT makes a welcome break from routine for any photographer, but particularly for a glamor specialist. Here, John Kelly details the events of one of his recent overseas trips and explains why he feels that they are an essential part of his work.

'On a well-organized overseas trip, I can often shoot more good work in three weeks than I could operating in my studio for three months. There are many reasons for this, the chief one being that a new environment can do wonders for both the photographer's and the models' morale. There is an urgency which creates an exciting momentum and this is invariably reflected in the photographs that result.

'Things can go dreadfully wrong, of course. I once arranged a two-week shoot in the Mediterranean to be faced only with non-stop rain, homesick models and my own bad temper. Such events are an exception, however. Even under the worst possible conditions, a creative photographer will be able to benefit in some way from the change in scene.

'The choice of location should be based first and foremost on the type of weather that can reasonably be expected at the time of year. No beautiful landscape can compensate for bad light. The next important consideration is variety in the surroundings, which, ideally, should include a coastal resort, distinctive landscapes and some interesting architecture. Good hotel facilities are important, too, so that, in the event of bad weather, interior shots are also possible.

'In the spring of 1981, I decided to make a working trip to Haiti in the Caribbean. I had been there once in 1976 on a calendar assignment and, although I hadn't explored the island much, I felt instinctively that it had enormous photographic potential. Any reservations I might have had were overcome by Jerry Barnes, my agent, who had been back to the island several times. He returned with hundreds of location shots that illustrated its potential, plus a well-stocked address book that guaranteed us help and co-operation from the residents.

'The importance of this last point cannot be over-emphasized. Working in a foreign country may be exciting, but it can also throw up all sorts of problems for the glamor photographer. Local customs, for instance, may be against photographing semi-nude models. The reaction can be anything from complete outrage to the entire community wanting to get in on the action and be photographed as well. It is essential to know what to expect.'

PREPARING FOR THE TRIP

'Like all my trips, this one emerged as a matter of necessity. I had a couple of pressing magazine and calendar assignments. I also wanted to boost my library stocks.

'My first step was to discuss in detail with the magazine editors what their requirements were. These presented no problems. The calendar assignment, on the other hand, was to feature trucks and trucking. I quickly decided to stop-over in Miami for a couple of days to take advantage of Florida locations for this.

'From this, you can see the importance of systematic pre-

planning, particularly where commissioned work is concerned. As far as my library shots were concerned, I simply informed the library to expect a consignment of pictures over the next few weeks. To shoot speculative work successfully, it is vital to have the courage of your own convictions and take the photographs you think are good. If this is supported by a feel for the market-place, you are likely to accomplish a great deal on a two- to three-week trip.'

'The most important initial decision was to decide how many and which models I should work with. I usually prefer girls who have travelled before and are happy working on location. They are generally more self-sufficient and able to cope with the strains and stresses that arise on a two- or three-week job. I also like to have worked with them on a couple of occasions before hiring them for an overseas assignment. On this occasion, however, I broke both of these rules. The final party consisted of six models, two of them twins and only two with overseas experience.

'It was crucial before leaving that the models all knew exactly

The Haiti assignment produced numerous superb locations (left), from deserted beaches to fine modern hotels surrounded by tropical vegetation and old buildings steeped in character. Research the possibilities before you set off – plan to be at the best places in the best light and weather conditions.

A calendar commission for truckers was dealt with in a stop-over in Miami (right). A good range of props had to be taken to ensure that effective color combinations with the trucks would be possible.
35-80mm zoom lens, Kodachrome 25, 1/60sec at f5.6.

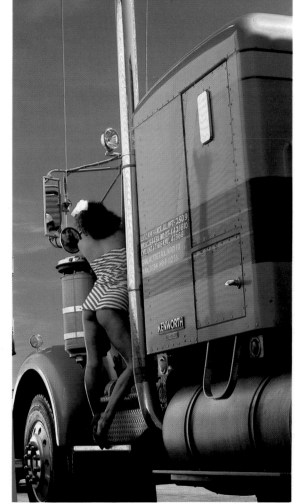

what would be expected of them in work terms and fees. They had to provide a model release and their own up-to-date passports and visas. I also asked them to bring along a basic summer-holiday wardrobe and to prepare their skins for a sun tan. The make-up artist and hairdresser were given the same detailed briefing. Insurance, covering personal, public liability and equipment also had to be arranged, plus accommodation, air tickets, car hire and so on. The basic team at any one time was to consist of myself, Jerry, make-up artist, hairdresser and at least two of the six models.

'A first-aid kit is essential, particularly for the tropics. Ours consisted of salt tablets, suntan lotion and sunburn cream, plasters, bandages and surgical tape, germicidal cream, headache and indigestion tablets. For myself, I took comfortable clothing both for location hunting and for photographic shoots. The right shoes and sufficient protection from the sun are particularly important. Hot days generally mean cool nights, so extra sweaters are necessary!'

PROPS, CLOTHES AND ACCESSORIES

'Unless I've been commissioned to take a photograph to an exact specification, I rarely predesign a shot unless I am sure of the location. Thus, I tend to take very few props with me overseas, unless they are absolutely necessary. For Haiti, although I had collected a couple of outfits I particularly wanted to feature in some of my shots, I decided to honor my tradition of chancing to luck and innovation to provide on-the-spot props. The models had already been asked to bring a basic summer wardrobe; I supplied some extras, such as sunglasses, summer hats, scarves, shawls, designer shoes and some jewelry.'

INTO THE SUN

'It took roughly three weeks from the day I decided to go to Haiti to actually boarding the airplane. Normally, I would take longer to prepare for a trip like this, but Jerry was fulsome in his guarantees that Haiti was the only place on earth where I could be sure of getting good weather, plus beautiful surroundings, in March. I never pass up a certainty.

'After two days of successful shooting in Miami, we boarded the airplane for Haiti. For the next four days we admired the island thru a haze of torrential rain from our hotel windows. Nevertheless, I was anxious to capitalize on the momentum that had built up in Florida and lost no time in getting behind the camera. The hotel proprietor was extremely helpful and gave us a free rein to photograph wherever we wanted. There were no problems with the power supply – we only used tungsten lighting – and the models were keen to work hard. It transpired that those few days of rain were, in fact, a blessing in disguise. One of the twins later suffered from severe sunburn and was unable to work. Had this happened at the start, we wouldn't have had any pictures of the two twins together. This would have been a great loss.'

'The two-and-a-half weeks of sunshine that followed ensured the success of the trip. Jerry contacted some old acquaintances and, with their help, was able to come up with some extraordinary beauty spots. In all, we must have covered about 30 interior and exterior locations and they all looked entirely different. As well as the luscious tropical island shots, some of the pictures could have been taken in East Africa and others in the American desert. Several locations that would have made stunning backdrops had to be abandoned for a variety of reasons – inaccessibility, no power supply – but I have filed them away for next time.

'Once I had decided on the location, the right model had to be selected for the photographs. One of the advantages of long trips is that a photographer can get to know the models extremely well and is therefore able to judge almost instinctively how they will photograph to the best advantage. In Haiti, for instance, I found that one girl worked extremely well indoors, but was quite uncomfortable in many outdoor locations. The surviving twin was extremely extrovert and excelled herself in outdoor shots.

'It's crucial that the photographer/model relationship is good at all times during a long overseas assignment, though, people being what they are, this isn't always possible. I usually try to keep abreast of what is going on without actually getting involved. This way, I can be sensitive to the model's feelings without having to comment on them. This approach seems to suit everyone, since most models are anxious to project a positive, professional image, especially to their photographer.

'But problems do arise – never more quickly than when people are forced to live and work closely together without a break. I tend to fire on all cylinders when I'm abroad and I expect the models to do likewise. Since there is only one of me and six of them, it's improbable that I'll push any of them to their limits, but the strain of being in a foreign country, often for the first time, is sometimes overwhelming for many of the younger, less experienced girls. Modelling is also an extremely competitive profession and it occasionally happens that the models do not mix well amongst themselves.

'In Haiti, we had a few crises of confidence and one nasty accident, in addition to the sun burn. By and large, our problems were well distributed over the three weeks and I was able to work satisfactorily on every single day we were on the island, come rain or shine.'

ASSIGNMENT TECHNIQUE

'The main reason why I make overseas trips is to follow the sun. For me – and I'm sure many other photographers – nothing can beat working with good natural sunlight. The sun is unpredictable, of course, but, in the course of a day, its movements can transform the mood and atmosphere of a scene several times over. To keep pace with and take advantage of these changes is one of the greatest challenges for any photographer.

'Learning to work quickly is one of the fundamental requirements of good photography. You must be acutely aware of everything you see and able to make instant decisions. Move an

THE MODELS

Janet, at 24 years old, is an experienced model. It was known that she could be relied on – both for professionalism in front of the camera and as a mature influence on the others.

Toni was only 18, but a really attractive model coming to be in great demand. It was her first trip abroad, but it was clear that she would handle it well.

The twins, Suzie and Sally, had just had their 22nd birthday. It was really fortunate that these busy models were available for the trip.

Lynn was only 16 when she came for an interview a few weeks before the trip. A real professionalism was soon revealed, however, and her sense of humor was invaluable.

Carole-Ann was also a newcomer to modelling at 17 years old. But she was a quick learner and worked hard – despite initial nerves.

EQUIPMENT CHECKLIST

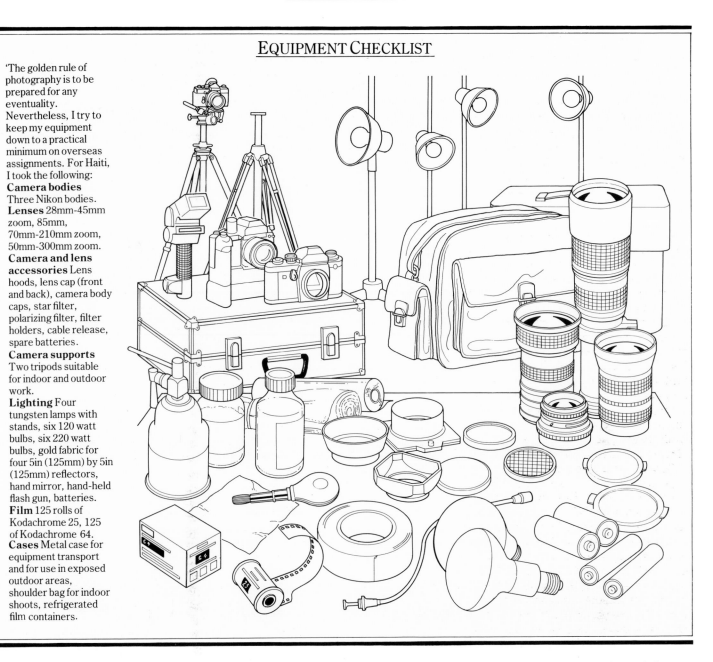

'The golden rule of photography is to be prepared for any eventuality. Nevertheless, I try to keep my equipment down to a practical minimum on overseas assignments. For Haiti, I took the following:

Camera bodies Three Nikon bodies.

Lenses 28mm-45mm zoom, 85mm, 70mm-210mm zoom, 50mm-300mm zoom.

Camera and lens accessories Lens hoods, lens cap (front and back), camera body caps, star filter, polarizing filter, filter holders, cable release, spare batteries.

Camera supports Two tripods suitable for indoor and outdoor work.

Lighting Four tungsten lamps with stands, six 120 watt bulbs, six 220 watt bulbs, gold fabric for four 5in (125mm) by 5in (125mm) reflectors, hand mirror, hand-held flash gun, batteries.

Film 125 rolls of Kodachrome 25, 125 of Kodachrome 64.

Cases Metal case for equipment transport and for use in exposed outdoor areas, shoulder bag for indoor shoots, refrigerated film containers.

inch, wait five seconds and you have a completely different picture. On location, therefore, I try to be constantly alert and never like to be far away from camera or model. Photography is about capturing moments in time and when time is limited, as on assignment, everything takes on greater significance.

'Trimming my needs – as far as equipment is concerned – is an important part of being able to work spontaneously. My equipment checklist for Haiti shows that by comparison to what I could have taken, my requirements were quite modest – no hand-held meters, for instance, and only two filters. Nor did I bother with a wide range of film stock or lighting equipment. I simply took what I believed would see me thru a three-week trip. Of course, it would be inadequate for other branches of photography, but, for my purposes as a glamor photographer, I had all I needed.

'If the light and model look good, it only takes a moment to pick up a camera (already loaded), compose a picture (each camera is fitted with a zoom lens, the three combining to give a 28mm-300mm range), select the aperture and shutter speed (reliable TTL on all cameras) and shoot. Of course, I could take half an hour to set up the same shot, but this is no guarantee that the results would be better. What often happens is that the model, the main focus of the picture, becomes bored and self-conscious.

'This is not to say that I constantly take gambles and shoot at breakneck speed. On the contrary, I merely cover myself as far as possible against creating an inhibiting atmosphere of high technology for the model.

'I like simple solutions to the problems of indoor photography, too. During our first four days, the rain forced me to take all my pictures indoors. I spent a lot of time searching for pools of light around the hotel that could be either warmed up or amplified by tungsten lamps and gold reflectors. I was not disappointed. By mixing my own light sources with what natural light was available, I could create what appeared to be brilliant sunbursts coming in thru the windows, even in the most overcast conditions. Everything except the sun, however, was pure Haiti.

'Technically, this was not a difficult operation. I boosted the low light with reflectors and spotlights, mounted the camera on a tripod and used a cable release for any shots under 1/30th of a second. The calm and quiet atmosphere this created made it easier for the model to keep perfectly still.

'The whole point of being on location is lost if you feel the need to duplicate studio conditions. If you don't feel confident enough to take the risks inherent in such a shoot, you are probably better off spending your money in the studio and not on an airplane fare.'

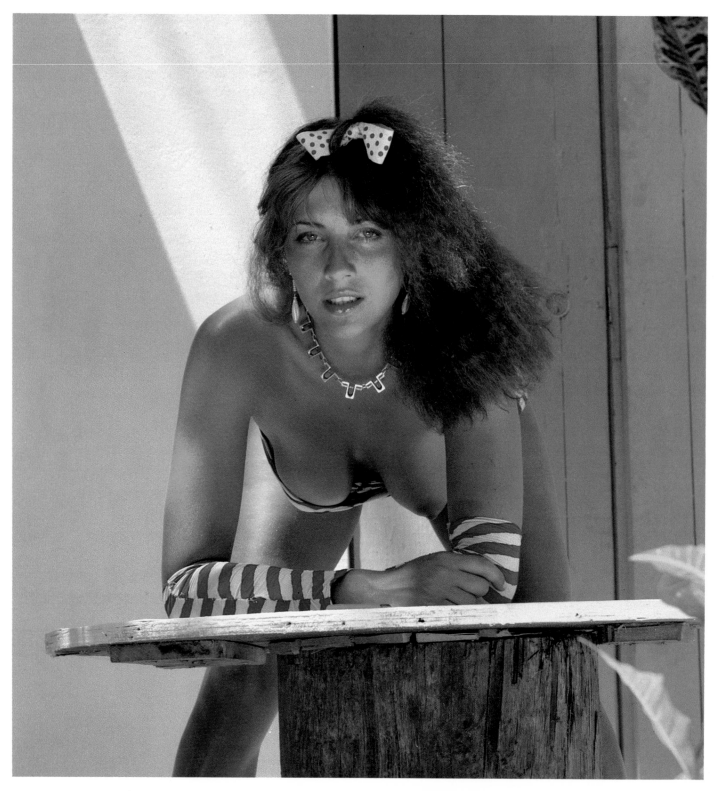

Janet (above) was the most experienced model on the assignment, used to going to exotic foreign places and quite relaxed in front of the camera. This location was chosen to take advantage of a shaft of strong sunshine from a skylight at the left, with a gold reflector on either side to the front facing the model to throw warm light on to her face and breasts. Notice how the striped sleeves and top were chosen to match the blue and white paint of the setting.
35-80mm zoom lens, Kodachrome 64, 1/30sec at f5.6.

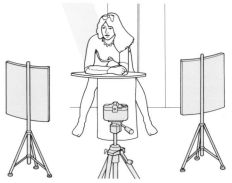

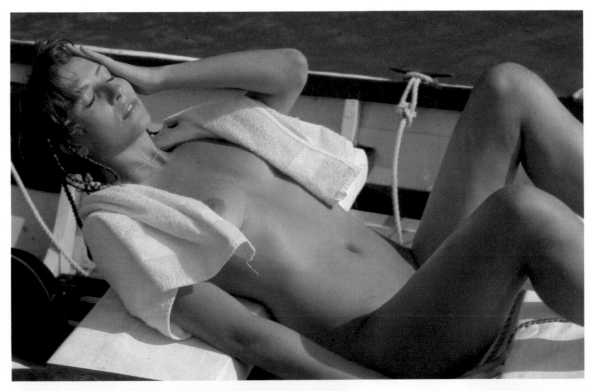

A polarizing filter had to be used for this shot in a boat (left) to cancel out the glare from the surface of the sea which was interfering with the light reading. The boat was pulled up next to the jetty to allow the photgrapher a firm base from which to work. The towel was chosen to match the color of the boat.
85mm lens, Kodachrome 25, 1/30sec at f5.6.

Late afternoon and early evening offer some of the best lighting conditions for glamor photography (left), with a calm and mellow atmosphere that can give great mood to the shot. The exposure for this example was set for the landscape rather than the model, with the fading light shimmering off the ripples in the bay. The bright reflections from water can be used to achieve a partial silhouette effect, as here.
300mm lens, Kodachrome 64, 1/60sec at f5.6.

It is a mistake to think jthat the strong sun of the mliddle of the day is essential for successful glamor photography. Evening light is soft yet directional (above), and is flattering to model and color film alike. The warm glow of the low sun gives a natural appearance to skin, with good highlights showing off the rounded shapes of the body, but without deep shadows that can cause ugly distractions. But you have to work fast as the light changes quickly.
85mm lens, Kodachrome 25, 1/30sec at f5.6.

147

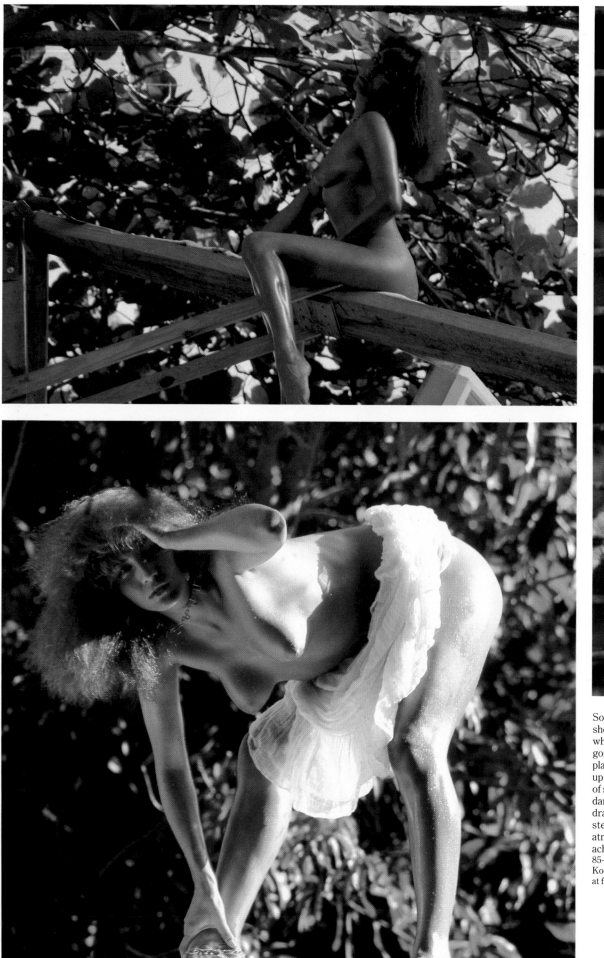

Sometimes effective shots are possible even when the light is almost gone (top left). By placing the model high up to catch the last rays of sun, and against a dark canopy of leaves, a dramatic shot with a steamy, jungle atmosphere was achieved.
85-210mm zoom lens, Kodachrome 25, 1/30sec at f5.6.

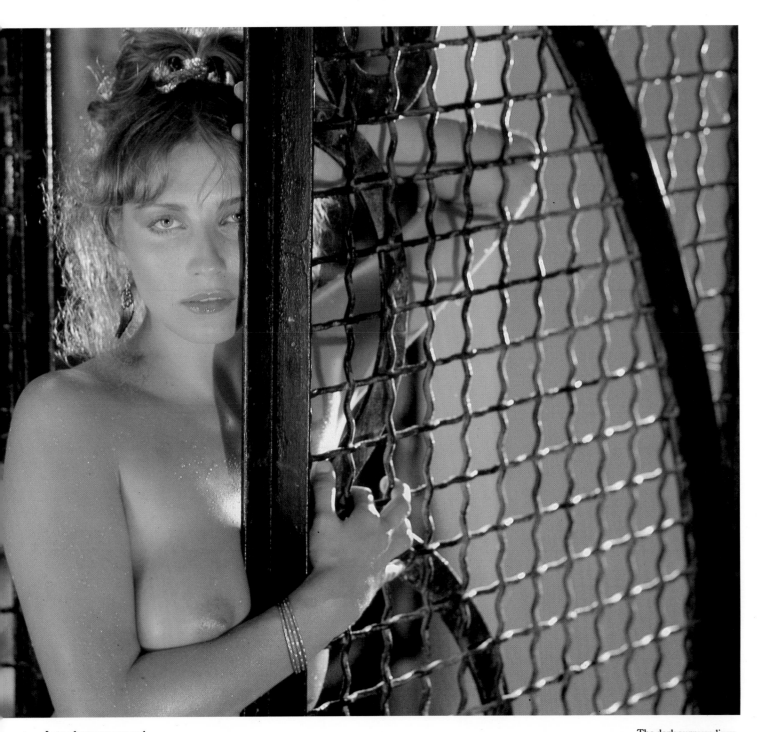

Late afternoon sun and a dark background of tropical trees contribute greatly to this scene (left), but it is the model's agile pose and sultry expression that bring it to life. Apart from the petticoat, she is wearing plenty of baby oil and has been sprayed with water to give the skin its lustre, appropriate to the tropical scene.
85-210mm zoom lens, Kodachrome 25, 1/60sec at f5.6.

The dark surroundings and poor daylight necessitated the use of artificial light for this shot (above). A spotlight was placed to the right of the model and bounced across from a gold reflector for directional lighting, with a main spotlight placed at the front to light her face, arm and breast. A second gold reflector to the left softened the shadows further.
85mm lens, Kodachrome 64, 1/60sec at f5.6.

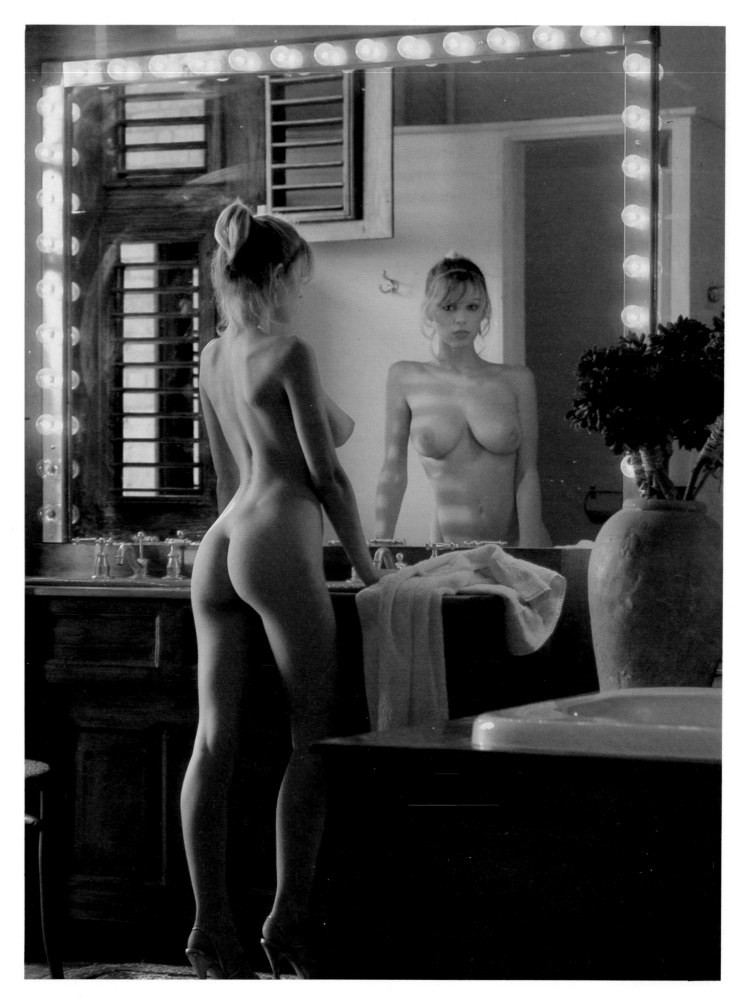

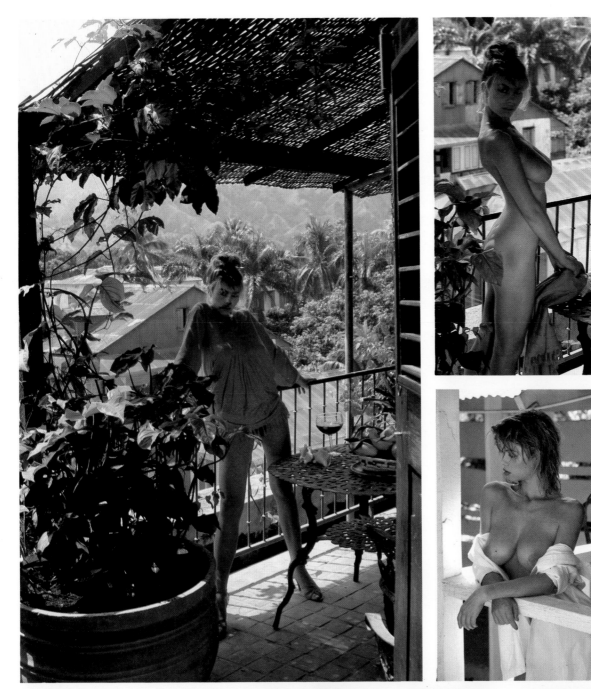

Taken on the same spot on the balcony as the shot to the left, a wide-angle zoom was set here (left) at a longer focal length to close in on the model and exclude much of the background. The background should play a major part in the shot or be kept to a minimum to avoid unwanted distraction. 35-80mm zoom lens, Kodachrome 25, 1/60sec at f5.6.

A particularly beautiful model will be a sufficient subject for even the most straightforward shots, such as this impromptu portrait (below left). With the model relaxed and ignoring the camera, this has some of the informal qualities of candid photography. Be prepared to take advantage of simple moments like these. 85mm lens, Kodachrome 25, 1/60sec at f4.

This shot was the first of the day (below), showing how quickly and well a good model can become used to the camera. Early morning daylight, reflecting from the white walls and filling in the shadows, was sufficient for an entirely natural view as Toni dried her hair in the sun on the balcony. 85-210mm zoom lens, Kodachrome 25, 1/30sec at f5.6.

The large mirror (left) was ideal for photography. It was just a question of waiting for the time of day when the most sun poured through the windows – in this case, at midday. All the room lights were switched on, with the bulbs around the mirror adding to the illumination and an extra glow coming from a concealed light. These tungsten lights add an orange glow on daylight balanced film. A wide-angle zoom lens was used. 35-80mm zoom lens, Kodachrome 64, 1/15sec at f8.

Early morning on the balcony (above) allowed a shot that took full advantage of the fantastic Haiti location, with rich tropical vegetation covering the mountains surrounding the hotel. The limited space made the shot difficult and a wide-angle lens had to be used. It had the advantage, however, of great depth of field, so that the plant in the foreground, the model and the palm trees in the distance are all in sharp focus. 28mm lens, Kodachrome 25, 1/30sec at f5.6.

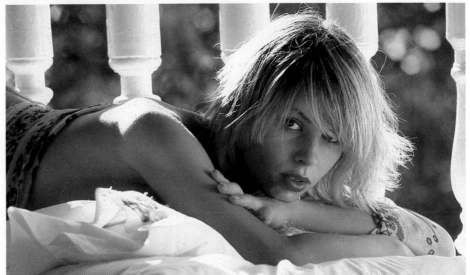

The assigment produced some additional work (right) when a Haitian brewery asked for some shots of the models with their products for use in a calendar. For the professional photographer on location, it is a good idea to contact local businesses that may be in the market for pictures.
85-210mm zoom lens, Kodachrome 25, 1/60sec at f5.6.

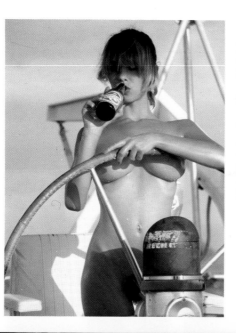

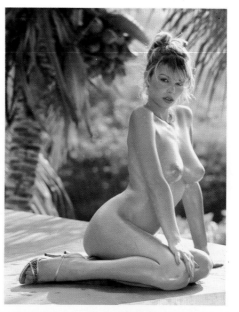

A classic glamor pose in an exotic location made an effective photograph (left). Reflectors placed quite close to the model softened the shadows and lit the face.
80-210mm zoom lens, Kodachrome 25, 1/60sec at f5.6.
The summerhouse of graceful metal tracery, one of Haiti's most interesting types of building, provided an excellent location (bottom). The shot was taken from about 10ft (3m) below in a courtyard, with the sun fading rapidly in the evening.
35-80mm zoom lens, Kodachrome 64, 1/30secs at f5.6.

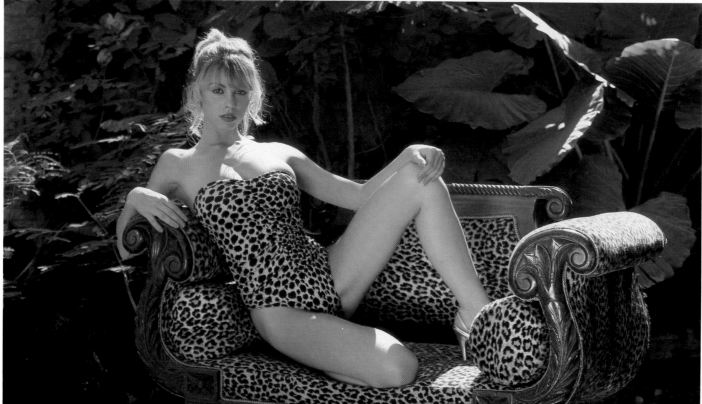

The sun behind the model provided the main light for the leopardskin swimsuit shot (above). Two reflectors were also used, to the front on either side of the camera. The leopardskin made a successful combination with the jungle foliage.
80-210mm zoom lens, Kodachrome 25, 1/30sec at f5.6.

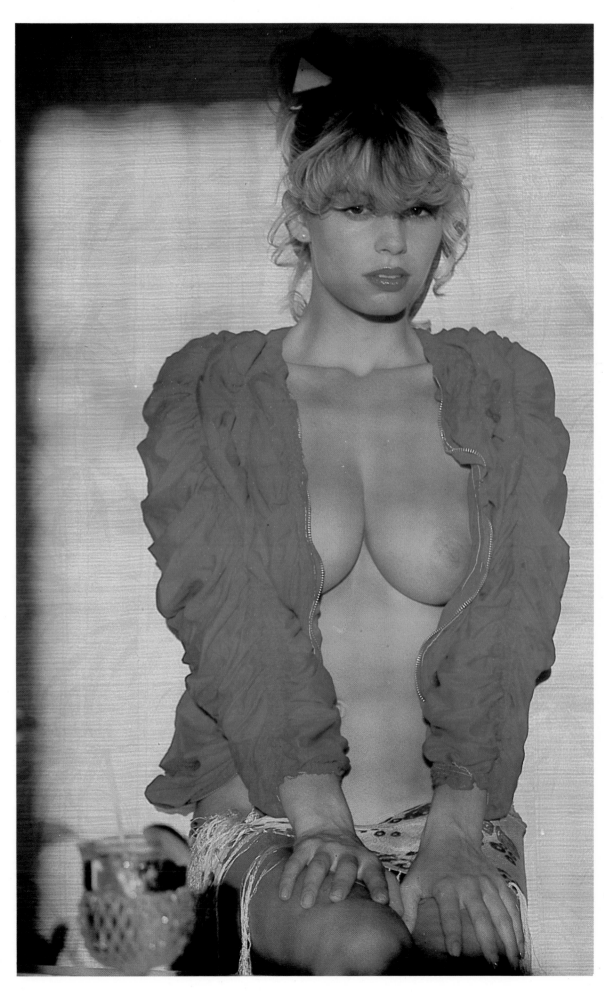

The late afternoon sun shining through a yellow blind created this special color effect (left), with no additional lighting. The red top was ideally suited to the warm color scheme. 85mm lens, Kodachrome 64, 1/30sec at f5.6.

On a warmer day, a sunnier mood prevailed (below). In fact, the sun was hidden behind clouds, which allowed this shot to be taken at midday without hard shadows appearing in the shot.
85-210mm zoom lens, Kodachrome 64, 1/30sec at f5.6.

The twins, Susie and Sally, provided some really good photographic opportunities until one of them suffered sunburn – a real danger to look out for when working in strong sun. The shot of Susie (right) in a pensive mood was taken on an overcast day. The poor light made the use of a spotlight necessary, placed to the left of the camera and aimed approximately at her right hand.
85mm lens, Kodachrome 64, 1/30sec at f4.

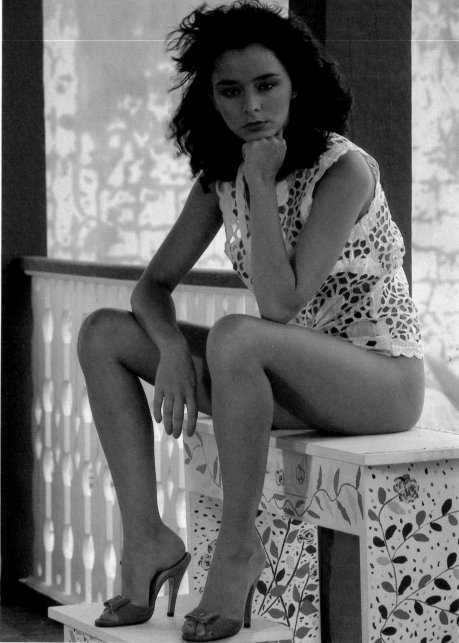

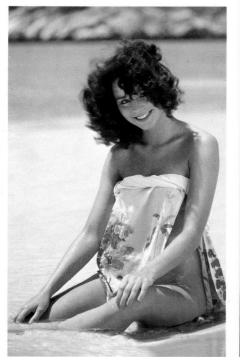

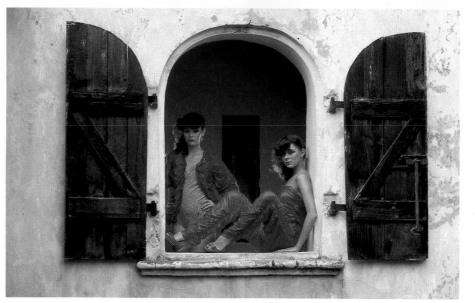

The Haiti location offered a few settings with an almost Mexican feel, such as this superb window (left). The costumes were chosen to enhance this mood. The conditions were particularly difficult, with a weak and unpredictable sun. Two spotlights inside the room were responsible for the attractive halo on the twins' hair.
85mm lens, Kodachrome 64, 1/30sec at f5.6.

The wide-angle zoom lens set at its shortest focal length of 35mm was needed to include the extensive view of the beautiful bay (right). Notice how the high viewpoint raises the horizon in the frame, allowing the blue sea to provide an uncluttered background and keeping the moored yacht from interfering with the main area of interest in the foreground. Hazy sun is quite sufficient to create an image of blissful warmth without harsh shadows.
35-80mm zoom lens, Kodachrome 25, 1/15sec at f5.6.

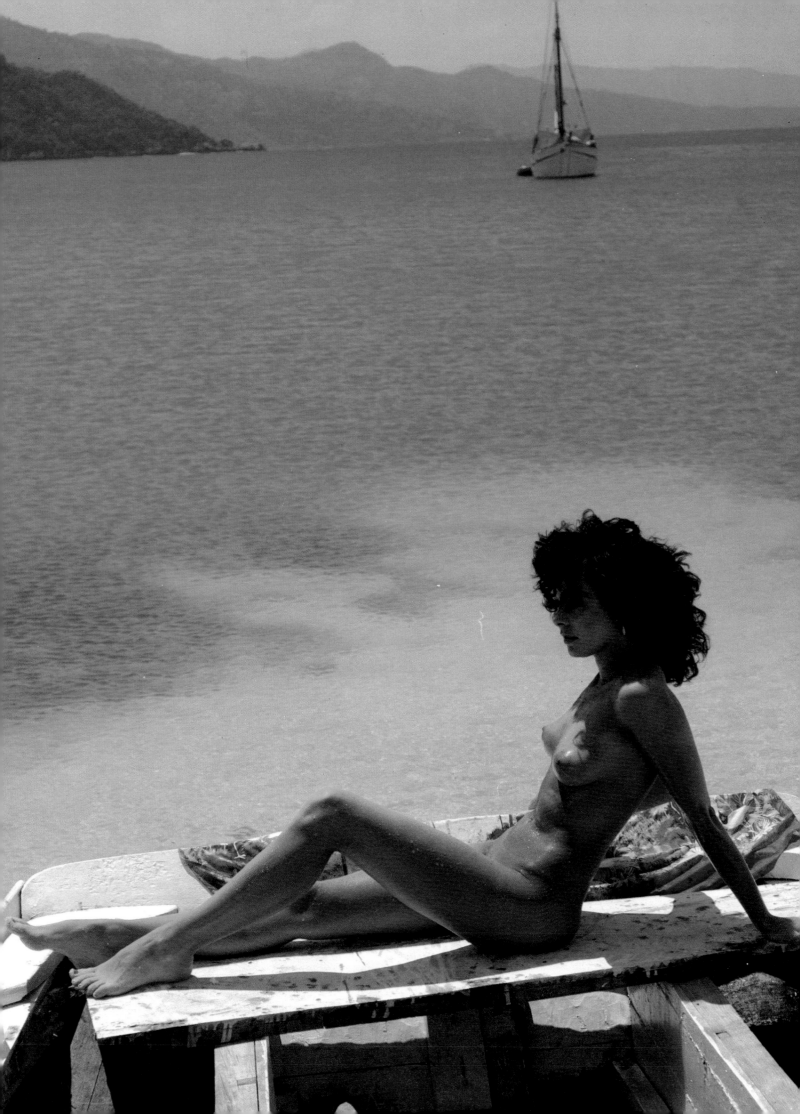

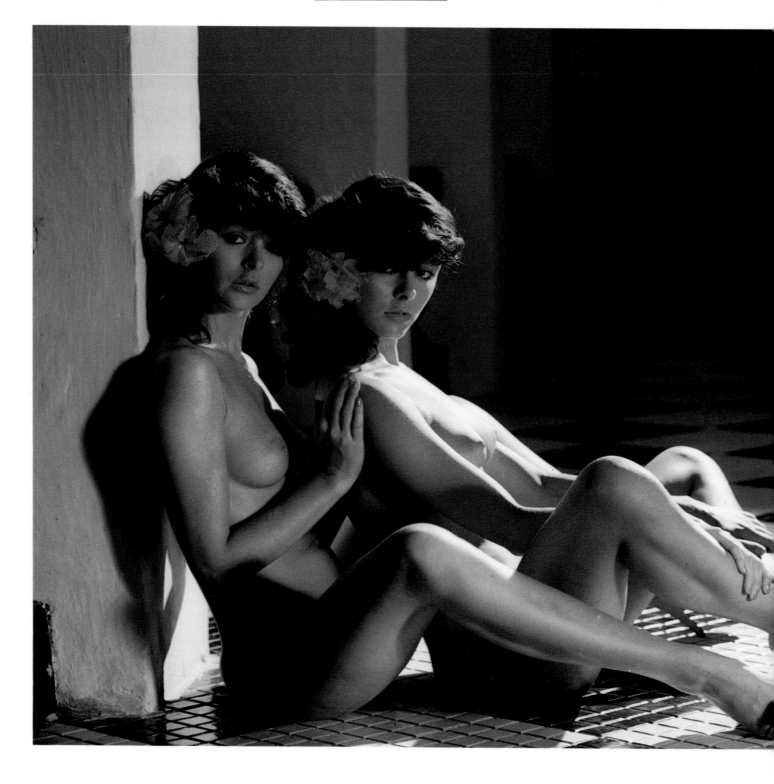

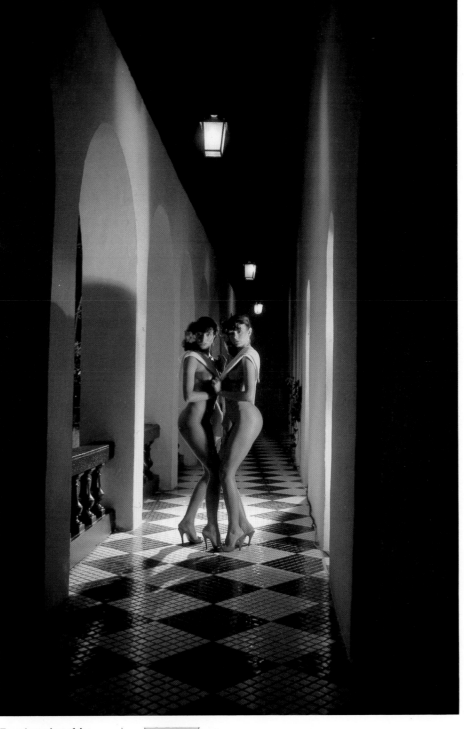

The hotel corridor (above left) provided a fine location, with the clean lines of the arches and an attractive tiled floor. For this shot, sunlight from the alcove on the left was bounced back with a gold reflector placed to the right. The twins' make-up, hairstyles, and props (the shoes and the flowers) were matched to increase the illusion of double vision.
85mm lens, Kodachrome 25, 1/15sec at f5.6.

For a long shot of the twins in the same corridor photographic lights were added. Two spotlamps were placed in the doorways and pointed away from the models to be bounced back by reflectors. Here, the pose was chosen for a mirror-image effect.
35-80mm zoom lens, Kodachrome 64, 1/30sec at f5.6.

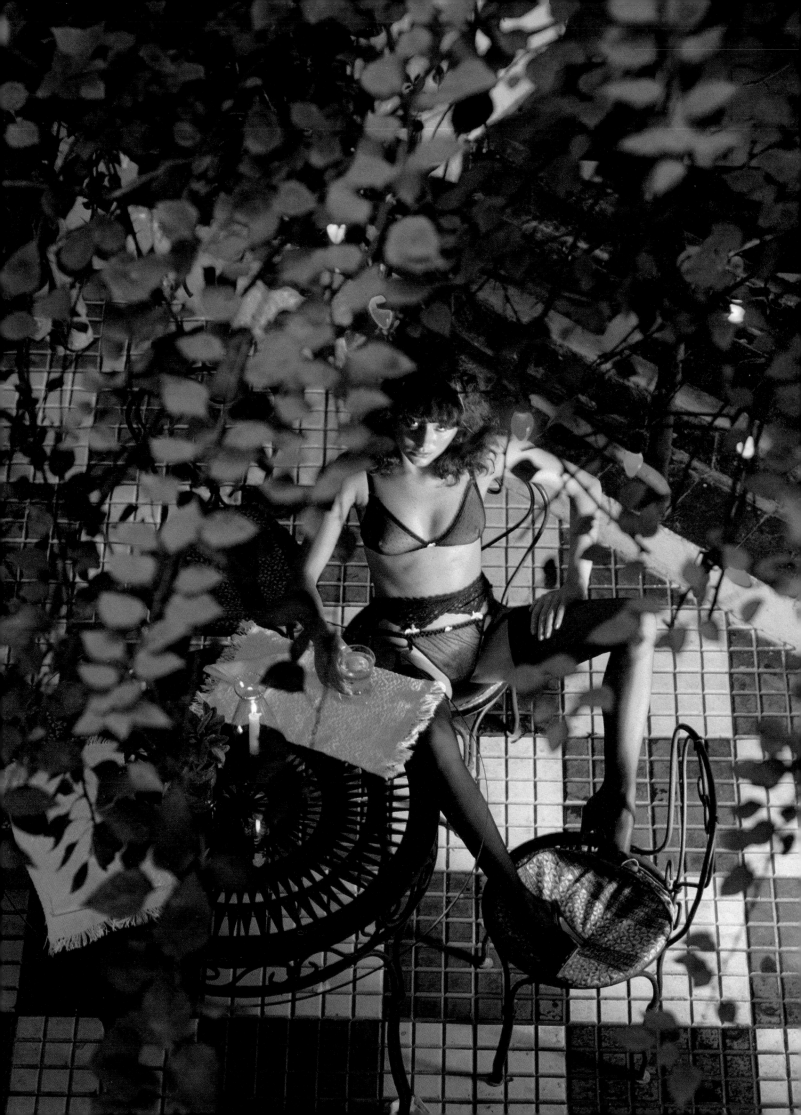

One of the best shots taken in Haiti (left) was set in a restaurant. Two spotlights on the floor to the right of the model provided warm directional lighting, with two reflectors, (one beside and one behind the model) providing fill-in.

Because of the shooting position, it was not possible to use a tripod, but the slow shutter speed of 1/15sec was made possible by bracing the camera against the balcony railings. 85mm lens, Kodachrome 64, 1/15sec at f4.

Portable flash produces hard unflattering light and is not generally suitable for glamor photography. For this interior shot, however, it was the only extra light possible (left). The flash was fitted to the top of the camera and set to half power so that the available lighting from the room lights and fruit machines would still show in the shot. It also kept the light on the models' faces and bodies acceptably soft. 85-200mm zoom lens, Kodachrome 64, 1/60sec at f8.

Haiti's painted woodwork (above) is distinctive and made effective props. The light was poor, so a single spotlight was used in addition to the daylight. 85mm lens, Kodachrome 64, 1/30sec at f4.

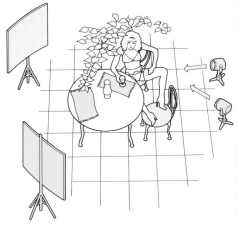

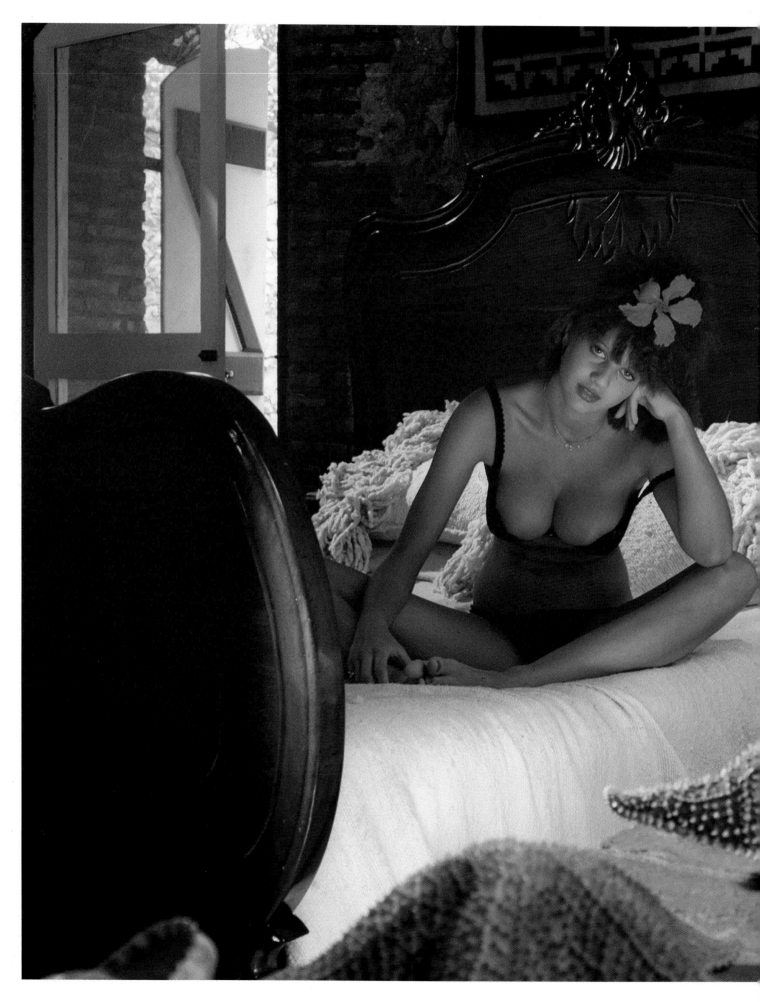

Using daylight film with tungsten spotlights alone (below), gives a rich orange color cast. With other types of photography, the results would be unacceptable, but for glamor work, the effect is flattering to the body. One light was placed to the side, and another behind the model.
85mm lens, Kodachrome 64, 1/15sec at f4.

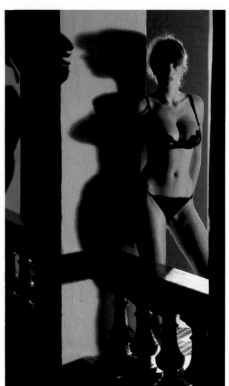

The hotel bedroom (left) was an ideal location, with a superb carved bed and local shells as decoration. The sun was quite bright and shone into the room from the door behind the camera and a window out of shot to the right. Extra lighting was needed, however. One spotlight was placed high up to the left, pointing directly at the bedside lamp. Another spotlight in front of the shells lit the bedspread and was reflected back to the model from a mirror placed behind the foot of the bed. A third spotlight in front of the scene was pointed towards a reflector just behind the line of shells, providing a generous fill-in, avoiding ugly shadows.
35-80mm zoom lens, Kodachrome 64, 1/15sec at f5.6.

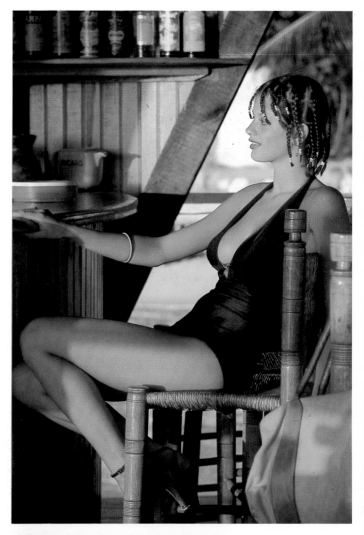

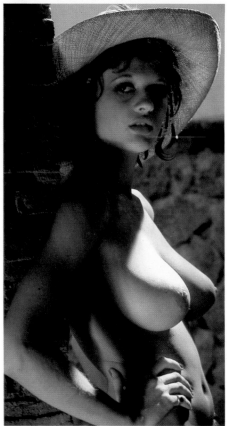

Lynn was nervous for this beach bar shot (above) – she was creating quite a stir with the other customers! The sun provided plenty of light for the shot, although a reflector facing upwards on the floor softened the shadows. Note how the black swimsuit is flattering to the fuller figure.
85-210mm zoom lens, Kodachrome 64, 1/15sec at f5.6.

There was only limited light available for this shot against a brick wall (left), with little being reflected from the dark surroundings. A white sheet was placed on the ground to reflect light back into the shadows.
55mm lens, Kodachrome 25, 1/15sec at f4.

On an overcast day, (right) a large gold reflector was used close to the model to add to the level of illumination.
85mm lens, Kodachrome 64, 1/30sec at f5.6.

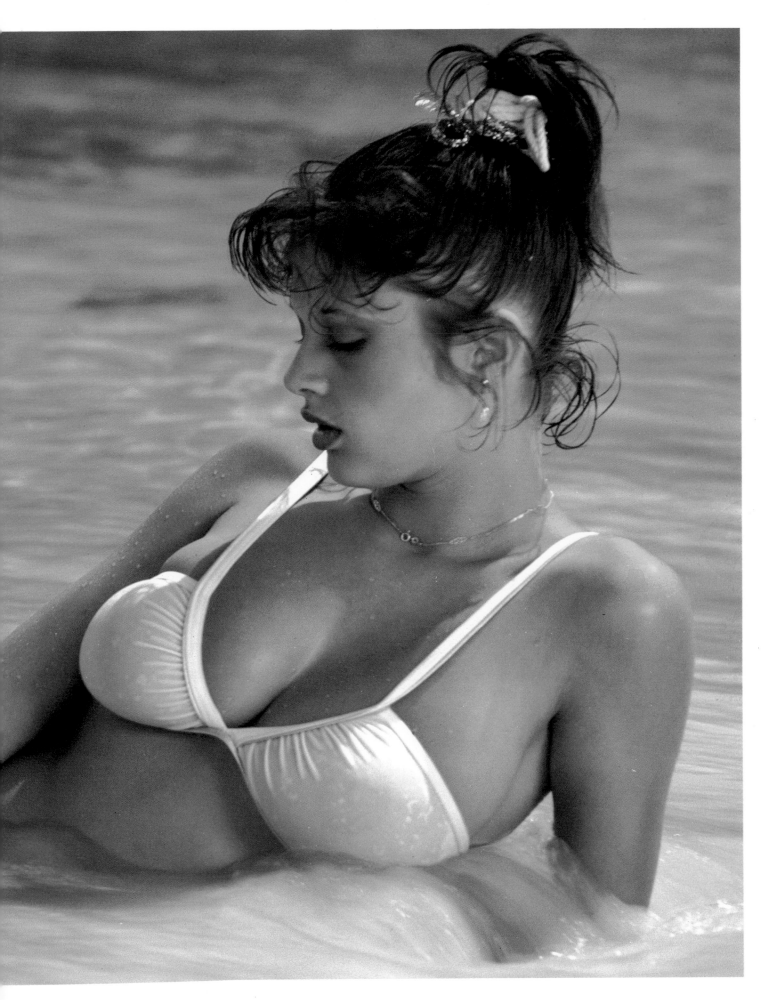

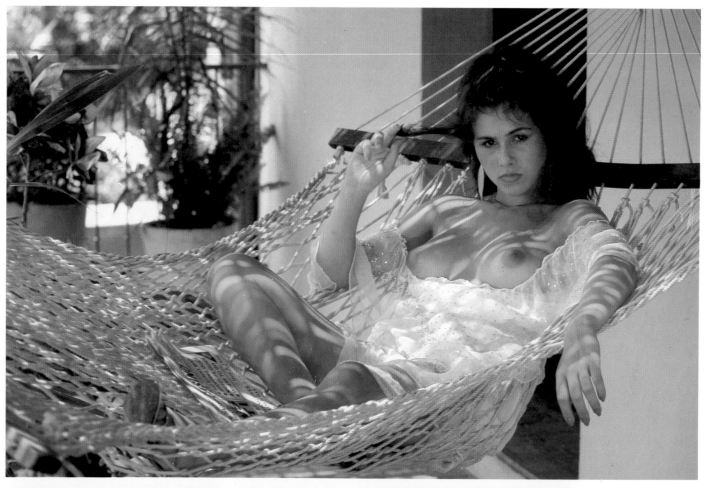

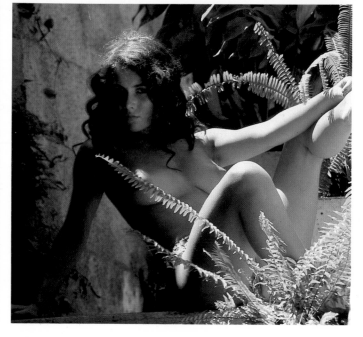

In contrast to the shots to the left, Carol-Ann here looks soft and feminine in a white evening dress (above). The soft shadows and dappled sunlight were sufficient illumination on their own.
85-210mm zoom lens, Kodachrome 64, 1/60sec at f5.6.

Switching to a sultry expression, the model shows another mood entirely (right). The sun shone through the cane chair from behind, with a gold reflector placed by the camera providing a softer frontal light.
85mm lens, Kodachrome 25, 1/30sec at f5.6.

Carol-Ann, who had not modelled before, proved quite a discovery, also looking quite different from shot to shot. The bikini shot (above) was taken at midday in very strong sun, so shade was welcome. Shooting through the leaves

added interest.
85-210mm zoom lens, Kodachrome 64, 1/60sec at f5.6.

Without the bikini (above) the same need for shade applied. In direct sun the range of contrast would be too great for the film. Reflections from white

walls behind the camera filled in the shadows to some extent, making the shade the best place for the model's face as the key area of the shot.
85-210mm zoom lens, Kodachrome 64, 1/60sec at f5.6.

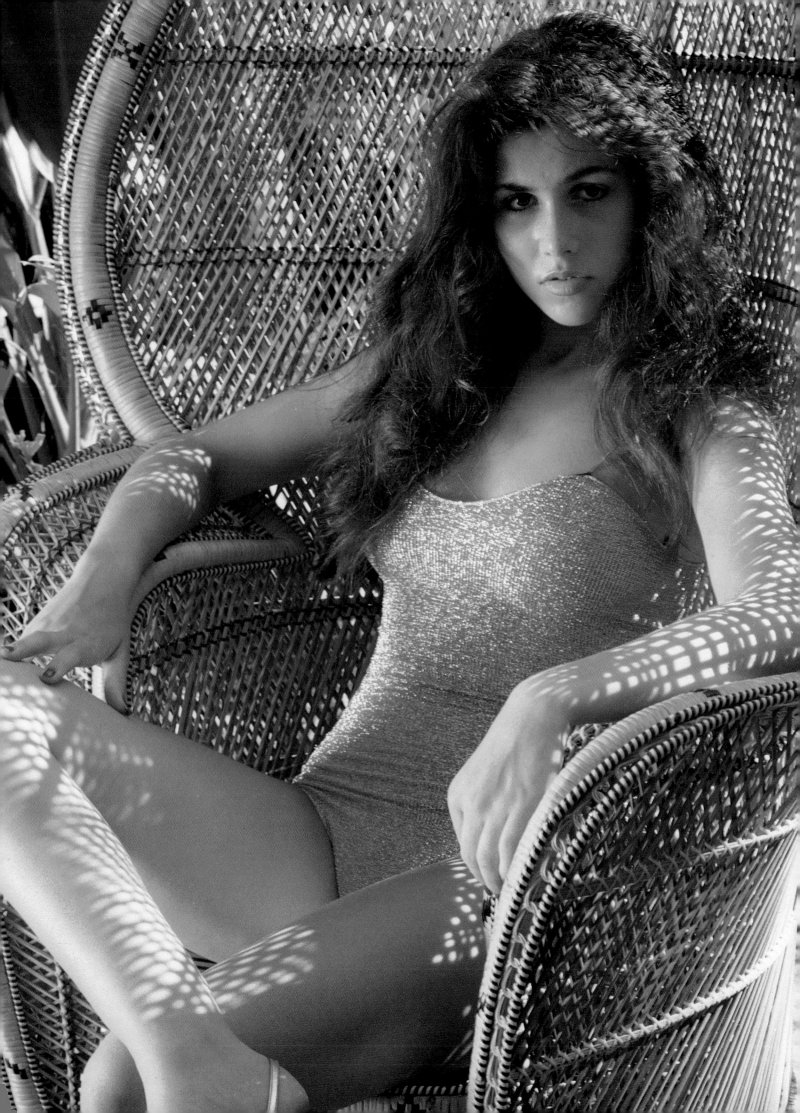

Presenting a portfolio

SO FAR, THIS BOOK has explored the practical business of taking glamor photographs. Whoever you take pictures of – whether it is your wife or girlfriend, an amateur or professional model, the same photographic rules apply. The only variable is the standard of photography that is produced in the end, a definition which applies equally to amateur and professional work.

By definition, professional standards are higher than those set by amateurs. Nevertheless, many amateurs produce stunning work and nowhere is this more apparent than in the glamor field. It will quickly become obvious if you have an instinct for this kind of photography. How you respond to your subject and vice versa is of prime importance, but the acid test is naturally the quality of the end product. If this is high, you may well consider turning professional.

Before taking such a step, however, you should consider that the world of professional glamor photography does not stop at good photography – it starts there. Much of it has very little to do with photography as such. One important thing to remember is that you will have to work with and depend on a lot of other people. These include clients, art directors, set designers, models, make-up artists and stylists, laboratory technicians and agents. The list is endless.

Another necessary requirement is either to develop a thick skin or to find an agent that has one already. Competing with other photographers you think are better than yourself can be tough, but losing work to those who are not is even tougher. You will have to select the right model for the job – one of the obvious perks of the profession – and will meet some of the world's most beautiful women. But you will also have the tricky task of explaining to some that they fall short of the necessary standards of physical beauty for the glamor world.

There is often travelling to be done. One day, you may find yourself working in one of the world's most expensive holiday resorts; equally, the next day, you may have to transform your own backyard into an equatorial jungle with half a dozen rubber plants.

In short, professional glamor photography has its peaks and troughs, but, if you are able to stay the course, it is a very enjoyable way of earning a living. It can also be extremely lucrative.

This section of the book discusses the logistics of turning professional and introduces you to some of the people professionals work with in the glamor field. It is intended to give you an insight into how and how not to approach the business of making glamor photography a full-time career – but in the end, success will depend on your own talent.

PRESENTATION AND PORTFOLIO

Every glamor photographer is something of a salesperson. If you want to sell yourself and your work, you must project a professional image. You must have a working address and get business cards and letterheads printed. If your telephone is unattended during the working day, install an answering machine, so that messages can be left for you. Any meeting you attend should be planned carefully; above all, make sure you have some tangible ideas to present.

First and foremost, however, you must create an impressive portfolio. A first rate portfolio is the foundation of any professional career. It must contain the best possible selection of your work to date, though, in certain instances, you should select work you know is suited to the taste of the particular client you are meeting. If you are presenting work to a magazine, say, it is often possible to get a clear idea of the kind of pictures it is in the market for by studying back numbers closely.

Your portfolio must combine two qualities; it must be stimulating and memorable. Remember that, in every presentation you make, your work will be competing against rivals. You should enlarge, or at least alter, the contents at intervals. If you have a changing flow of work, your portfolio will always have something fresh and new in it. There is nothing worse than returning again and again to the same editor, with exactly the same work to show.

The comments that potential clients make on your pictures will naturally vary; if nothing else, different reactions to the same photographs will confirm the subjectivity of art direction. Do not necessarily take every comment to heart, though, if comments made at several presentations warrant it, you should decide whether to add or discard photographs from your presentation.

DISPLAYING YOUR WORK

Although content is the most important element in the portfolio, you should go to maximum lengths to ensure that your pictures are displayed to the best possible effect.

Published work should play a special part in any presentation. It shows that you have an established track record; this will make a new client feel confident about commissioning you. Always collect printed copies of your work; if possible, obtain final proofs from the publisher as well, since these are sometimes of higher quality than the printed version. Have such material laminated professionally (a number of companies provide a laminating service specifically for presentations and portfolios, with a choice of backing material, borders and finishes). The final product not only looks professional; it protects your work at the same time.

The normal way of presenting work is in the form of color transparencies, which are viewed on a light box. The best way to present transparencies is mounted in sets. Black card mounting, available from any photographic store, shows off color to its best advantage. Print your name and telephone number on the mount cards.

Color prints are more useful in the initial stages of presentation. Make a selection of your best transparencies, have them enlarged, printed and laminated. Such prints can illustrate more clearly the quality of your work. Small prints can be used to demonstrate the broad range and style of the stock of pictures you have built up, but a few really high quality, large prints of your very best shots will give a more appealing impression of how good your pictures will look enlarged – particularly if you do not have published work to show.

PRESENTATION AND DISPLAY

Attractive presentation of your work is vital if you hope to make any sales (right). As transparencies are the preferred medium, black card window mounts are an ideal solution. Choose your best pictures and arrange them to show the full range of your work – indoor and outdoor shots, close-ups and full figures. A portfolio with a ring binder system will present them easily and attractively to your potential clients. Any published material – pages from magazines and so on – should be neatly presented. Some of your very best shots could be made into laminated prints. These are of high quality and can look very good – although they are expensive.

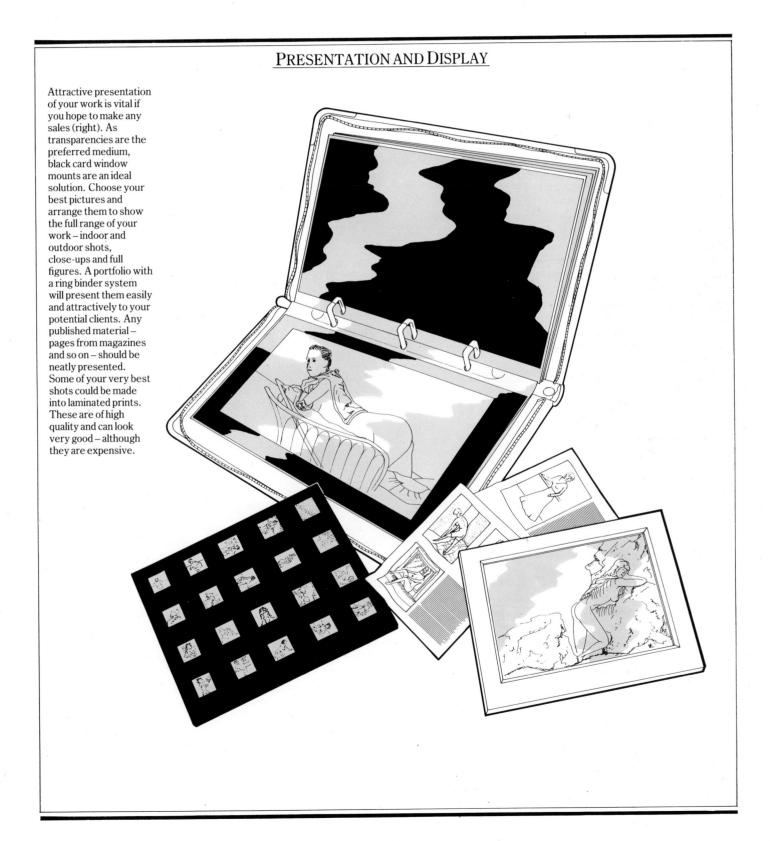

Creating a calendar

A CALENDAR IS ONE of the most rewarding commissions for any glamor photographer. Not only are you able to convey a theme or message in a series of pictures; it is also extremely satisfying to see your photographs on display, rather than between the covers of a magazine. Even for a top professional, though, there is no sure way of securing a calendar assignment or even guaranteeing that you will hold the account from one year to the next.

Glamor calendars are big business. Because many companies use them as major advertising vehicles, budgets are usually quite high. You will be working with top models and a first-rate design team. In return, you must deliver a high-quality product to the client. If you get it right, the calendar will grace the walls of homes, bars, offices and factories for a full year and the company will be delighted with the promotion. If you get it wrong, the calendar will quickly end up in the trash can and you can cross that client off your books.

Most large organizations are usually willing to see an established photographer for a presentation. If the meeting goes well, the photographer is invited to show some concrete ideas and designs for the calendar. The photographer who gets the job is the one who, in the opinion of the art director and marketing manager, has offered the best solution to the concept.

One of John Kelly's favorite assignments was the 1978 'Unipart' calendar. 'I had my heart set on a Californian theme of two starlets bursting their way into the movie business. I believed I knew exactly what I wanted and that I would find this in Hollywood. Working with an art director, I was able to rough out the blueprint for the calendar and was given the job.'

The next step was to find the right models. 'We were looking for two girls to fit the same role, but each had to offer star quality, as well as something special and uniquely personal. We were lucky to find the right balance, with two models who complemented each other perfectly.'

No location shoot ever runs perfectly. Though the costumes, for instance, were designed and made in Britain, a number of changes were made to them during the actual photo-sessions to suit the mood of the moment. In fact, many other aspects of the original design were eventually changed. If there is one thing you can be certain of when organizing a complex location job, it is that plans can only be made up to a certain point. Last minute crises will inevitably occur; the photographer will have to take immediate and sometimes difficult decisions. It takes a great deal of skill and experience to see a job through successfully, especially since, with large budgets at stake, everything assumes greater importance. For this reason, it is imperative that client and photographer have a good working relationship, so that as many eventualities as possible can be discussed before they happen. Such pre-planning lessens the risk of serious disagreement later.

In Los Angeles, for instance, John Kelly had to scout around for the right location to fit each subject. 'Although my agent, Jerry Barnes, had made a preliminary trip to Los Angeles a couple of months before the shoot, no definite locations had been established and we had a better idea of what we could not do, rather than what we could do. Location hunting in unfamiliar areas is always difficult and can be particularly frustrating if you know exactly what you're looking for. If you concentrate on the specific, too, it is easy to overlook alternatives.

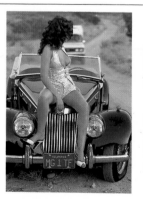

For an important calendar commission, considerable back-up may be available from the clients. Here, the agency's art department produced roughs of the types of shot they wanted – all contributing to the careful planning.

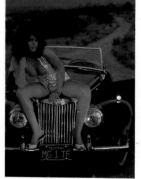

One shot used an old MG sports car in the Californian desert. In the afternoon there were interruptions from traffic and the light offered little atmosphere.
85-210mm zoom lens, Kodachrome 25, 1/60sec at f5.6.

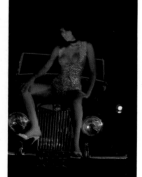

When the sun was going down over the mountains in the evening, a more interesting light was achieved. Reflectors added light to the model.
85-210mm zoom lens, Kodachrome 25, 1/15sec at f5.6.

As the darkness increased another shot was tried using car headlamps for the illumination. The desert can no longer be seen.
85-210mm zoom lens, Kodachrome 25, 1/4sec at f5.6.

An opulent set and a book on Greta Garbo made this shot (left). The setting would have been spectacular in any case, but the book's cover adds an effective visual joke. Natural light from a window was used with two gold reflectors to the front. 85mm lens, Kodachrome 25, 1/15sec at f5.6.

The famed director's chair and the studio lighting equipment set the model clearly on a Hollywood sound stage (right). The luxurious silk dressing gown adds to the image. Three spotlamps were used. 85mm lens, Kodachrome 25, 1/30sec at f5.6.

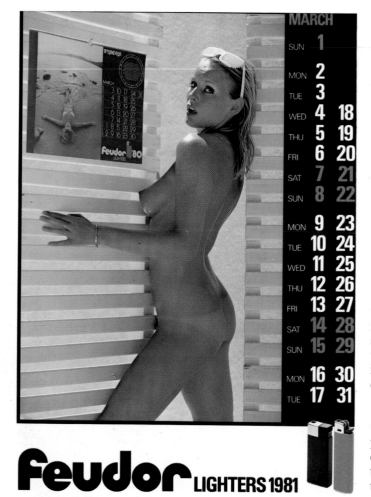

feudor LIGHTERS 1981

'In the event, I had very little option but to keep an open mind. Many of my Hollywood dreams had to be put on ice, as we were routinely refused permission to photograph at the places we had chosen. It was extremely discouraging and more than once or twice, I felt in complete despair. However, set-backs only make success that more satisfying. On a good day's shooting, when we knew that the results would be what we wanted, spirits were high.

'The routine was for Jerry to find the location and props. I would vet them the night before the shoot with the art director, following this with a meeting with the stylist, make-up artist and the models. The actual picture would only start to take on a life of its own once we had reached the location and I had the chance to make decisions about what was available. Such factors as the space and light available and the mood of the model all had to be assessed. In all, we spent two weeks in California and took 18 sets of pictures, from which 'Unipart' selected their 12 favorites.'

Obviously, not all calendar assignments fall into the league of big budgets, expert art direction, top models and exotic locations. As in all glamor photography, there are different levels to which to aspire. Nevertheless, if you are persistent, have good ideas and the ability to carry them through, you will probably be able to break into some area of the calendar market. Remember that working within the limits of a tight budget should never be inhibiting; it should be a challenge and incentive to find the right creative solution for the right price.

THE TRICKS OF RETOUCHING

Contrary to popular belief, very little retouching is done in glamor photography. Whenever possible, you should eliminate mistakes during the actual sessions rather than later. However, there are times when retouching is called for and here Bill Cooke, the technical director of a leading retouching studio, tells you how he approaches the task.

'Corrective work on models is usually required only in beauty and fashion photography when absolute perfection in the paramount aim,' Bill Cooke says. 'No matter how good a model is, there will always be the odd blemish, line or stretchmark that has to be eliminated if she is advertising skin care products or cosmetics. Shots that emphasize hands, feet or legs invariably require some kind of retouching, especially if the model has had to stand on one leg, or in a fixed position, for a long time. Veins in the hands and feet swell very quickly under hot photographic lights. We have never been asked to change the entire shape of a model or to slim her down. Models are selected in the first place because they are right for the job and the photographer is expected to edit the picture inside the camera. In glamor work, too, models are expected to be natural and the odd laughter line or freckle adds, rather than detracts, from the entire image.'

One of the chief reasons for retouching was when frontal or partial nudity was considered offensive. This is seldom the case nowadays and, if it occurs, modesty is usually not the only factor involved. In 1980, for instance, John Kelly was approached by an agency who wanted to use his photographs for a calendar they were producing for a client. Part of the brief was to incorporate the client's name or product into a number of the shots. The only way this could be done was by photo-composition, a job that again can only be handled by a competent retouching studio.

'Photo-composition and photo-montage can involve relatively simple or extremely sophisticated techniques,' explains Bill Cooke. 'The calendar was not a complicated job, but it required skill and imagination to superimpose the client's image into the photographs in a convincing way. We did this by printing the name directly on to clothes or accessories that the model was wearing, or incorporating the product into the picture, so the model appeared either to be holding it or wearing it in some way'.

Combining images can be done in the camera with still-life photography. With models it involves retouching procedures. Good studios can achieve extraordinary results. Here, for example, a client's name (on the previous year's calendar) is added to an existing shot. 1 The original photograph was chosen to include a suitable space for the addition. 2 The 1980 calendar was photographed to a suitable size and at the correct angle. 3 A duplicate was made of the original with the space for the calendar masked out. 4 The calendar was duped in a similar masked form. 5 and 6 Register marks are added to each image so that they can be combined in a further duplicate in precise alignment.

Agents and agencies

WHEN YOU FIRST turn professional, you should remember that there are considerably more photographers looking for agents than there are agents looking for photographers. Finding an agent at all, therefore, is not necessarily easy, while finding the right agent for you as an individual can be even harder.

In the first place, you must have attained a certain professional standard before an agent will generally agree to represent you. In normal circumstances, agents are interested only in representing photographers commanding high fees; otherwise it is not worth their time and effort trying to find you work. Equally, it is hardly worth your while to pay large commissions to an agent who rarely gets you assignments.

If, however, you start to find that administration, paperwork and knocking on doors are using up valuable time that could be better spent behind a camera, the chances are that you are ready to join forces with an agent. Usually, agents work for a commission of around 50% (if the material is from stock) and approximately 25% (if the photographs are commissioned). The relationship between photographer and agent can vary from a formal arrangement to handle your stock shots, with little or no personal contact, to close involvement with all aspects of your career.

The most important requirement between agent and photographer is mutual trust. Before you sign any agreement with an agent, however, it is important to get a number of basic issues clear to avoid the possibility of any misunderstanding. The following are the basic questions that any professional glamor photographer would ask before coming to such an agreement.

What exactly is the agent's commission and does it apply to all work you do, or just the jobs the agent secures for you? Is he or she your sole agent, or can you be represented by someone else in countries where the agent has no representation? How and when will you be paid for the work you have done? Will you or the agent be responsible for the cost of presentations?

Is the agent capable of handling all the administrative work involved in setting up a complex assignment? Will the agent instigate and organize speculative shoots for stock photographs? Has the agent good working relationships with the major model agencies and is therefore able to arrange the hire of models, make-up artists and stylists at short notice? Will the agent be closely involved in overseas assignments and how much responsibility will he or she assume for their preparation?

How much authority will the agent have to assign rights? Will the agent insist on copyright notices and credit lines on your behalf? Will the agent accept any liability for loss or damage by the agency and what percentage of loss or damage compensation paid by a third party will you receive? How long will you be obliged to keep your work with the agent? (Because of the high costs involved, an agent may insist on being able to handle the material for several years). Will your agent have an option for renewal at the end of the contract? If the agency changes ownership or closes down, do you have a contractual right to immediate return of your material?

Unless you are well-established, it is unlikely that you will be

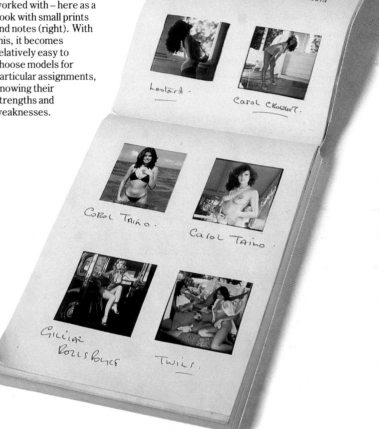

Models are vital to successful glamor work. The professional can build up a visual record of models he has worked with – here as a book with small prints and notes (right). With this, it becomes relatively easy to choose models for particular assignments, knowing their strengths and weaknesses.

lucky enough to have an agent who is able to work solely on your behalf, assuming responsibility for almost everything except the actual taking of photographs. Indeed, it is probably unwise for a photographer to relinquish all administrative involvement. Apart from enhancing the commitment to a job, it can also be extremely exciting to see an assignment through from beginning to end.

STOCK AGENCIES

It is also possible to work entirely through what is termed a stock agency. This means that you remain a free agent, able to select your own models, deciding for yourself what photogaphs to take of whom and when.

To register with such an agency, you will probably have to submit at least 200 photographs representative of a larger selection of your work. Once accepted by the agency, you can send further batches at regular intervals. Such libraries are not only extremely efficient; they also are in regular contact with buyers all over the world. They know whom to approach with which photographs and can often be more successful in securing

high fees. In addition, a library with a good reputation will be used regularly by picture researchers for top-quality publications.

However, relying on stock agencies does have its drawbacks. The initial expenses – model and location fees, cost of film stock and so on – are the photographer's alone; unless you are confident that your pictures will sell, you will find yourself heavily out of pocket. A stock agency usually charges 50% commission and will pay you only after it has been paid by the people buying your photographs. It can therefore sometimes take several months before you see any financial return on your work.

The best policy is probably to forget about the photographs the minute you lodge them with an agency. Though you may find this to be a regular source of income, the acid test, as always, is whether your work is good or commercial enough to sell. If, however, you intend to invest in expensive model fees or location work abroad, it is worth checking beforehand to ensure that the agency is interested in and will distribute your work. There is never any guarantee that an agency will take all your photographs, so it is important that you are familiar with the marketplace and are able to judge its requirements as far as possible. With experience, you will soon get to know what is acceptable and what is not. On the other hand, you are always better off relying on your own standards and taste, because this is the only way of developing your own style. Compromise will only win you a reputation for mediocrity that will be hard to shake off.

Remember that every photograph carries your name and so is an advertisement of your work. Provide your agency with enough original material to be syndicated because duplicate transparencies are inferior in quality. Never be afraid to shoot a lot of film. Many excellent photographs are lost because the photographer made the false economy of saving on film stock.

Developing a good working relationship with your agency is extremely important. You must not ask them to syndicate work you have already sold independently in any circumstances. Unless the agency knows it has sole distribution rights to your work, it will not make any effort on your behalf and both parties will suffer accordingly.

In general, stock sales usually work best for photographers who shoot a large amount of material in the normal course of their careers and so find the extra sales a pleasant bonus. With persistence, however, it is possible to make it your main activity, particularly in the glamor field.

MODEL AGENCIES

In the professional world, therefore, just as much can depend on the quality of the model as on that of the photographer. Model agencies are thus a vital part of the glamor photographer's world. Many photographers prefer to work thru an agency if they need a girl for a specific job. By doing so, they are guaranteed certain standards and are saved the problems that often arise when a model is unsure of herself and the situation. This is not to say that such photographers will not work with a girl who is not attached to an agency. If someone is worth photographing, their status is irrelevant, but sooner or later most successful models need the guidance and protection of an agent.

Samantha Bond runs an agency that specializes in glamor models. As a former model herself, she is acutely aware of the needs not only of her models, but also of clients and photographers.

'Glamor models are different from fashion models,' she explains, 'in that they are generally prettier in the conventional sense and must have a good figure. While they have to be slim (the camera adds 14lbs all over), they cannot be boney or flat-chested.'

To these qualities, Samantha Bond also adds those of dedication and enormous stamina. 'Professional models are paid good rates,' she says, 'and for this they are often expected to work long hours under difficult conditions and still appear fresh and alluring. They must know exactly what they look like and how to project in a certain way on command.' With such exacting standards, it is not surprising that few girls make the grade.

Establishing yourself as a model is also an expensive process. A girl must pay for a set of composite photographs – these can cost up to $US 1,000 for color or $US 500 for black and white – made into 'Z' cards. These are usually produced by specialist printers, who include the distribution of the pictures to photographers and advertising agencies in the price.

'Getting a good set of photographs is essential for any model,' Samantha Bond explains, 'and, in order to cut costs all round, we often work with photographers who want to build up their portfolios. Neither the model, nor the photographer, charges a fee for their services, so everyone benefits.'

Here, it should be stressed that the arrangement outlined above applies only to professional glamor photographers – not to amateurs. 'The glamor business is highly professional,' Samantha Bond says, 'and anyone who is hoping to jump on the bandwagon because it seems like fun finds out very quickly that they are *persona non grata*. Any talented person who is serious about their work will get ahead, but, in this business, amateurs and part-time professionals definitely don't fall into that category, in my opinion.'

Most agencies charge 20% of the overall fee for matching model and client. Hourly and daily rates are set, but trips are usually negotiable, since the model is not required to work all the time. Also, it is normal practice for overseas assignments to involve, or be regarded as, perks and the fees tend to reflect this point of view.

MODEL RELEASES

To avoid the risk of misunderstandings, it is important that your models signs a release form, giving you permission to use any photographs you take of her. The normal procedure is to sign such a release after the photographs have been taken, since your model should be happy with the way the session went and is content to let you have the results published. If, however, she indicates that she will only allow the photographs to be used in a specific publication, then it is vital that you agree this before you take any pictures at all. Occasionally, a model will insist on seeing the photographs before she signs a release, but this is very rare with professionals. The situation is only likely to arise with inexperienced or amateur models.

STUDYING THE MARKET

Without an agent or stock agency, it will be an extremely difficult and expensive process to get your work syndicated. However, it is not an impossible one. All over the world, there are magazines and publications looking for good-quality glamor photographs. If you models are beautiful and your work professional enough, you should certainly get your photographs published. Picture editors of magazines, in particular, are always searching for new talent.

If you have a set, or number of sets, of photographs to sell, present them in the best way possible. If you are aiming for a commission, prepare an idea in advance, bearing in mind editorial and artistic policy. Better still, bring some good pictures of the model you intend to use with you. It is vital that your work is of a high enough standard to convince an editor that you are capable of executing your ideas effectively. There is no point in having brilliant concepts, but an inadequate portfolio.

Remember, too, that one of the greatest assests any photographer can possess is a good model. Many photographers' careers have been launched on the strength of a successful partnership with a new, exciting model.

WHAT 'PLAYBOY' LOOKS FOR

One publication consistently associated with top-quality glamor photography is 'Playboy' magazine. Through its photographs, 'Playboy' visually communicates the contemporary and sophisticated lifestyle that it has come to symbolize. Victor Lownes, Vice-Chairman of Playboy International until 1981, believes that 'Playboy' looks for the following qualities in a photographer.

'Someone who not only understands but also shares the 'Playboy' philosophy,' he says. 'Then they must have the talent and professional knowledge to project that in their photographs. This isn't at all easy, because, although the 'Playboy' image is quite tangible, it is nevertheless always subject to change. Our photographs must reflect only the most contemporary approach to life, with a strong US bias. In actual fact, there are very few photographers who are able to do this successfully. Those that do have worked for us steadily for years and have pretty well cornered the market.'

Only a fraction of the girls who approach 'Playboy' to become a Playmate are selected as possible candidates. Then follows two or three test shot sessions, much deliberation and, more often than not, rejection.

'It is not enough for a woman just to be beautiful in order to be chosen as a Playmate,' Victor Lownes explains. 'She must also be accessible and someone with whom our readers can identify. Playmates aren't exactly the girl next door, but they are someone most men would give an arm and a leg to live down the road from. She is approachable, fun-loving, unpretentious and, above all, sexy.'

The 'Playboy' photographer, therefore, must say all this in his pictures. He must provide an atmosphere that is conducive to making his model relax under completely unrelaxing circumstances. It may be her first – though never her last – photographic assignment.

'Our photographers,' says Victor Lownes, 'must reveal something about the girl's own sexual nature, not their own. We aren't interested in what the man behind the camera is thinking; he should be invisible in every sense of that word. What our readers want is to feel that they know a woman. We could write a million words about what makes someone tick, but it wouldn't say as much as a certain expression, or a special look in the eyes. This is the human quality that can only be captured in photographs and, again, by very few photographers.'

FEES

When starting a professional career, gaining experience is more important than anything else. Never over-price yourself or turn down a job because the fee is low. It is only by doing a lot of work – some, indeed, outside the specialist glamor field – that you will be able to establish yourself as a true top professional.

Nevertheless, it is important to know what you are worth. If you have an agent, or are registered with a stock agency, they will be able to guide you. However, very few beginners have this advantage. By contacting any of the major photographers' associations, such as the American Society of Magazine Photographers in the USA and the Association of Fashion, Advertising and Editorial Photographers in Britain, you can ascertain what is the general scale of fees. Remember, though, that such figures only serve as guidelines. For the most part, photographers sell their services on a free market.

Magazines offer standard rates for uncommissioned photographs, no matter how much it cost you to set up the shot. Commissions are negotiable; the fee will obviously reflect the amount of work and skill involved. If special effects or elaborate sets are called for, the fee will obviously be higher than that for a more straightforward photograph.

The highest fees are found in advertising. The logistics of an advertising assignment can be complex; a one-day shoot can require several days of preparation. While the client may carry a large part of the pre-production burden, the photographer is still expected to contribute quite heavily. Make sure you agree in writing your fee in advance and what is expected for it. This rule applies to all assignments that you undertake.

COPYRIGHT

Copyright law varies from country to country. There are also differences in the degree to which the law may be interpreted. You should be aware of the copyright laws of the country in which you are based and of any country to which you may be selling work.

In the USA, the owner of the copyright is the photographer in nearly all cases. The main exception to this is in the case of staff photographers, where the employer retains copyright. You can, of course, surrender your copyright, so examine any contract carefully before you sign it if you object to such a clause.

The situation in Britain is slightly more complex. There, the owner of the copyright is the person who owns the material on which the photograph was processed or when a photograph has been commissioned by a third party. In all cases, establish in writing who holds the copyright for any work done before you take on an assignment.

As a general rule of thumb, you hold copyright for any photographs you take independently at your own expense. These you are free to sell several times over, or to assign permission for their use, unless you make an agreement to the contrary. In commissioned work, the copyright is retained by the person who commissioned you.

Regardless of the legal position, there are certain ethical standards that any professional photographer would be foolish to breach. If a client is led to believe, for instance, that he has an exclusive on a photograph that is subsequently published elsewhere, he will almost certainly refuse to do business with that photographer again. If you want to publish or display any work in which you do not hold the copyright, contact the person who does and ask for permission to use it. Unless there is a conflict of interests, you will almost invariably be given permission, provided you credit the copyright holder.

In the event of a dispute, it is essential to seek professional advice.

INDEX